AOQIANG ED.

COLOR
CODE
BRANDING
& IDENTITY

COLOR
BRANDING E IDENTIDAD

CODES DE COULEUR
MARQUE ET IDENTITÉ

promopress

COLOR CODE
BRANDING & IDENTITY

Color, branding e identidad
Codes de couleur, marque et identité

Editor: Wang Shaoqiang
Spanish preface revised by: Jesús de Cos Pinto
Translators of the preface:
Kevin Krell, English translation
Marjorie Gouzée, French translation

Copyright © 2016 by Sandu Publishing Co., Ltd.
Copyright © 2016 English language edition by
Promopress for sale in Europe and America.
PROMOPRESS is a brand of:
Promotora de Prensa Internacional S.A.
C/ Ausiàs March, 124
08013 Barcelona, Spain
Phone: 0034 93 245 14 64
Fax: 0034 93 265 48 83
info@promopress.es
www.promopresseditions.com
Facebook: Promopress Editions
Twitter: Promopress Editions @PromopressEd
Sponsored by Design 360°
– Concept and Design Magazine
Edited and produced by
Sandu Publishing Co., Ltd.
Book design, concepts & art direction by
Sandu Publishing Co., Ltd.
info@sandupublishing.com

Cover design:
spread: David Lorente

ISBN 978-84-16504-51-0

Printed in China

Contents

005 **Preface**

009 **Works**

233 **Index**

240 **Acknowledgements**

Preface

By Gaby Salazar (Spicy Mint)

To speak of color in design is more than just speaking about a chromatic phenomenon. To speak about color is to speak of emotions, of feelings that arise when we observe the graphic elements to which we are constantly exposed. Each color corresponds to a psychological reaction that communicates, without the need of words or shapes, a message that will ultimately grant personality to the product, material or brand that accompanies it.

When working on a branding project, the first thing we seek is style. We visualize shapes, the elements we need based on the desired personality, as if it were a very specific biography, and it is color that helps to finally define this biography. Consider, for example, pieces of experimental jewelry. If we adorn the pieces with a light, pink hue, using the right elements can suggest the notion of a young, fresh, upper middle class girl who enjoys going shopping in an original way. However, if we simply change the color but maintain the context, it is possible to redirect the message of the brand, for example, to a 34-year-old man who likes to be on the cutting edge, who has what he needs and gets what he wants. Everything changes if we choose the right color.

Personally, when I do the weekly shopping with my husband, we enjoy checking the shelves in search of attractive packages that we can save when the product they contain is no longer useful. It is at this moment when the design endures and the message is preserved due to the harmony of its elements. Color, above all, is crucial. Color can return us to enduring emotions, provided we know how to use it well.

The extent to which color has influenced us is undeniable. Think about how it is becoming more and more common to hear expressions like "McDonalds yellow" "Facebook blue" and, of course, "Coca-Cola red". If those colors were changed even slightly in their parent brands, the customer would feel like something was wrong and would even have doubts about consuming the product. Color defines who sends the message, the message itself and the emotion it triggers in the person who receives the message.

Color isn't just anything. It is an essential building block in the construction of a brand. It is something that appears to be simple but that defines the course that the identity of the brand takes. So why not? Let's talk about color.

Préface

De Gaby Salazar (Menta Picante)

Parler de la couleur dans le design ne consiste pas simplement à mentionner un phénomène chromatique. Parler de la couleur, c'est évoquer les émotions, les sentiments suscités au moment d'observer les éléments graphiques auxquels on est constamment exposés. Chaque couleur entraîne une réaction psychologique capable, sans avoir besoin de mots ou de formes, de transmettre un message qui insufflera une personnalité au produit, au matériel ou à la marque qu'elle accompagne.

Quand on travaille sur un projet de marque, on commence par chercher un style. Les formes et autres éléments nécessaires sont ensuite visualisés en fonction de la personnalité souhaitée, comme pour une biographie très particulière, et c'est la couleur qui permet d'achever de définir cette biographie. Ainsi, prenons une bijouterie de pièces expérimentales. Si nous l'habillons d'un rose clair, avec les éléments nécessaires, nous pouvons faire naître l'image d'une jeune fille fraîche, appartenant à la classe moyenne supérieure, qui aime faire du shopping de manière originale. En revanche, si nous ne changeons que la couleur tout en conservant le contexte, il est possible de rediriger le message de la marque vers, par exemple, un homme de 34 ans désireux d'être à la pointe de la mode, qui a ce qu'il faut et obtient ce qu'il veut. Grâce à la bonne couleur, tout change.

Quand mon mari et moi faisons nos courses, nous en profitons toujours pour scruter les étagères à la recherche de beaux emballages que nous pourrons conserver quand le produit sera consommé. Voilà comment le design perdure et comment le message est préservé grâce à l'harmonie de ses éléments. La couleur est fondamentale. Elle rend les émotions durables, à condition d'être bien utilisée.

La couleur nous a fortement influencés, c'est plus qu'évident. Il est de plus en plus fréquent d'entendre les expressions « jaune McDonald », « bleu Facebook » sans oublier, bien sûr, « rouge Coca-Cola ». Si ces marques modifient ne fût-ce que très légèrement leurs couleurs, le client aura le sentiment que quelque chose cloche et il hésitera même à consommer ces produits. La couleur définit non seulement l'émetteur du message, mais également le message en lui-même ainsi que l'émotion ressentie par le destinataire.

La couleur n'est pas négligeable, c'est un socle indispensable dans la construction d'une marque. Un élément en apparence simple, certes, mais qui définit en réalité la future voie de l'identité de cette marque. Alors, qu'en pensez-vous ? Parlons des couleurs.

Prefacio

By Gaby Salazar (Menta Picante)

Hablar del color en el diseño es algo más que hablar de un fenómeno cromático. Hablar de color es hablar de emociones, de sentimientos que surgen cuando la persona observa los elementos gráficos a los que está expuesta constantemente. Cada color equivale a una reacción psicológica que comunica, sin necesidad de palabra o forma, un mensaje que acabará por darle una personalidad al producto, material o marca al que acompañe.

Al trabajar un proyecto de branding, lo primero que se busca es un estilo. Se visualizan las formas, los elementos que se necesitan a partir de la personalidad deseada, como si fuera una biografía muy particular, y es el color el que ayuda a acabar de definir esa biografía. Tomemos, por ejemplo, una joyería de piezas experimentales. Si la vestimos con un tono rosa claro, con los elementos necesarios, podemos acercarnos a la idea de una chica joven, fresca, perteneciente a la clase media alta, que disfruta de ir de compras de manera original. En cambio, si modificamos únicamente el color pero mantenemos el contexto, es posible que redirijamos el mensaje de la marca, por ejemplo, a un hombre de 34 años a quien le gusta estar a la vanguardia, que tiene lo que necesita y adquiere lo que desea. Todo cambia si eliges el color adecuado.

En lo personal, cuando hago las compras semanales con mi esposo disfrutamos de revisar los anaqueles en busca de embalajes atractivos que podamos guardar cuando el producto que contienen se termine. Es entonces cuando el diseño perdura y el mensaje se mantiene gracias a la armonía de sus elementos. El color, sobre todo, es fundamental. El color vuelve las emociones permanentes, siempre que lo sepamos usar bien.

Y es que está muy claro lo mucho que el color nos ha influido. Pensemos en cómo cada vez es más común oír las expresiones "amarillo McDonalds", "azul Facebook" y, por supuesto, "rojo Coca-Cola". Si esos colores se modificaran un poco en sus marcas progenitoras el cliente tendría la sensación de que algo no está bien e incluso dudaría de consumir ese producto. El color define a quien envía el mensaje, al mensaje mismo y la emoción que surgirá en quien lo reciba.

El color no es cualquier cosa, es una base indispensable en la construcción de una marca. Es algo que parece sencillo, pero que define el curso que tomará la identidad de esa marca. Así que, ¿por qué no? Hablemos de color.

Raps / Festival de Sucesos Paranormales

Design: Estefanía Leiva

The theme of the festival is mostly paranormal, particularly everything related to human beings and the relationship with the "beyond".

The festival takes place in a framework of three days in which there will be projected as the main activity, seminars and workshops are also given.

His name is chosen according to the meaning. Raps are poltergeist activity related sounds. Unusual noises are produced without explainable cause, and it is assumed, come from beyond.

The designers chose a typographic mark, which ends the name "raps" with a "/" mark. This sign is the kind of division of the two worlds, theirs and the "beyond" the spirit, the world of the paranormal.

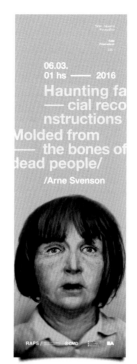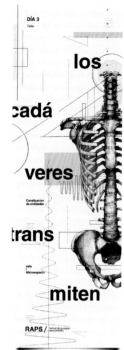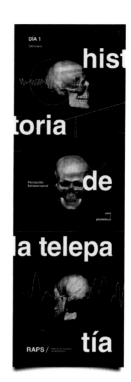

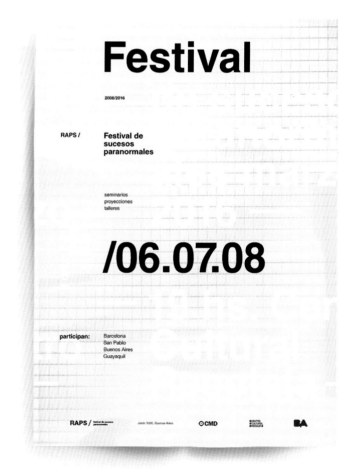

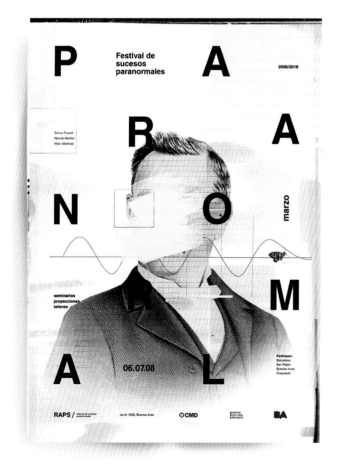

festival

sucesos
paranor
ales
centro c
ultural

Simon Pummell
Narciso Ibáñez Serrador
Marc Martínez
Carlos Mayolozky
Héctor Hernández Vicens
Jhon Watts

/06.07.08

19 hs
Recoleta

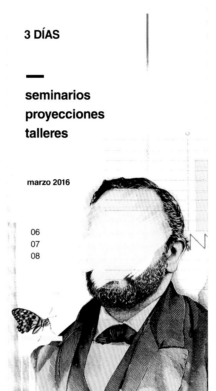

3 DÍAS

—

seminarios
proyecciones
talleres

marzo 2016

06
07
08

RAPS / festival de sucesos paranormales

DÍA 3

canalización
de entidades —

c
ia

DÍA

RAPS / festival de sucesos paranormales ⊙CMD BA CENTRO CULTURAL RECOLETA

c

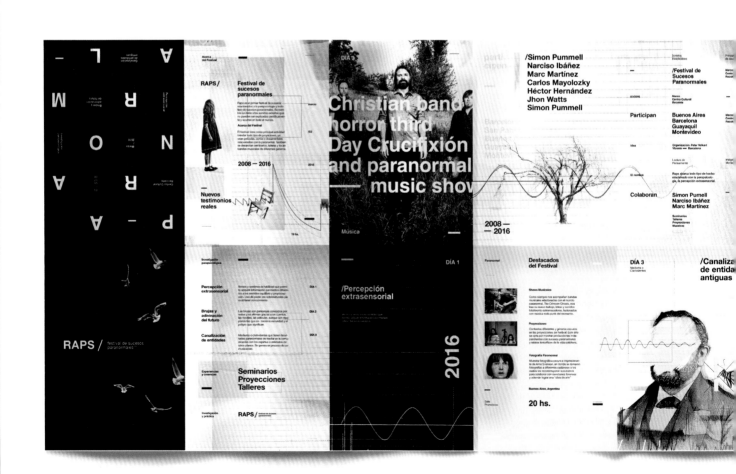

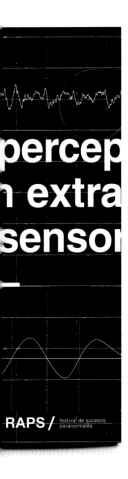

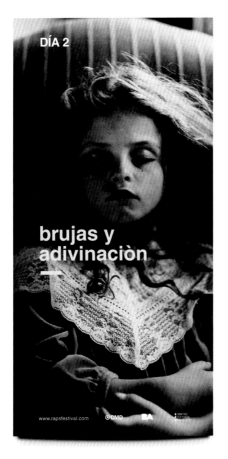

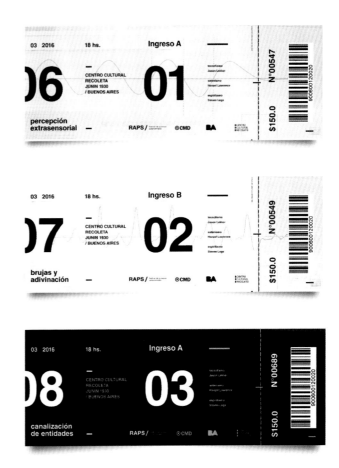

Briefcase

Design: Anagrama

Briefcase is an industrial design studio located in Mexico City that applies their projects as interventions in urban spaces. The studio focuses in open spaces and urban areas, which served as inspiration during the brand's development.

The logotype alludes to the fusion and duality between two personalities and philosophies. These are taken to form one single graphic expression that is both modern and timeless.

Urban landscapes inspired the stationary and the layouts present throughout the brand's elements. The contrasting typography and colors, such as the bright yellow, aim to imitate open spaces and the signage that is seen in cities, as well as other elements, all of which reflect Briefcase's work.

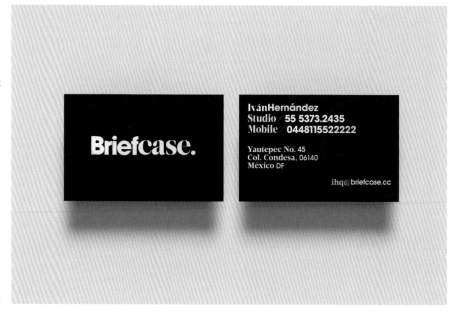

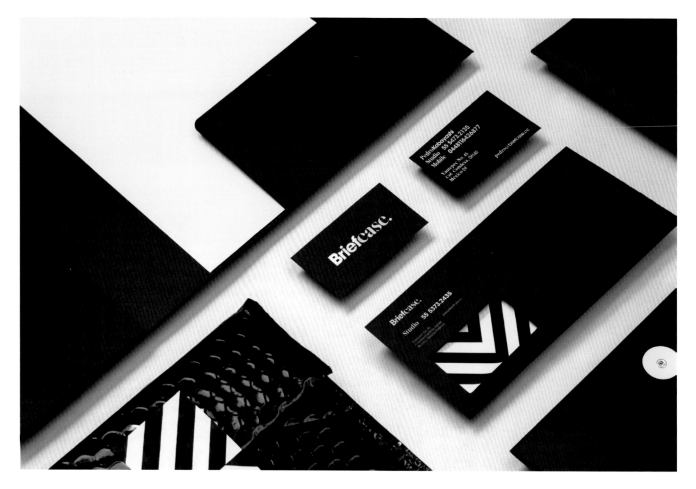

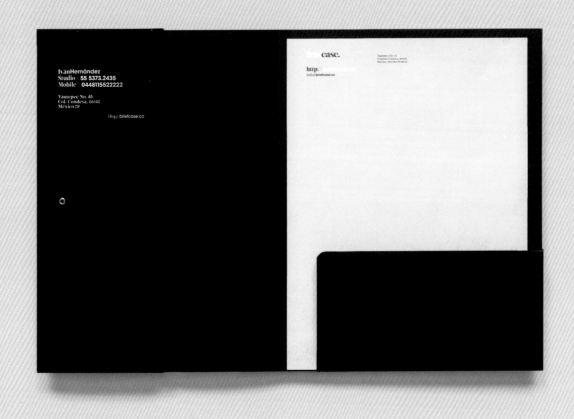

Karen Ruz

Agency: Memo &Moi
Design: Guillermo Castellanos Flores
Art Direction: Moisés Guillén Romero
Photography: Moisés Guillén,
Guillermo Castellanos

Branding design for Mexican industrial designer Karen Ruz. Karen Ruz is a designer of all types of products, and she is considered as a "multi-specialist" always guided by her ideals and natural curiosity for new and ancient technology. Her mission as a designer begins by giving back to the people, conceiving objects that really satisfy their needs and solve their problems, redesigning what haven't been succeeded, correcting and re-establishing what has been left behind. Part of her pursuits as a designer is the preservation of dreams and the construction of nostalgia, everything that forms part of the truly essential things, the symbolic, and the heritable. Her inspiration comes from the impossible, from storytelling and things that cause excitement. Art, sensations, and memories guide her, feed her soul, and give her fragments of her true essence ready to be materialized.

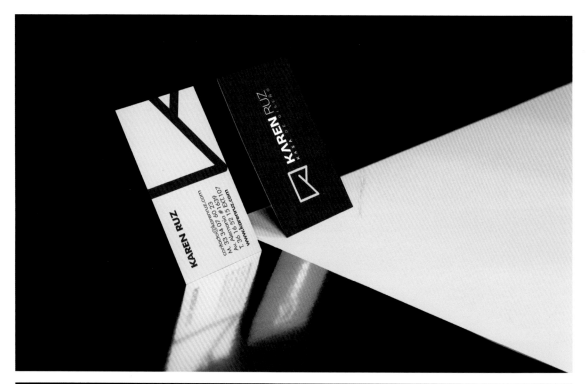

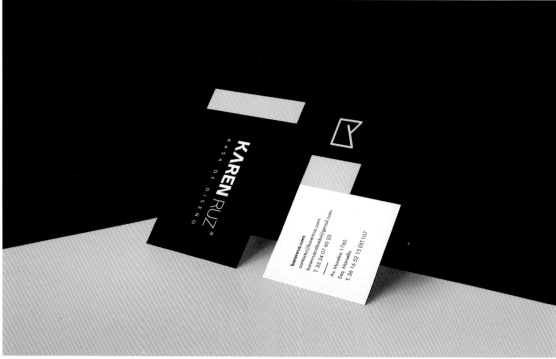

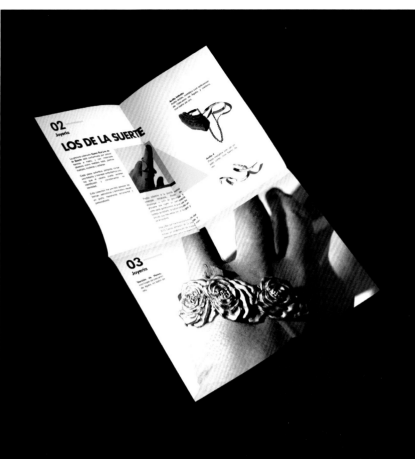

NonCitizen

Design: The Welcome Branding Group

Focused on set decoration for movies and advertising, NonCitizen develop projects in Mexico and USA and use this "immigrant situation" as an inspiration for the design concept: passports, border pass, and border police uniforms. Color choice is a consequence of the design concept and is pumped up by a lighter kind of yellow.

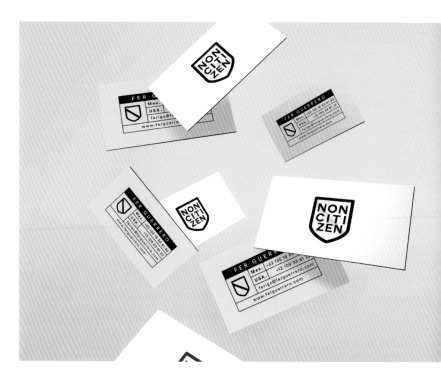

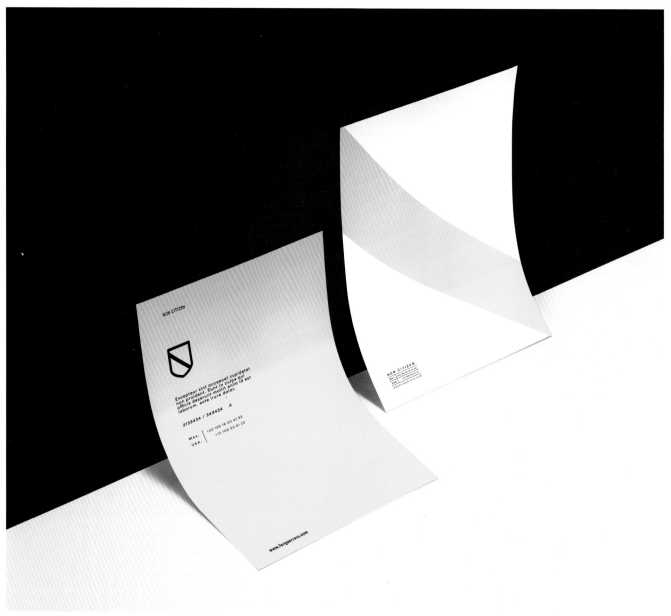

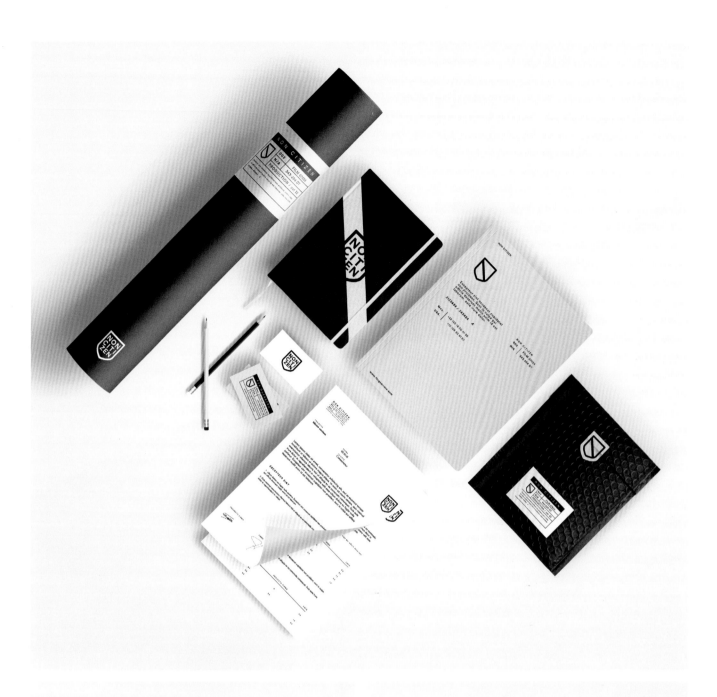

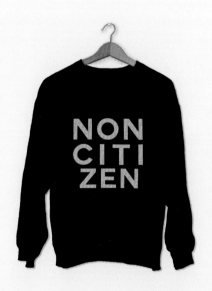

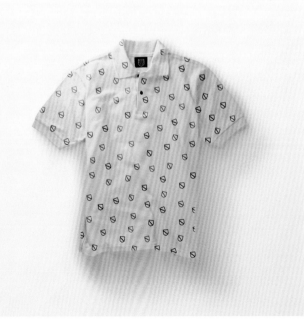

Yappi Films Identity

Design: Farrukh Sharipov

The idea of logo and identity has been created from drawing sketches of different kind of human creatures. As a result, the designer composed the images of Stickman and camera. The designer used the yellow color and graphically pictured Mr. Yappy, sticky man with camera instead of head. The designer have widened this idea and connect it with real world by means of using not only camera, but also other video tools as well. Yappi Films has obtained new characters which have been constantly changed on company's logo.

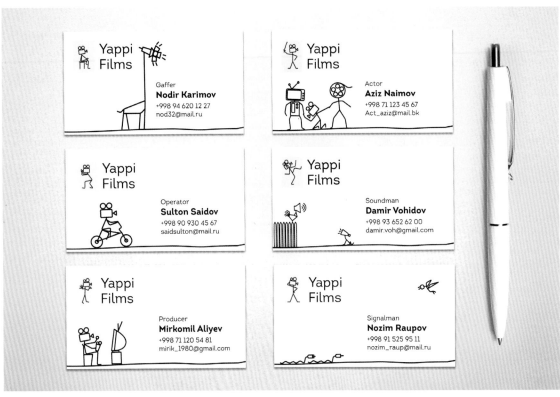

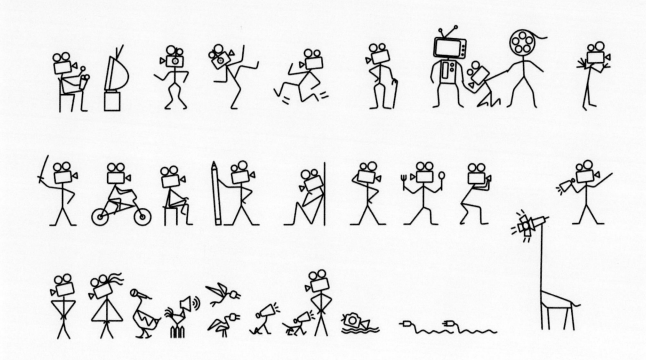

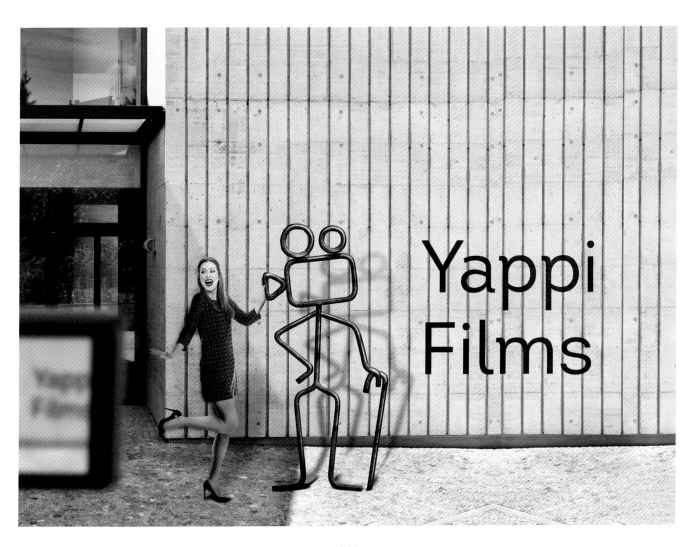

Alessa

Design: Agustono

Alessa is a houseware products consist of door handle, kitchen sink and door frame. The target market for Alessa is middle class to high. That's why the designer created this logo with the yellow color. The logo have to be simple and the color can't be too intimidating but at the same time eye catching.

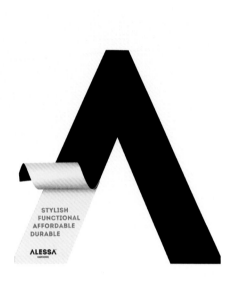

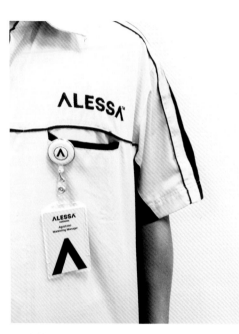

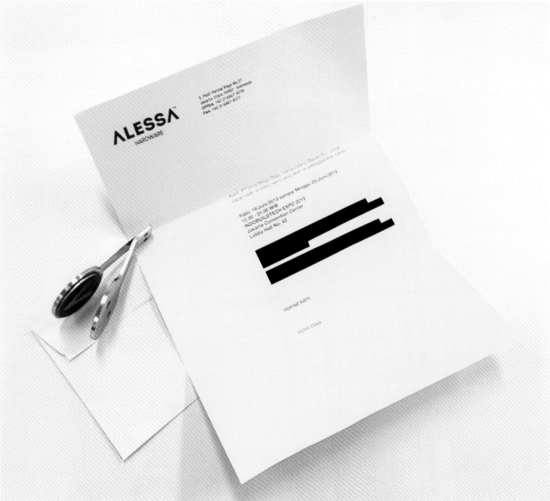

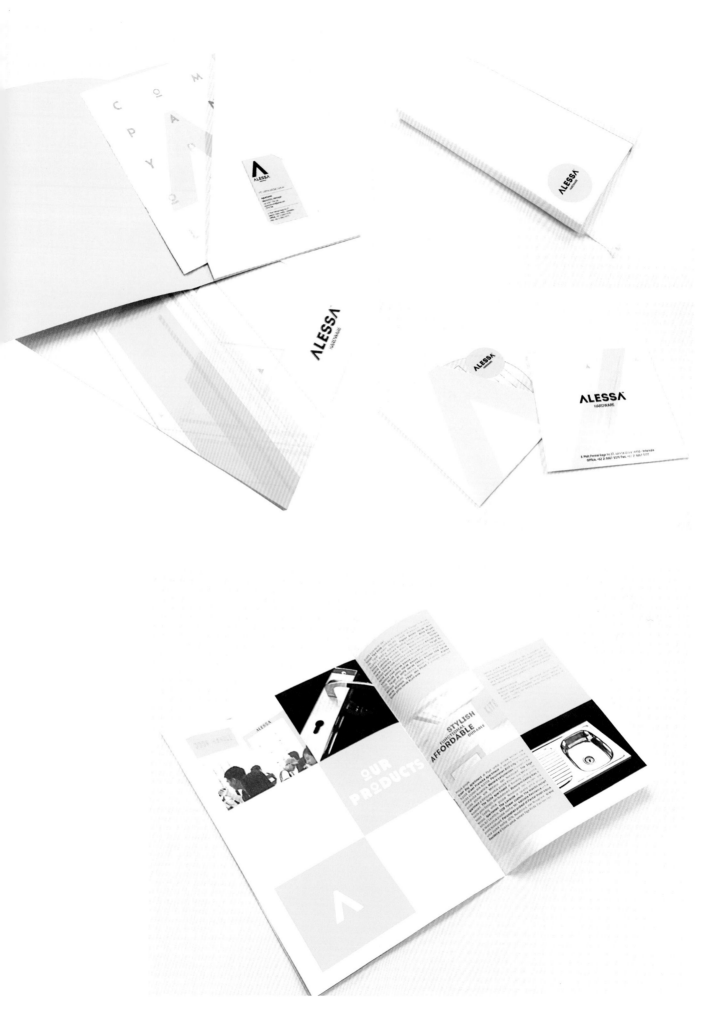

Tahvo Niskanen

Design: Rokas Sutkaitis

Tahvo Niskanen is a multidisciplinary audio engineer based in Finland.

The identity highlights serious nature of audio engineering without making it look too complicated. The mark draws inspiration from the physics of sound. Three "N's" taken from surname Niskanen forms abstract interpretation of sound waves – perhaps the most recognizable symbol of sound.

The mark is accompanied by amply spaced sans serif wordmark that mimics the aesthetics of the monogram and continues to carry the minimalistic tone. The identity is finished with subtle stationary work. Fresh colors and triangular elements derived from the mark add feeling of dynamism and unite whole identity into one body.

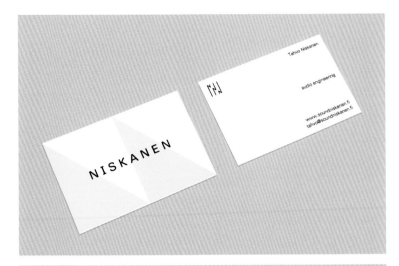

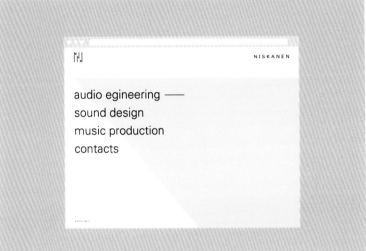

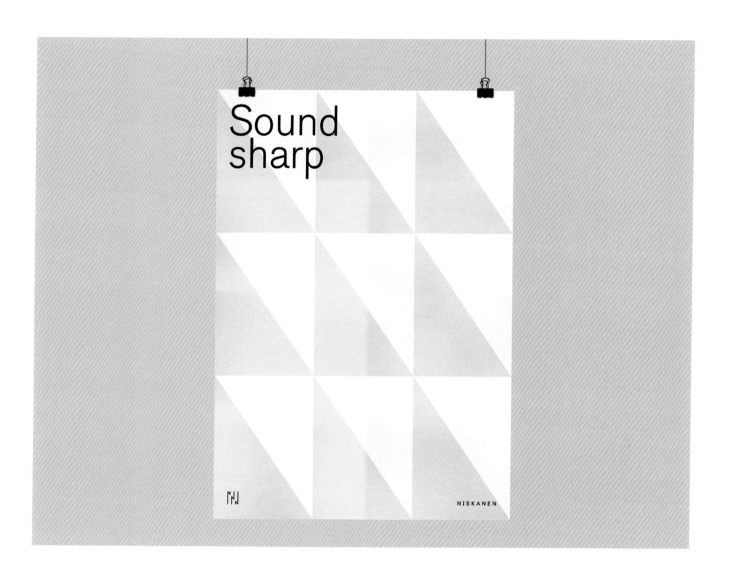

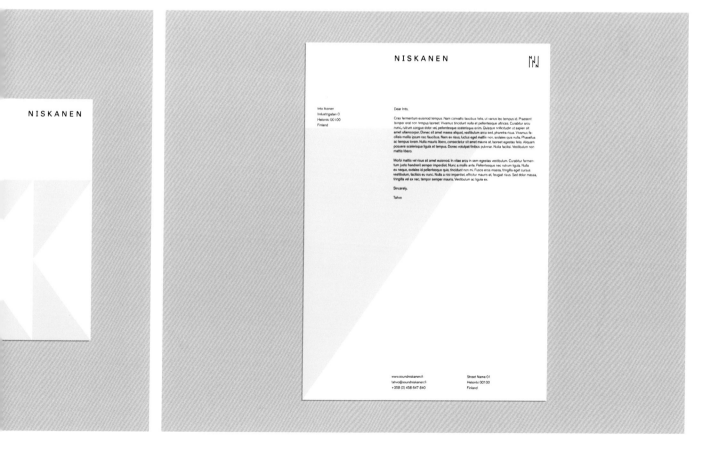

Corporate Design for Cologne Intelligence

Creative Direction: Benjamin Arndt
Art Direction: Friederike Gaigl
Design: Evelyn Brugger-Erol
Agency: Arndtteunissen

The designers used several workshops to tease out the essence of the brand, developing a system of umbrella and sub-brands that reflects the new corporate structure. The design focuses on graphic clarity and the authenticity of language and imagery, and is highly flexible. The parenthesis motif is a recurring theme of the new brand image – a symbol of outward cohesion and inward agility. Stationery, mailings, and a comprehensive website have been created based on this new brand image.

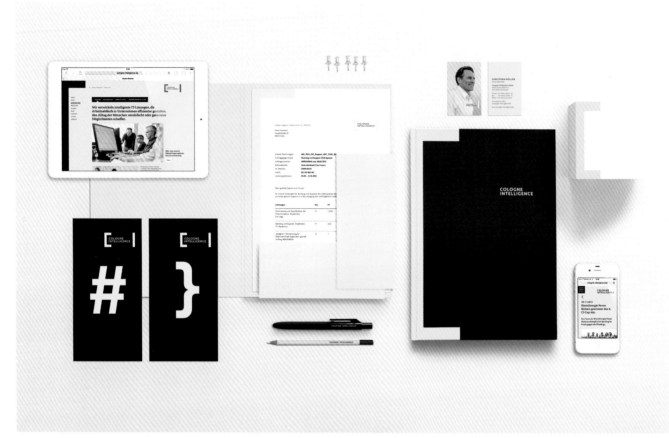

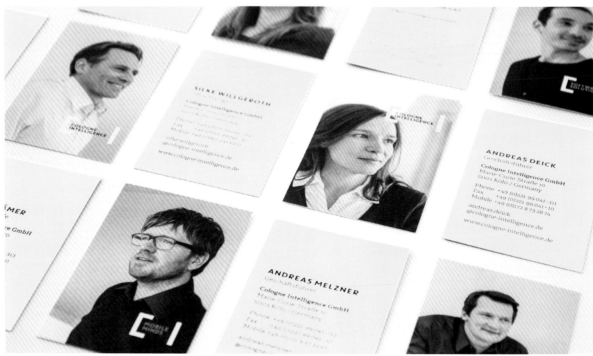

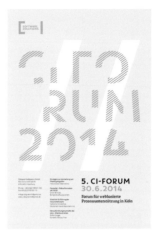
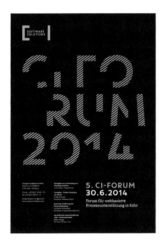
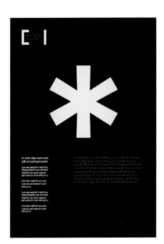
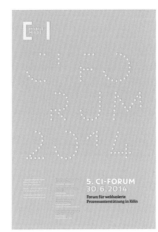

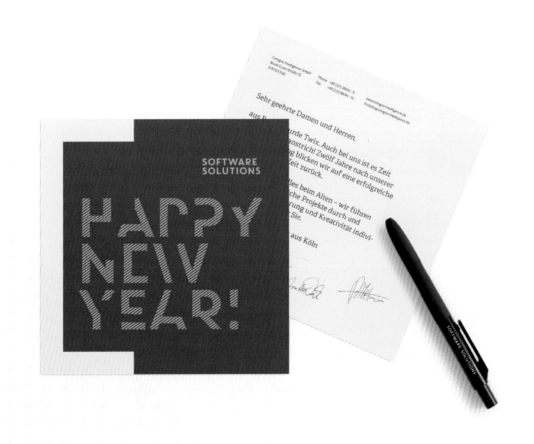

Just in Case

Design: Menosunocerouno

Just in Case – End of the World Survival Kit is a modern Mexican design for the end of times, crafted and designed by Menosunocerouno. It's designed to be the perfect gift for friends and clients, and of course, only the ones that the designers want to keep.

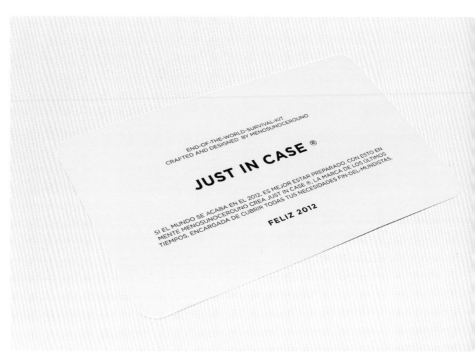

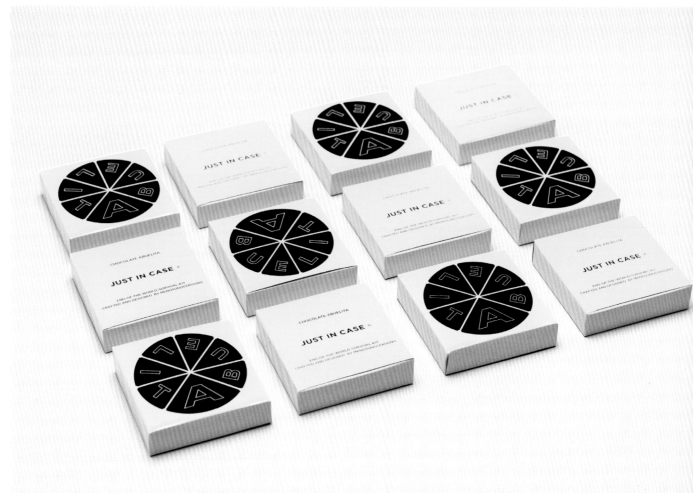

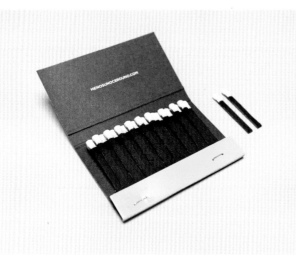

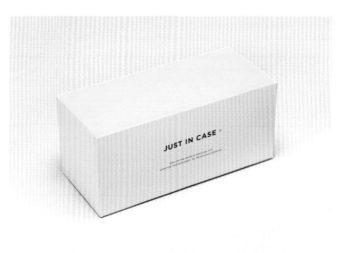

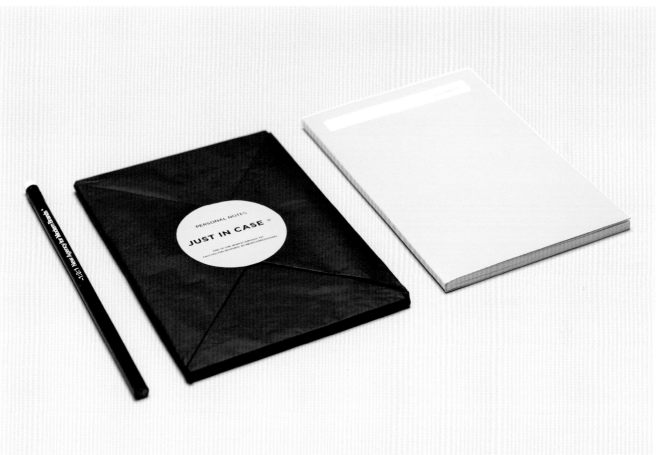

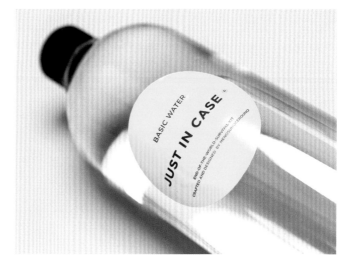

Tetris Season

Design: Aleš Brce, Giovanni de Flego,
Michele Zazzara, Marco Boncompagno

The identity for Tetris (a music club in Trieste,
Italy) plays with 3D perspectives of the club's
mark which compose a confused texture
that conceptually represents the melting pot
of musical styles proposed in the various
shows. A shiny yellow color highlights the
events info and it is used as a covering of the
black and white texture. A signal color that
contrasts with the dark environment inside
the room. The promotional materials were
printed in one color, mostly on low budget
printers, on white or yellow colored papers.
The technique of "pasting over" different
sheets is deliberately rough.

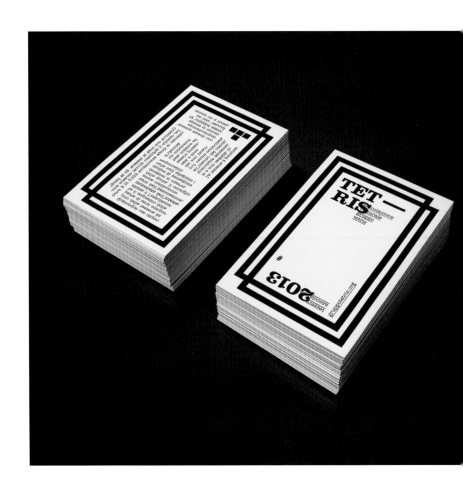

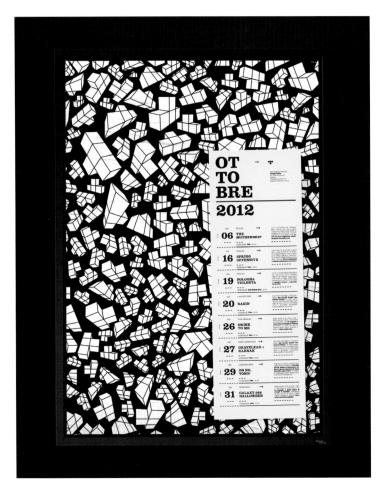

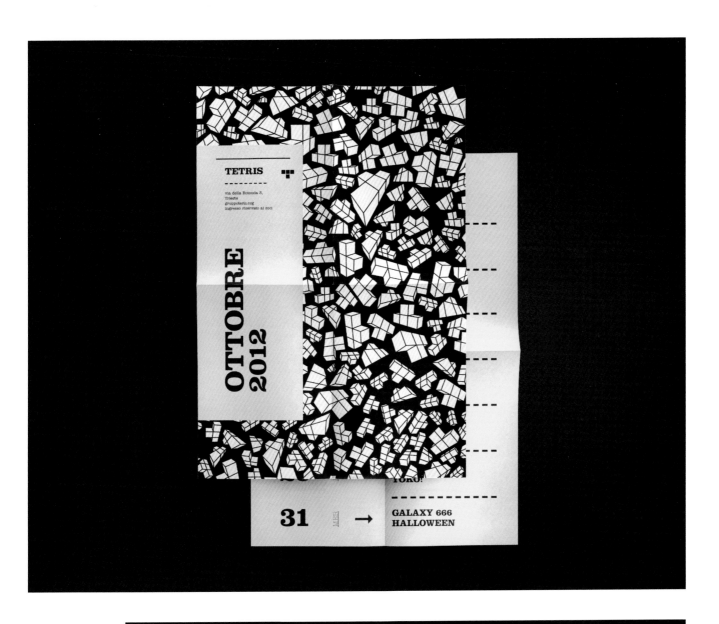

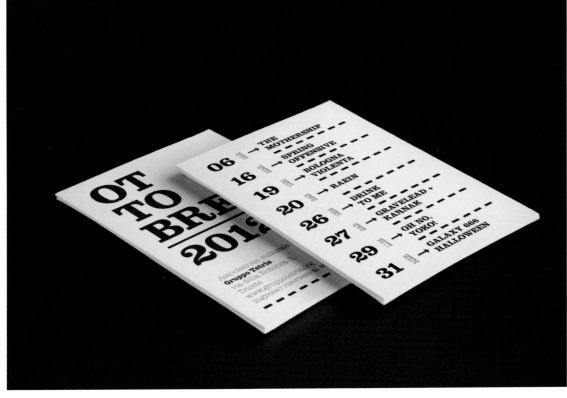

Yellow Frog

Creative Direction: Christian Vögtlin
Agency: ADDA Studio

A small branding for a coaching and
consulting company called Yellow Frog.

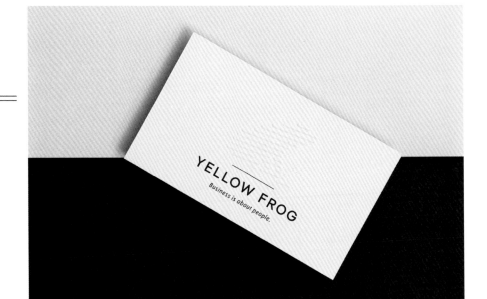

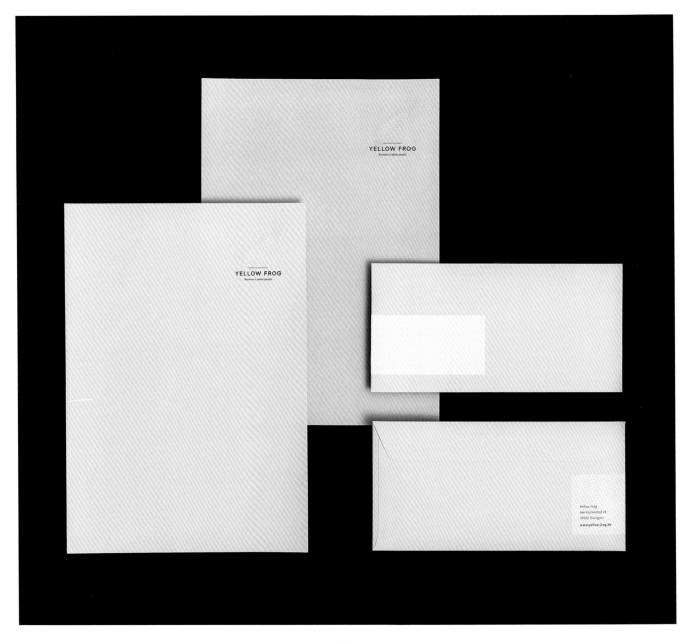

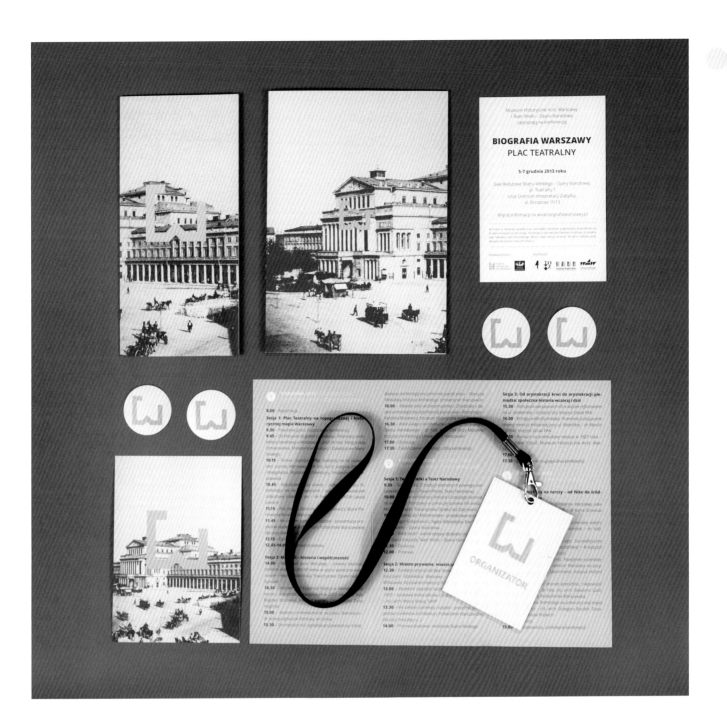

Warsaw's Biography Conference

Design: Ania Swiatlowska
Photography: Adrian Czechowski

"Warsaw's Biography" is series of scientific conferences about the city's historical architecture, urban spaces, and development paths, which were held in Warsaw. The visual identity set included the logo, poster, flyer, invitation, notebook, stickers, and nametags.

2016 cashslide
dual calendar

Creative Direction: Kim Hyunmi
Design: Kim Meejin
Illustration: Jung Seoa

Inspired by the form of the Korean traditional furniture of "dressing mirror stands" motif, the designer created the inside of the calendar and triangle shape on the top to make the dual calendar.

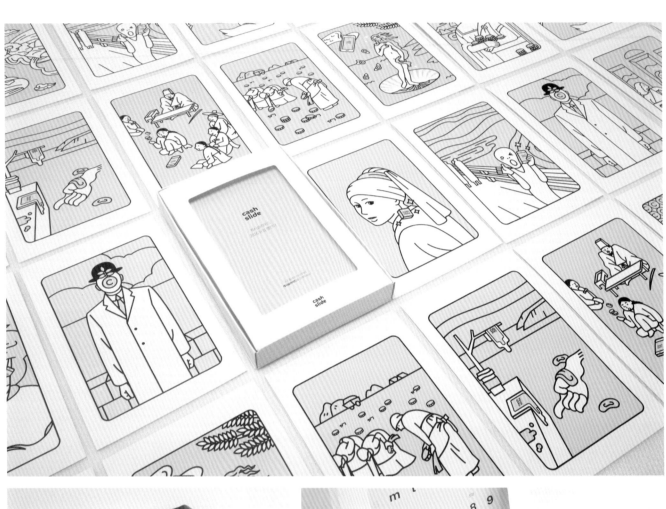

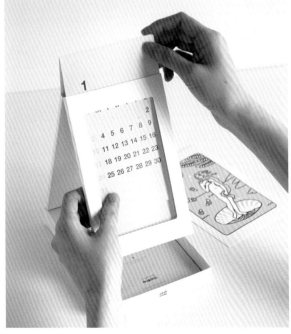

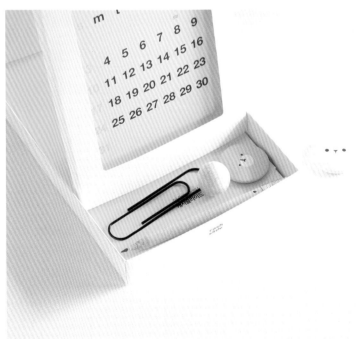

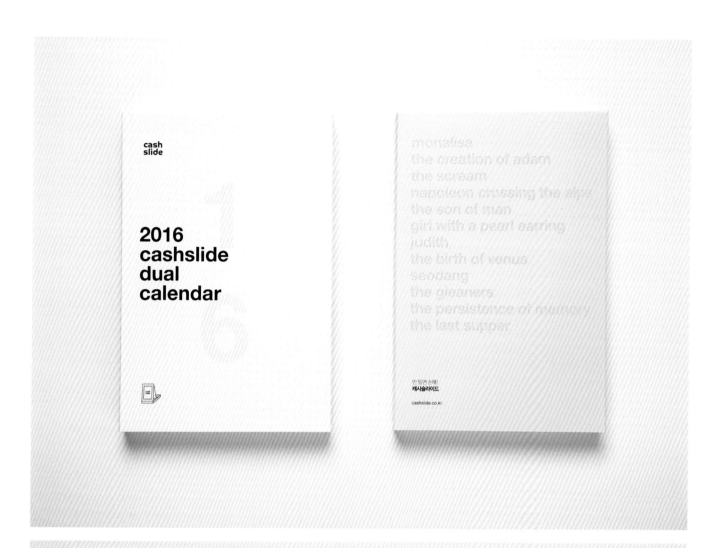

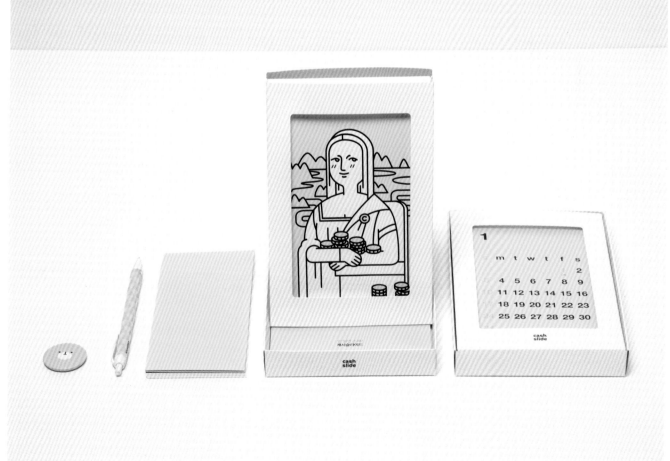

Casino – Food Place Concept

Design: Victoria Gallardo

The project is a complete food experience design from the graphic identity to the space and environment based on the study of a university's casino as a second home, or kitchen. The main concept was domestic, which could be seen from the notes left for others like reminders or messages.

Regarding that, the visual language of the post-it notes was used, such as the shades of yellow with black in contrast, creating a strong narrative to unify the different elements through color, along with hand writing and gestures to emphasize the identity, which is reflected in the logo designed and the lettering manifest.

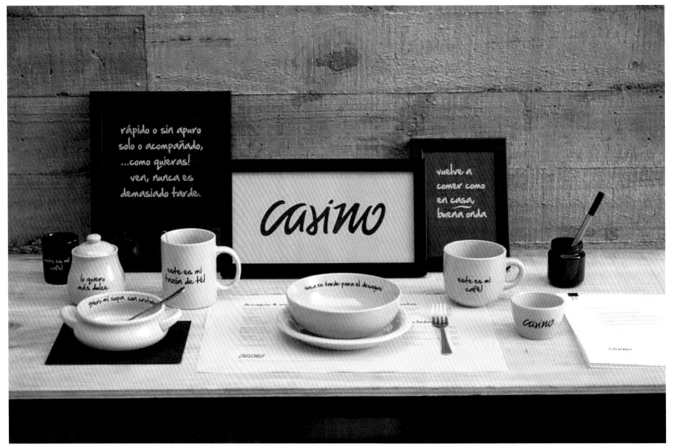

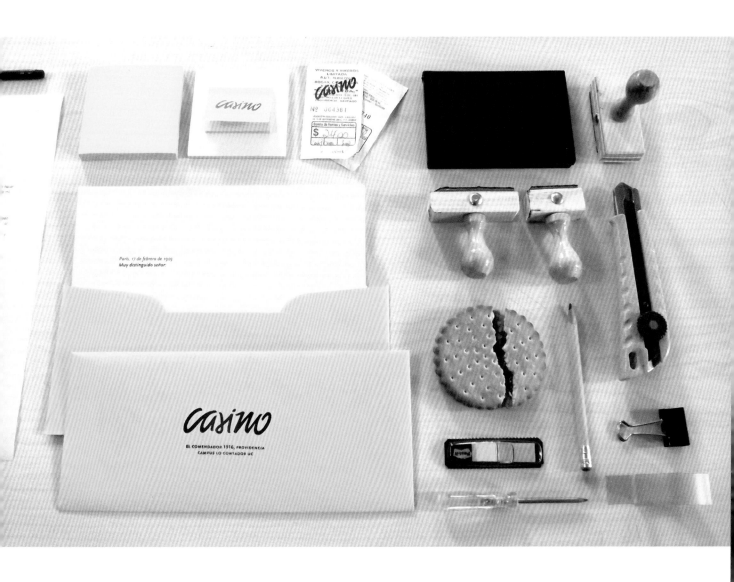

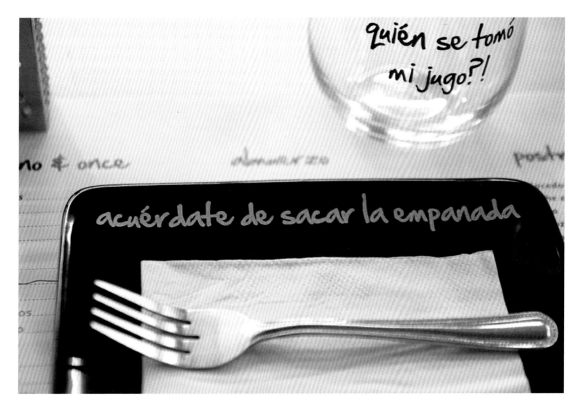

Sofia Design Week

Creative Direction: Ivaylo Nedkov, Maria Milusheva
Design: Ivaylo Nedkov, Boris Borisov
Agency: Four Plus Studio
Photography: Vasil Germanov, Zlatimir Arakliev

Sofia Design Week is an international festival for design and visual culture, which takes place every June in Sofia. The topic of this edition was "The Balkan Date", so the designers' task was to come up with a creative communication that provokes interest and questions about the Balkans' design scene and its role, potential and peculiarities. The designers' concept and the visual communication for the campaign explore the main contradictions that define the Balkan design stage: global and local, East and West, tradition and innovation, communism and capitalism, etc.

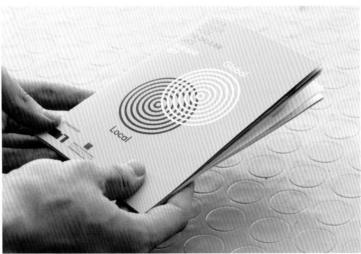

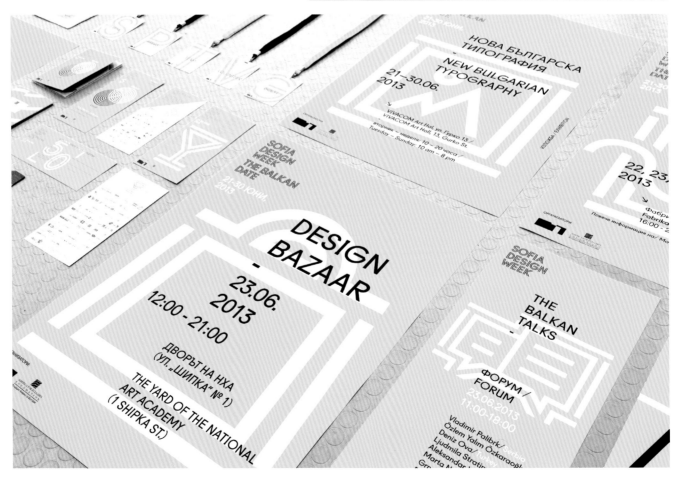

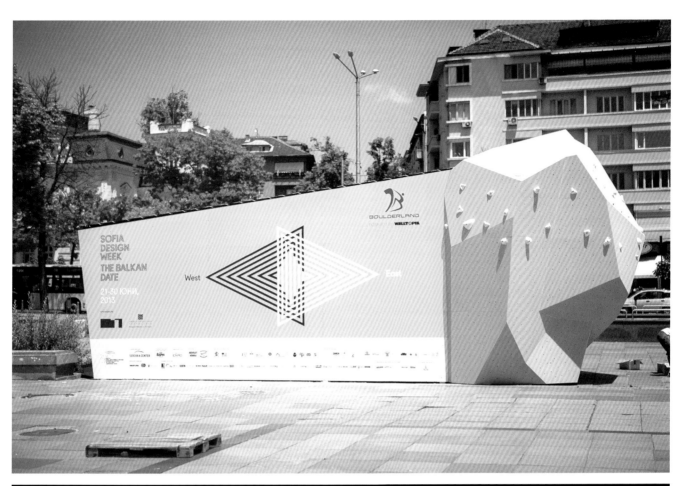

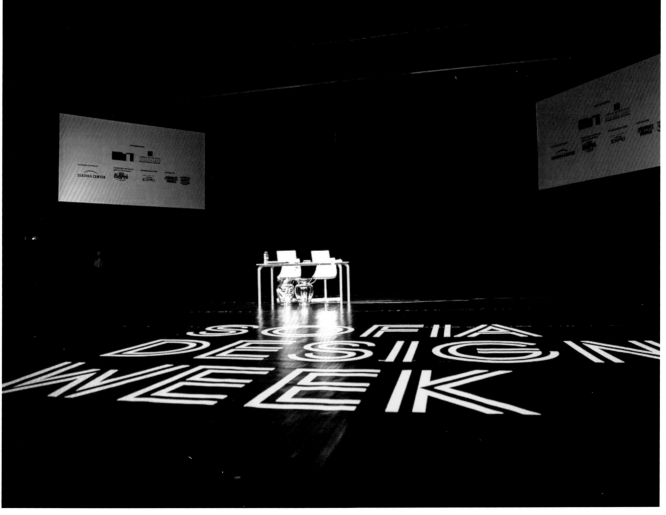

Fundación Capital

Design: Anagrama

Fundación Capital is a non-profit organization with several bases located in Latin America that centers its efforts in fostering new ideas to challenge the persistence of poverty and exclusion.

The design process was started by taking inspiration from bees, symbols of hard work and organization in the animal kingdom. Since Fundación Capital is located in many countries in Latin America and has plans to expand further, the designers turned the bee-like icon 90 degrees, transforming it into a pin, much like the ones on Google Maps. This way, the designers turned the very simple, striped, balloon-like symbol into a metaphor for generating hope by creating jobs and development in a variety of places.

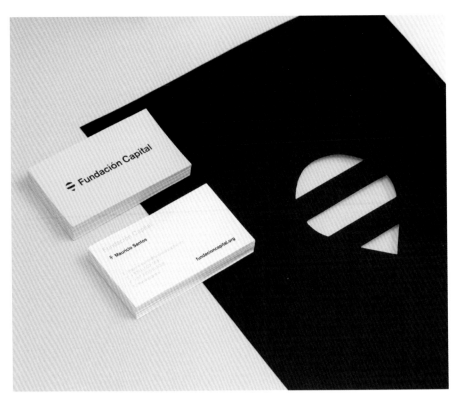

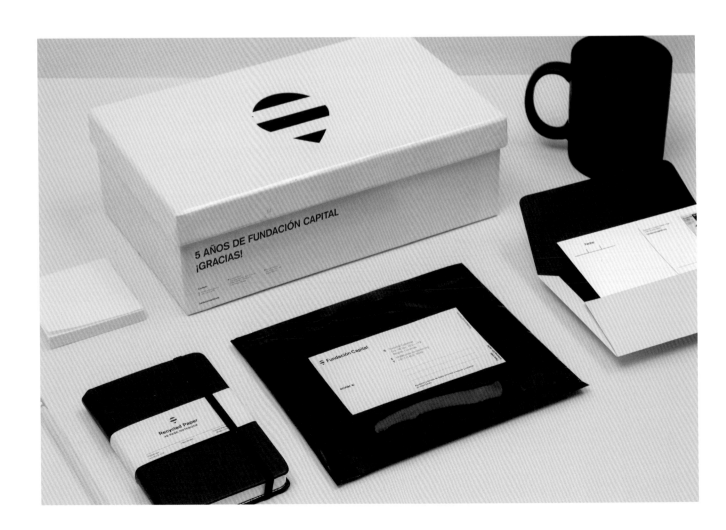

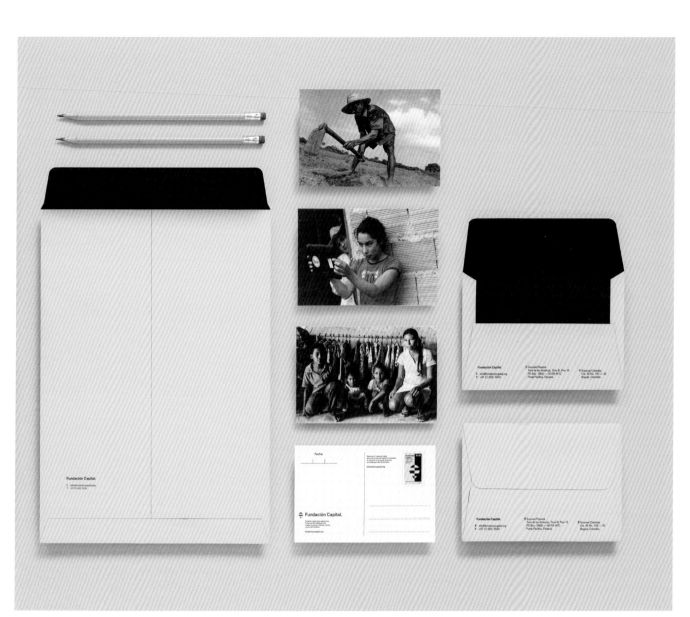

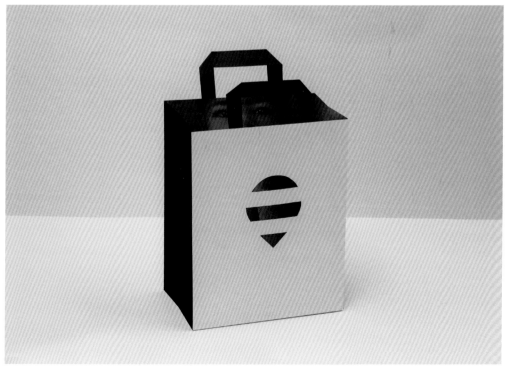

Attido

Agency: Bond Creative Agency
Design: Marko Salonen
Photography: Paavo Lehtonen

Bond helped this rapidly growing business IT systems specialist update their brand for the international market. The new brand concept consists of a minimalist and powerful visual identity. The new name, Attido, as well as the bold brand promise "Until it's done", are communicating their uncompromising approach.

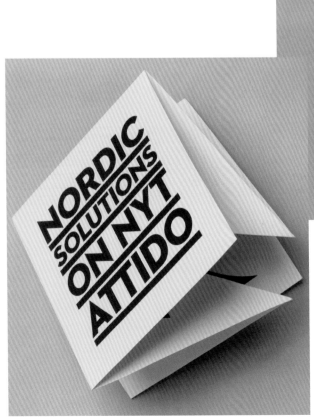

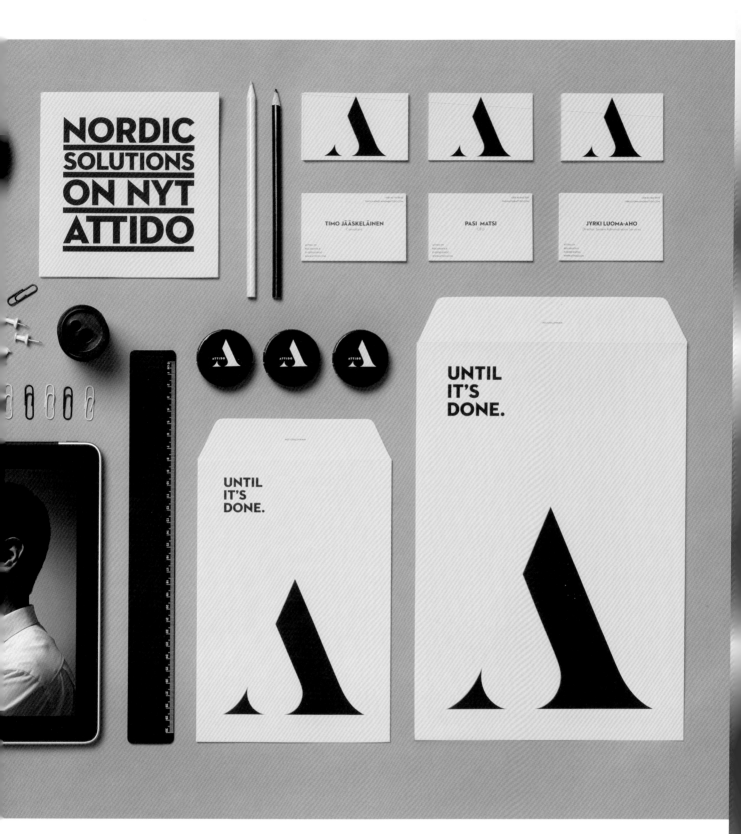

FOR Branding

Direction: Jongwon Won
Planning: Chanjong Jeon, Nayeon Park
Design: Jongwon Won

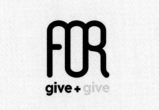

"FOR," meaning reform and donation, is a new brand in clothes and accessories for improving the existing culture of donation. Its name, "FOR," has two means. The first is a circulation of donation consists of donators, sellers and beneficiaries. The second is a word "for" itself meaning the a production of goods "for someone." Additionally, by applying the main color, yellow, means a activity and brightness, the designers emphasized it is not one of the ordinary brands in clothes, but a brand able to change a new culture of donation.

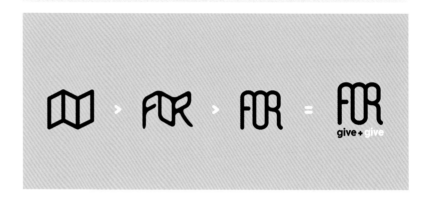

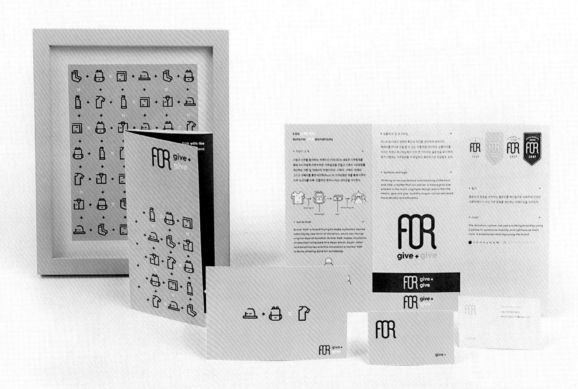

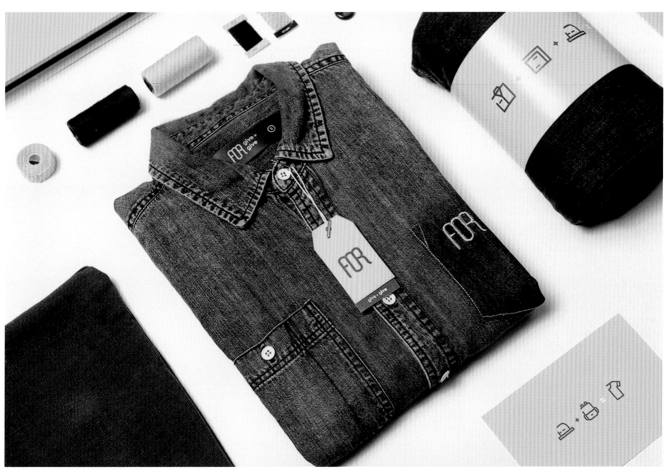

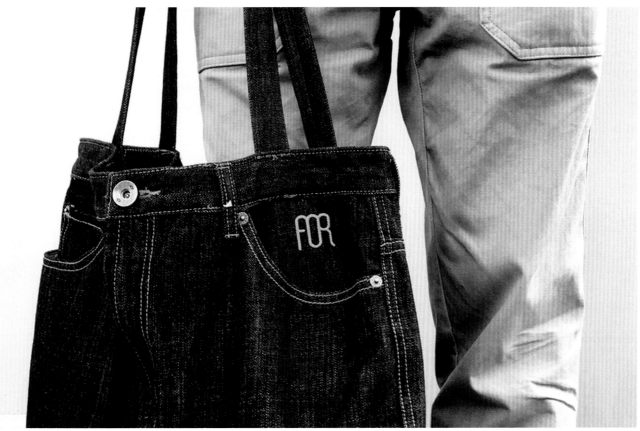

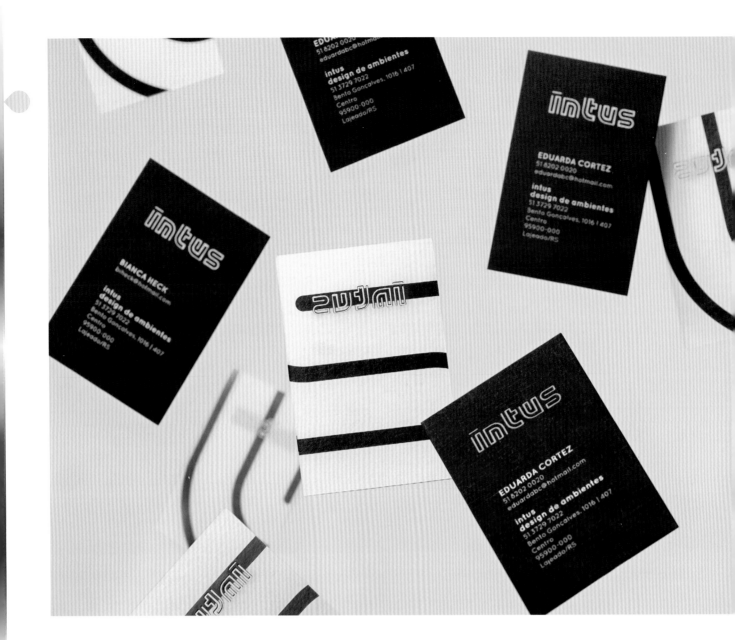

Intus

Agency: Frente
Design: Germano Redecker, Luiza
Oliveira, Rodrigo Brod, Vagner Zarpellon

The logo developed for Intus translates, in
a visual way, the essence of the name and
work of the interior design office. From a
continuous line, which runs through the
inside of each letter, Intus is written in a
functional, but unconventional way.

The color scheme is based on the choice
of papers used for the stationery.

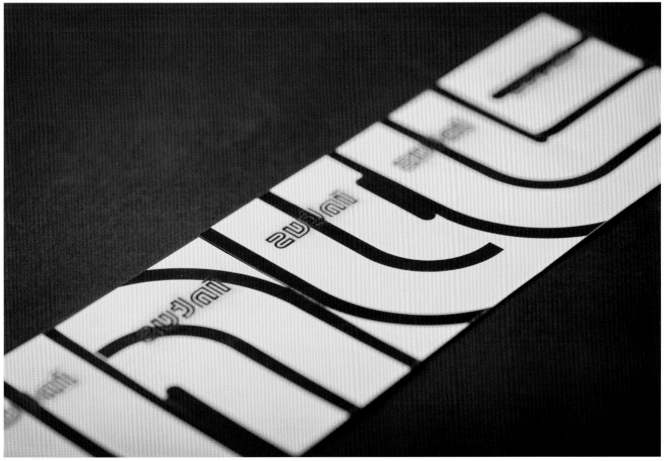

La Refactoría

Agency: Mubien Studio
Creative Direction: David Mubien
Photography: Adrián Castanedo

La Refactoría is a technology agency formed by professionals with extensive experience in developing projects and digital products. They specialize in working closely with traditional marketing agencies. They needed a corporate identity that represents their values. The designers created a direct identity without isotype in which is reflected the meaning of the word "refactoring" by connecting the e/a vowels and defined the digital environment in which the company operates thanks to the underscore. The designers also design their office signage and stationery.

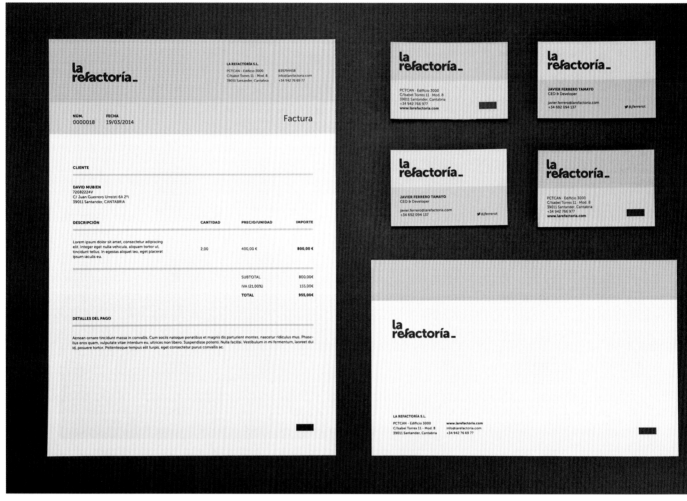

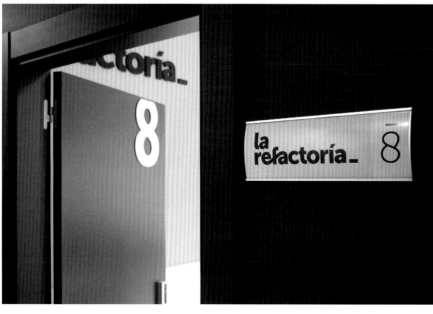

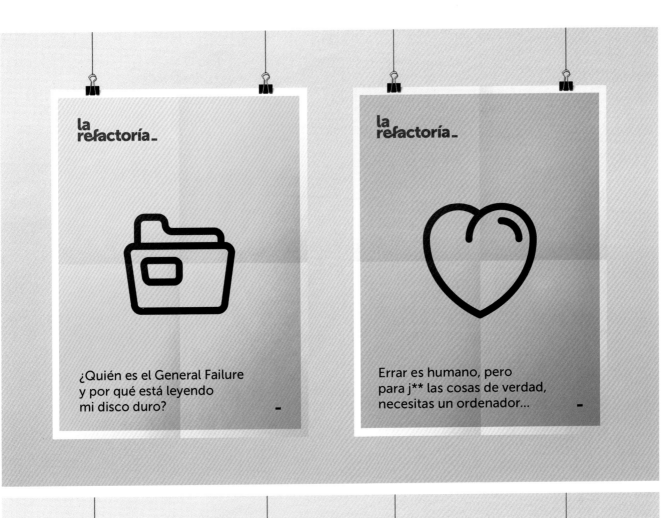

la refactoría_

¿Quién es el General Failure
y por qué está leyendo
mi disco duro?

la refactoría_

Errar es humano, pero
para j** las cosas de verdad,
necesitas un ordenador...

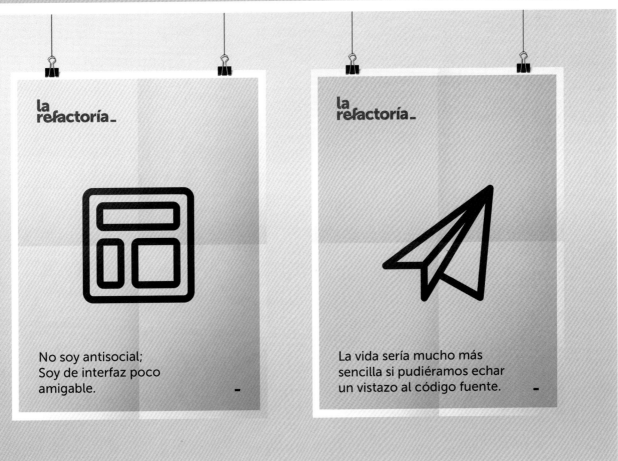

la refactoría_

No soy antisocial;
Soy de interfaz poco
amigable.

la refactoría_

La vida sería mucho más
sencilla si pudiéramos echar
un vistazo al código fuente.

Ham on Wheels

Agency: Forma & Co
Art Direction: Chu Uroz
Marketing Concept: Albert Castellón
Interior Design and Art Installations:
External Reference Architects

Forma & Co designed the graphic identity for Ham on Wheels, a new concept of a premium fast-food restaurant, specializing in cocas (baked bread) with spread tomato and ham, set in and around the bicycle culture.

The logo has been solved underlining the word "on," to make the play on words with the name "ham" more obvious, while at the same time using the typical graphic resource for "on wheels" type of establishment. In addition, the designers have created other elements for the interior of the restaurant – projected by designer Chu Uroz – such as decorative hams hanging from the ceiling, road marks that are at the same time interior signaling, or the menus and drink mats.

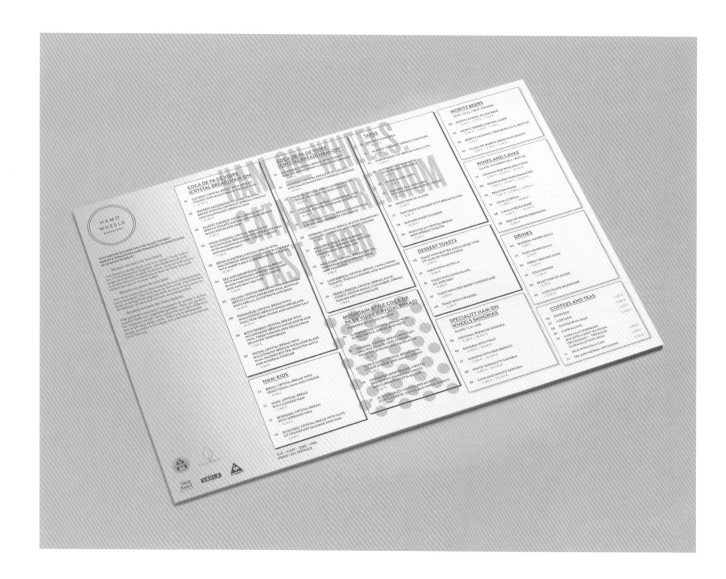

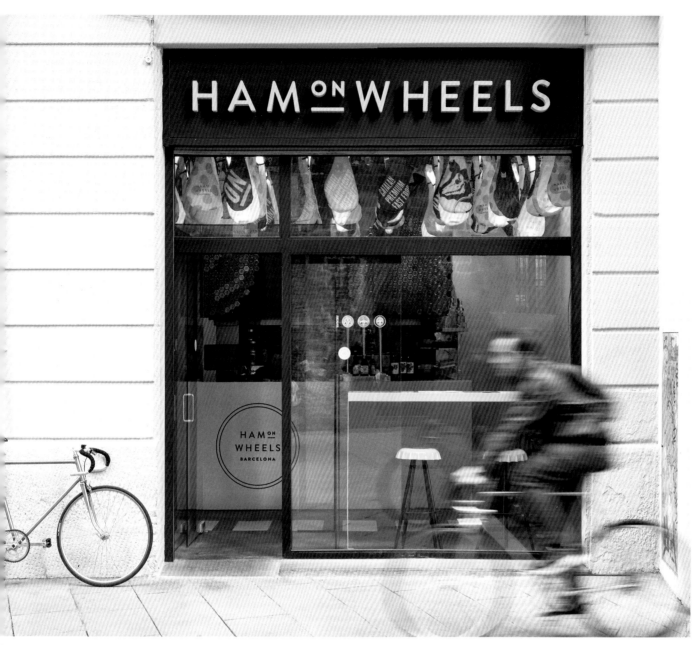

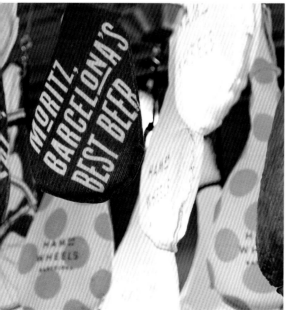

Red Wine Gift Box

Design: Anton Ivanov
Art Director: Jasmina Nakeva
Agency: Studio Mozaika

The designers like working with their hands, and that is why they decided to make this Christmas presents for their clients all by themselves. They branded the wine with their own stickers. The paper bag was also handmade. The designers used black 350gsm cardboard, yellow ribbon and, of course, one of their stickers. The bottle was neatly packed in a black tissue paper and each present was personalized with the name of the recipient, handwritten by the designers.

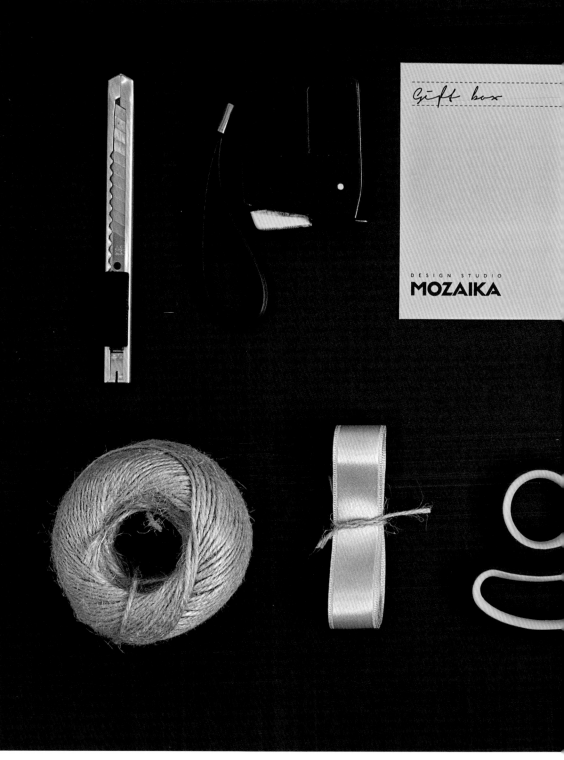

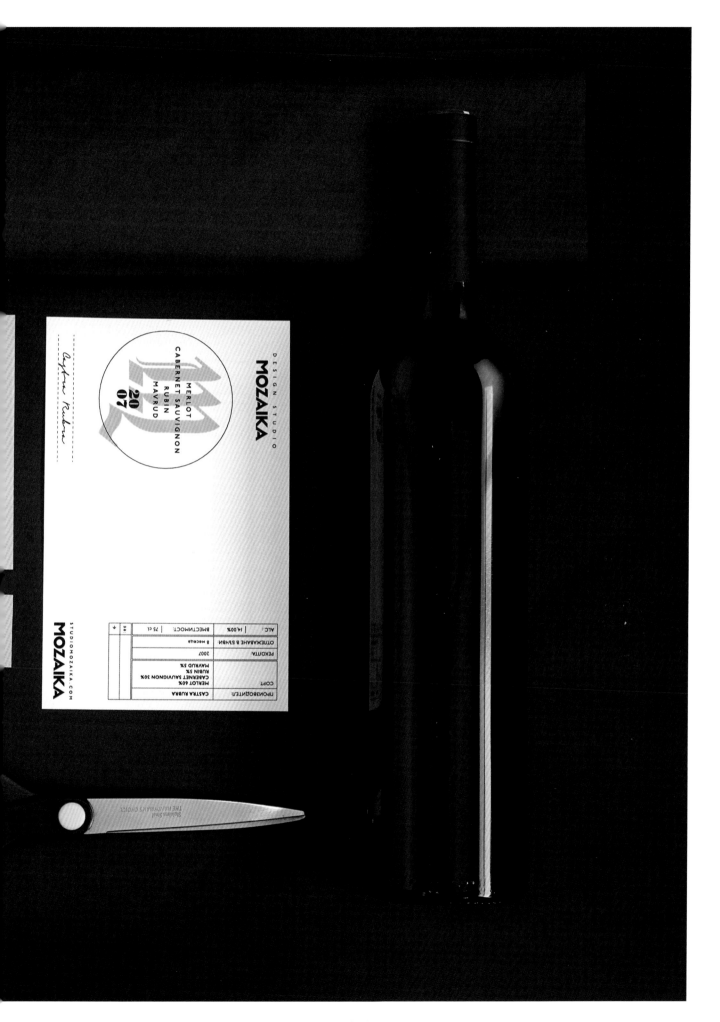

The World Bar
Queenstown

Design: makebardo®

The main focus of this project was to symbolize the concept of a "new beginning" through a "point" of departure. It's a simple concept, direct and effective. Accompanied by warm colors and earth colors, the main yellow color was used to generate visual impact, which is associated with happiness, joy, and optimism. The sub-brands were also developed through a dot with a top view of the icons, providing an unusual perspective and a unique look. The advertising material was based on the phrase "old dog, new tricks" referring to a fresh new place that has history and personality.

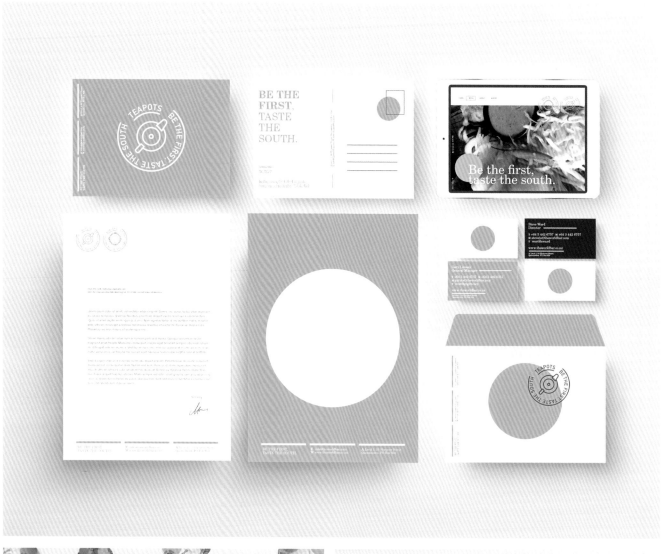

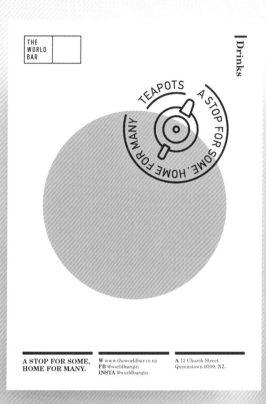

THE WORLD BAR

TEAPOTS
A STOP FOR SOME, HOME FOR MANY

A STOP FOR SOME, HOME FOR MANY.

W www.theworldbar.co.nz
FB @worldbarqtn
INSTA @worldbarqtn

A 12 Church Street
Queenstown 9300, NZ.

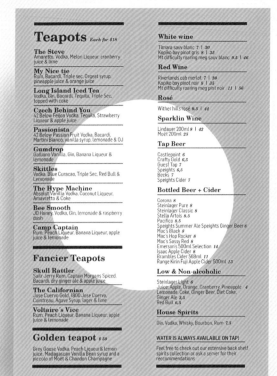

Teapots *Each for $18*

The Steve
Amaretto, Vodka, Melon Liqueur, cranberry juice & lime

My Nice tie
Rum, Bacardi, Triple sec, Orgeat syrup, pineapple juice & orange juice

Long Island Iced Tea
Vodka, Gin, Bacardi, Tequila, Triple Sec, topped with coke

Czech Behind You
42 Below Feijoa Vodka, Tequila, Strawberry Liqueur & apple juice

Passionista
42 Below Passion Fruit Vodka, Bacardi, Martini Bianco, vanilla syrup, lemonade & OJ

Gumdrop
Galliano Vanilla, Gin, Banana Liqueur & lemonade

Skittles
Vodka, Blue Curacao, Triple Sec, Red Bull & Lemonade

The Hype Machine
Absolut Vanilla Vodka, Coconut Liqueur, Amaretto & Coke

Bee Smooth
JD Honey, Vodka, Gin, lemonade & raspberry dash

Camp Captain
Rum, Peach Liqueur, Banana Liqueur, apple juice & lemonade

Fancier Teapots

Skull Rattler
Sailr Jerry Rum, Captain Morgans Spiced, Bacardi, dry ginger ale & apple juice

The Californian
Jose Cuervo Gold, 1800 Jose Cuervo, Cointreau, Agave Syrup, lager & lime

Voltaire's Vice
Rum, Peach Liqueur, Banana Liqueur, apple juice & lemonade

Golden teapot *$50*

Grey Goose Vodka, Peach Liqueur & lemon juice, Madagascan Vanilla Bean syrup and a piccolo of Moët & Chandon Champagne

White wine
Timara sauv blanc 7 | 30
Kopiko bay pinot gris 8 | 35
Mt difficulty roaring meg sauv blanc 9.5 | 46

Red Wine
Riverlands cab merlot 7 | 30
Kopiko bay pinot noir 8 | 35
Mt difficulty roaring meg pinot noir 11 | 56

Rosé
Wither hills rosé 9.5 | 44

Sparklin Wine
Lindauer 200ml 8 | 42
Moët 200ml 23

Tap Beer
Castlepoint 6
Crafty Gold 6.5
Guest Tap 7
Speights 6.5
Becks 7
Speights Cider 7

Bottled Beer + Cider
Corona 8
Steinlager Pure 8
Steinlager Classic 8
Stella Artois 8.5
Pacifico 8.5
Speights Summer Ale Speights Ginger Beer 8
Mac's Black 8
Mac's Hop Rocker 8
Mac's Sassy Red 8
Emerson's 500ml Selection 14
Isaac Apple Cider 8
Brambles Cider 568ml 11
Range Kirin Fuji Apple Cider 500ml 13

Low & Non-alcoholic
Juice; Apple, Orange, Cranberry, Pineapple 4
Lemonade, Coke, Ginger Beer, Diet Coke,
Ginger Ale 3.5
Red Bull 6.5

House Spirits
Gin, Vodka, Whisky, Bourbon, Rum 7.5

WATER IS ALWAYS AVAILABLE ON TAP!

Feel free to check out our extensive back shelf spirits collection or ask a server for their recommendations

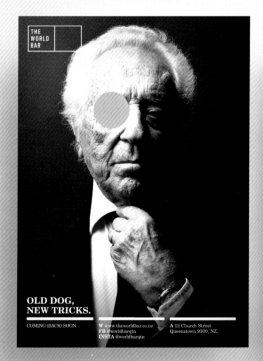

THE WORLD BAR

OLD DOG, NEW TRICKS.

COMING (BACK) SOON

W www.theworldbar.co.nz
FB @worldbarqtn
INSTA @worldbarqtn

A 12 Church Street
Queenstown 9300, NZ.

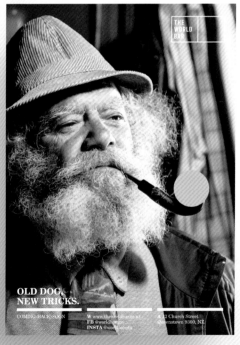

THE WORLD BAR

OLD DOG, NEW TRICKS.

COMING (BACK) SOON

W www.theworldbar.co.nz
FB @worldbarqtn
INSTA @worldbarqtn

A 12 Church Street
Queenstown 9300, NZ.

Branch Creative

Design: Noeeko Studio

Branch Creative is an executive production and advertising house that represents a pool of photographers, illustrators, and commercial directors from around the world. The designers created a sophisticated identity system with a playful typography treatment.

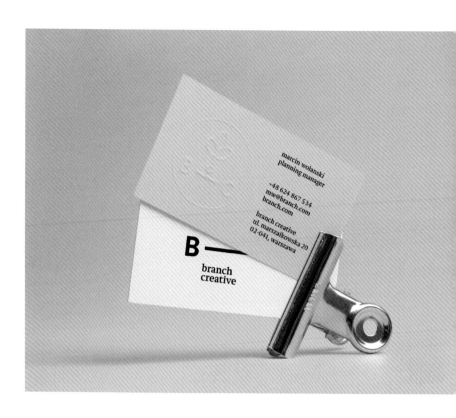

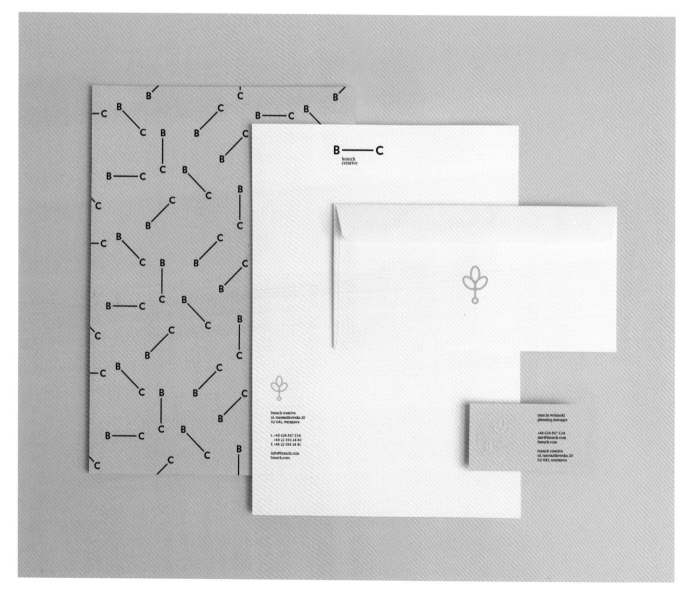

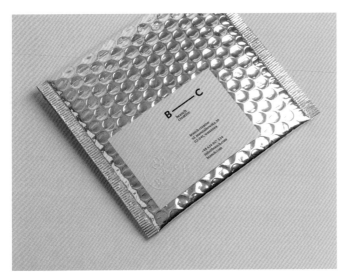

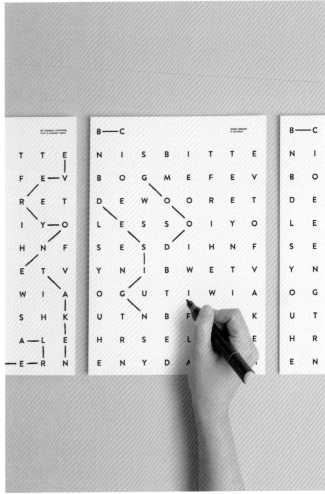

BE YOURSELF EVERYONE
ELSE IS ALREADY TAKEN

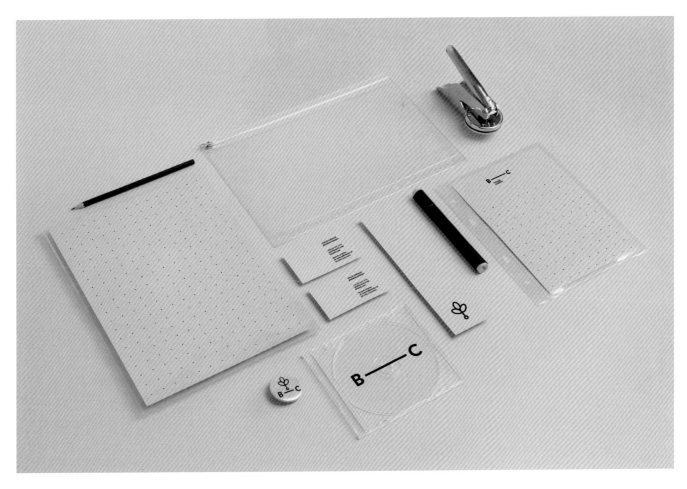

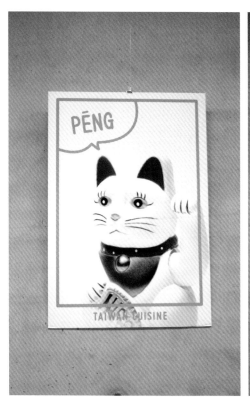
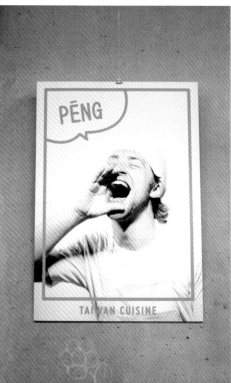
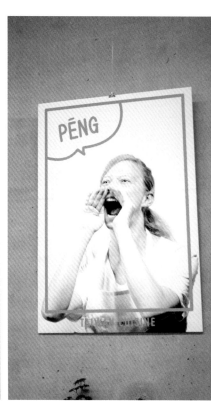

Peng – Taiwan Cuisine

Design: Andreas Williger

Peng – Taiwan Cuisine is a fictional restaurant invented as the designer's Bachelor project. It is designed as a Taiwanese fast food restaurant that could be established in Germany. Inspired by Taiwanese food culture, this restaurant only serves one kind of dish – dumplings filled with meat and vegetables. By entering the store, customers can choose if they want to sit inside or take the meal away. All dishes and drinks can be selected on a menu-list. Fried, cooked, steamed or deep fried. You have the choice and can fill in the blanks. Social Media events have been established to spread Peng's popularity.

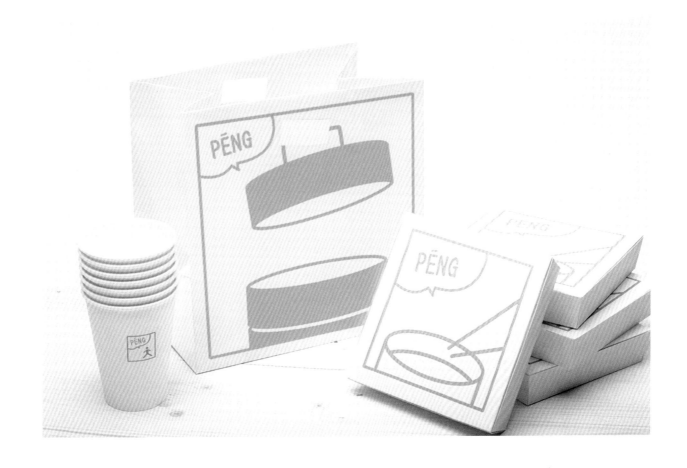

Rawganique

Design: Peltan-Brosz Roland

The designers were commissioned to create their new visual identity. They made a system that is strict with its logo and font. But like nature itself from where the firm has its most inspiration, the identity had to be more opened and closer. That is why in order that the identity is one in every way and reflects the new lifestyle that the firm proclaims, the designers thought of using something personal like handwriting. In handwriting, the designers saw the presence of the personal touch to each product, it gives the impression of a custom made material and breaks away from commerce and conventional and it is modern. So the designers devised a custom typeface for Rawganique, that due to modern printing technique they could create more versions of written words on labels. In this way, almost all labels differ from one another, because every label set on the offset printing sheet which is different from one another in terms of typeface and pattern crop to.

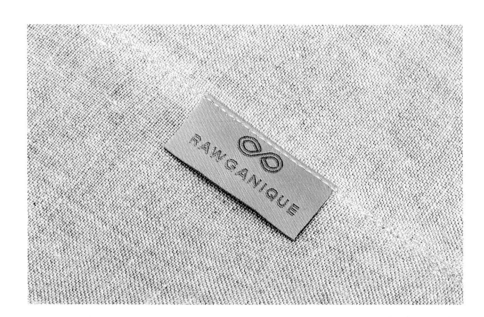

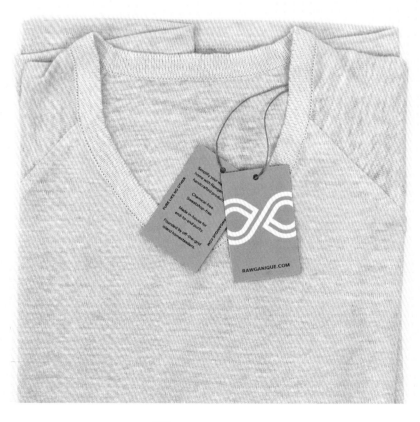

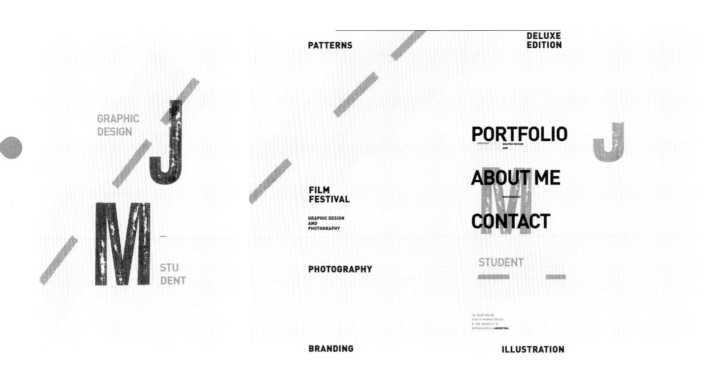

Personal Branding

Design: Julia Miceli

This is designer Julia Miceli's personal identity. After she started creating it, Julia realized how difficult it is to search for a real personal identity. If you are working for someone else it is easier to know what the client is looking for. But being your own client can be tricky. In this case she has challenged herself to design what she wants to show, what she wants to communicate through her "first card of presentation" that is, her CV and all what a personal Identity includes.

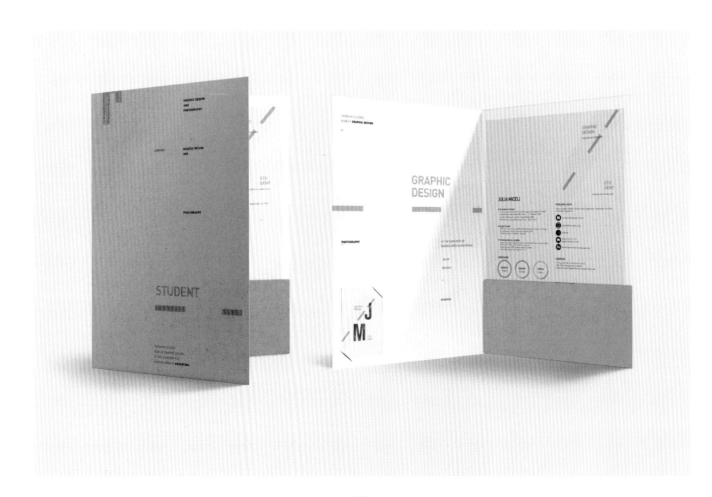

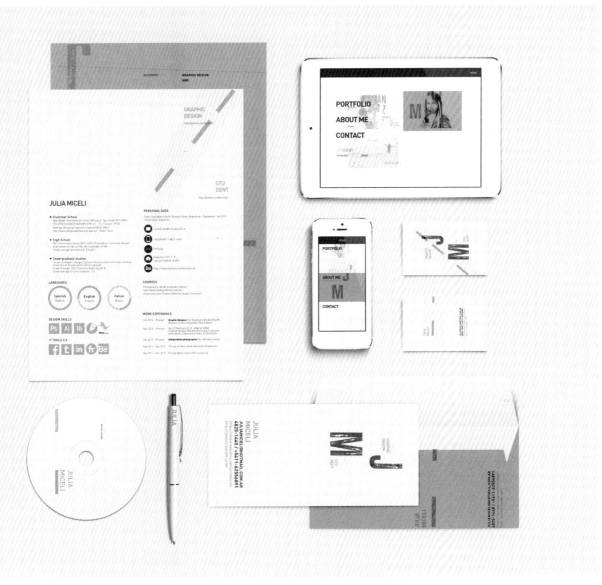

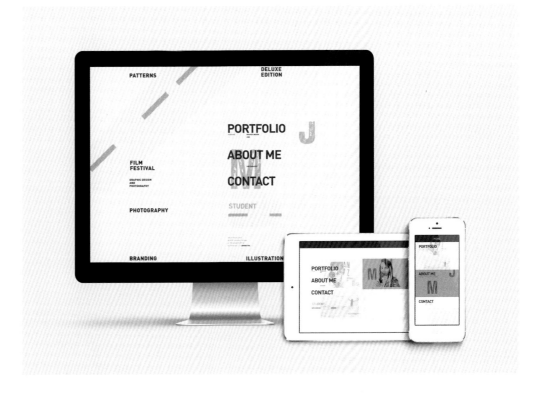

Cain & Abel

Design: Marcin Markowski

The Cain & Abel poster is part of the visual identification prepared for the theatre's festival Close Strangers. On the poster, you can see personified scissors, which, in a gesture of cutting off his brother's head, also hurts himself. Interestingly, the poster has evolved into a form beyond its classical definition. This transformation takes the form of a spatial installation. As with the poster, so as here, the designers have to deal with the artistic expression of the relationship between the title brothers. The only difference is that in the installation both brothers take the form of letters. Using an optical illusion, the word "Cain" is spatially inscribed into the word "Abel". The idea is to observe the entire structure.

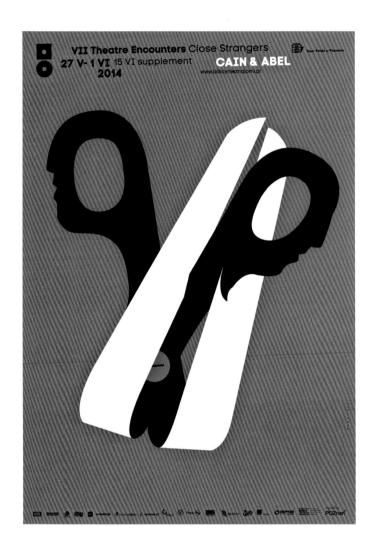

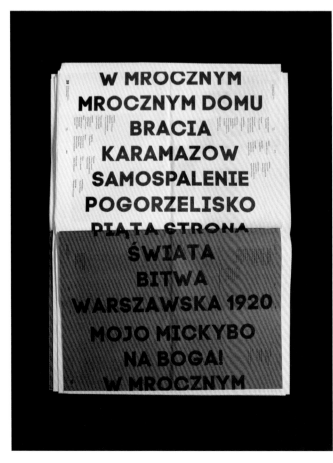

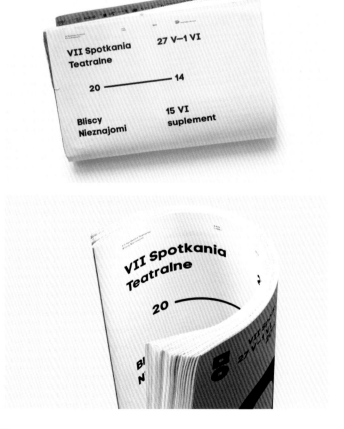

Vivaldi Antonio – Art Hall

Design: Hwanie Choi

The project includes an image showing the fashion and customs of past musicians. This tells you whether the space is any space and shows the sense of space representation.

The main color is orange of Antonio Vivaldi. It shows a Vivaldi violin to express and to represent the hair color of the past Vivaldi. Orange is lively and gives the feeling of living makes clear pure feeling. The orange has been used in the main logo symbol. In addition, posters, leaflets, stationery, mobile UI such as is used on all surfaces mated. Orange does not greatly deform the meaning of design, because not become awkward places where light and dark.

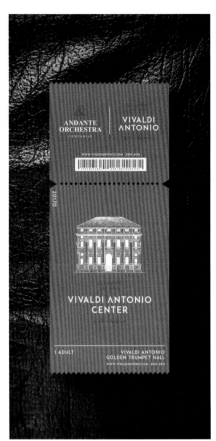

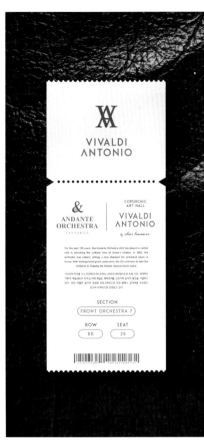

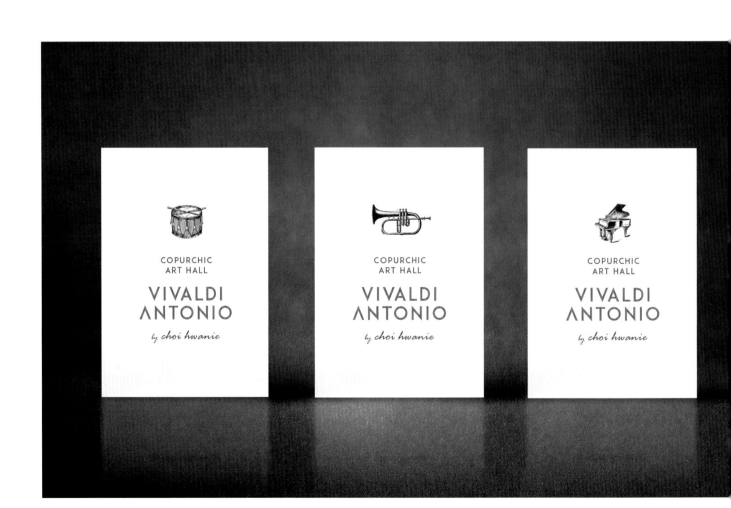

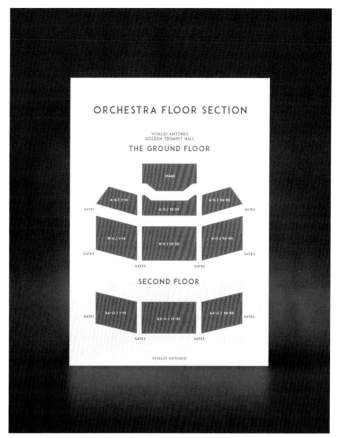

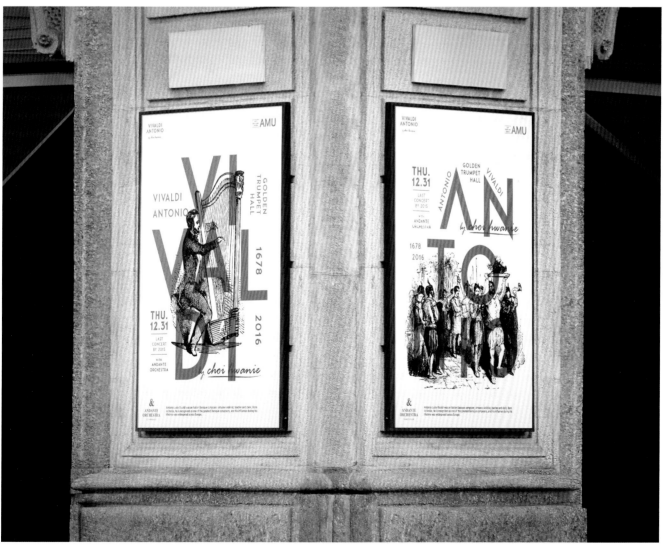

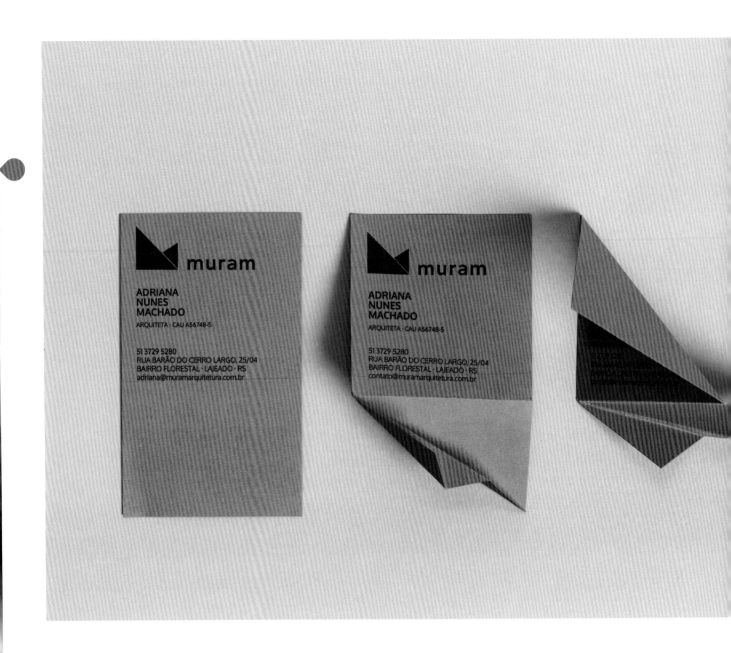

Muram

Agency: Frente
Design: Rodrigo Brod,
Germano Hentges Redecker, Samyr Paz

The visual identity developed for the
architecture studio Muram takes simple
shapes to create a complex three dimensional
structure. Metaphor of an architecture project,
the stationery aims to translate on a tactile and
visual way the essence of their work, using
abstract shapes and an unique color to acquire
a simple yet elegant solution. From the paper
to the structure, the brand was conceived in
order to be built from a "folding grid", creating
a vivid color palette that emerges from the
lights and shadows created by the paper folds.

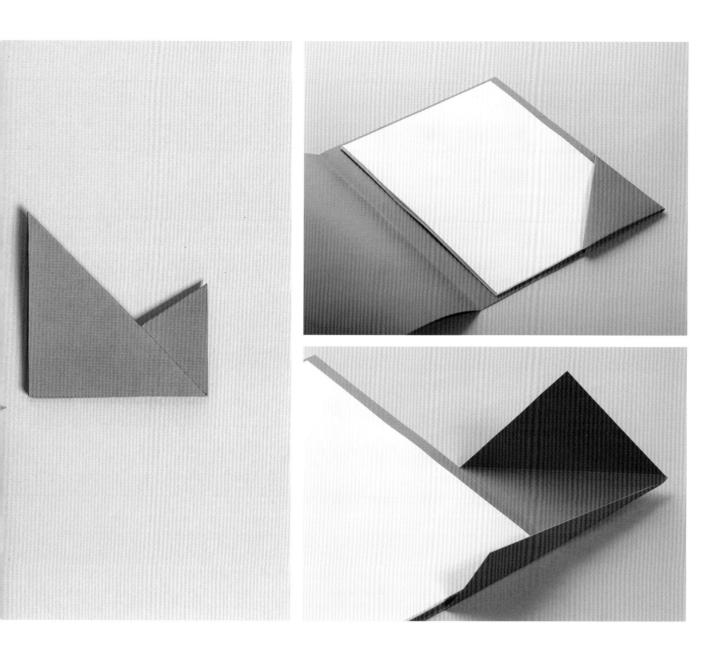

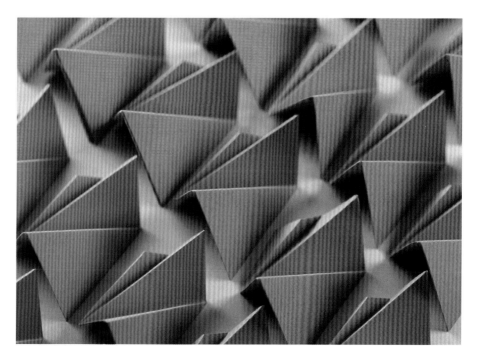

"A ship in the harbour is safe.
But that's not what ships
are built for."

"Fifteen men on the Dead
Man's Chest. Yo-ho-ho
and a bottle of rum."

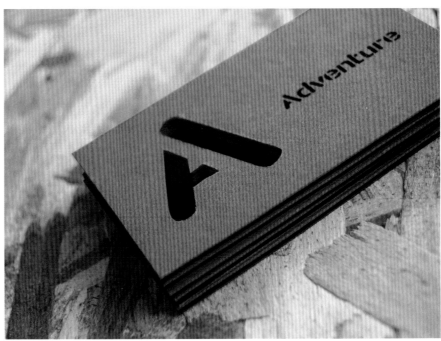

Adventure Films

Design: Sam Lane
Agency: Alphabet

Branding and art direction for Adventure Films, a creatively-led independent film production company based in Luxembourg.

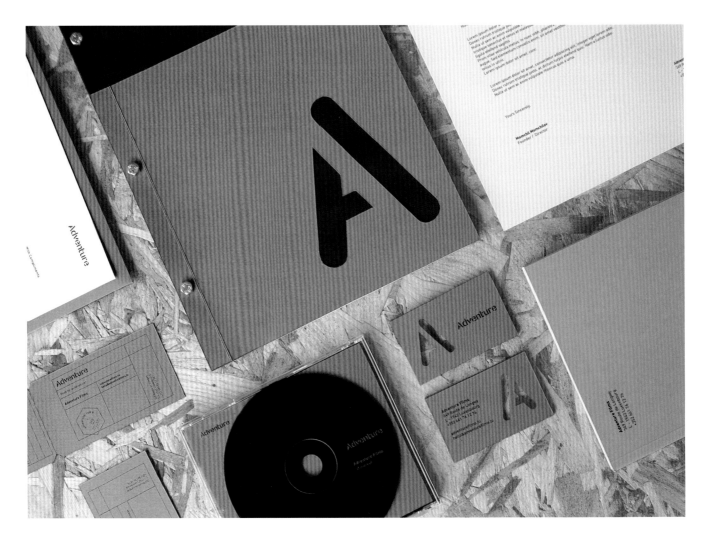

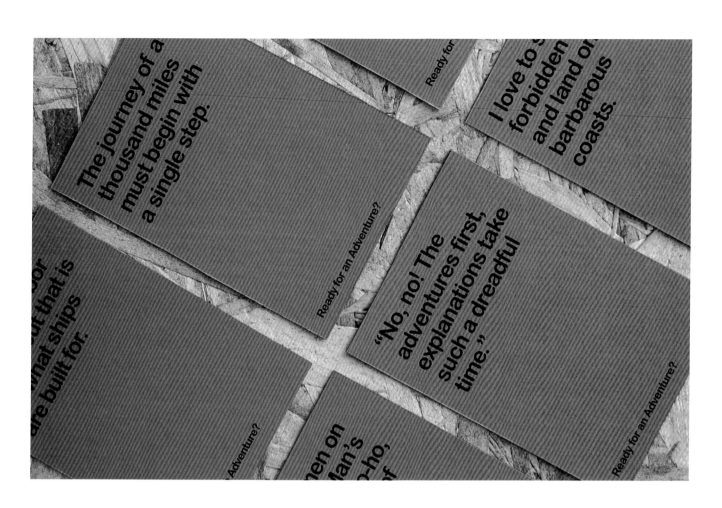

The journey of a thousand miles must begin with a single step.

I love to s forbidden and land on barbarous coasts.

or that is ships are built for.

"No, no! The adventures first, explanations take such a dreadful time."

Ready for an Adventure?

Ready for an Adventure?

Adventure?

Ready for an Adventure?

men on Man's o-ho, of

We've been on some great adventures with clients from all walks of life. Take a peek at a few highlights and see what you think.

Las Naciones

Agency: Firmalt
Creative Direction: Manuel Llaguno
Design: Déborah G. Neaves

Las Naciones is a fast casual restaurant that takes inspiration from around the world to offer a variety of salads, sandwiches and fresh baked goods.

The designers based the visuals for the brand on international communication methods and signage. This means using typographic and graphical elements from airports, flags, and maritime signal flags; where clarity and straight-forwardness are crucial. The logotype takes from the most recognizable international identification method: the flag.

The packaging was carefully designed to protect the integrity of each product and ensure its safe delivery, whilst using the minimal amount of material required for structural integrity. The result is a beautifully patterned and instantly recognizable container that is high in aesthetics, yet low in cost.

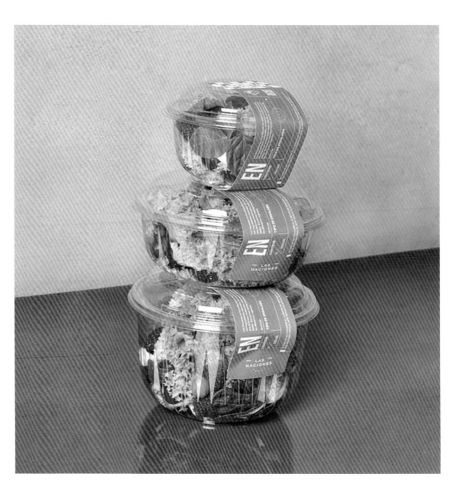

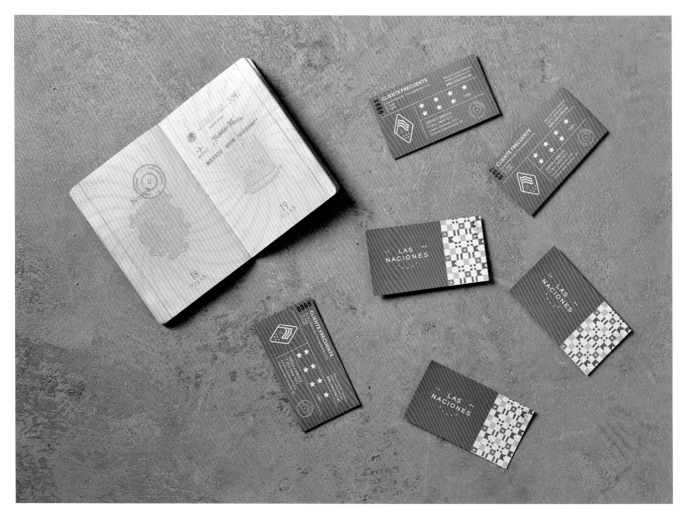

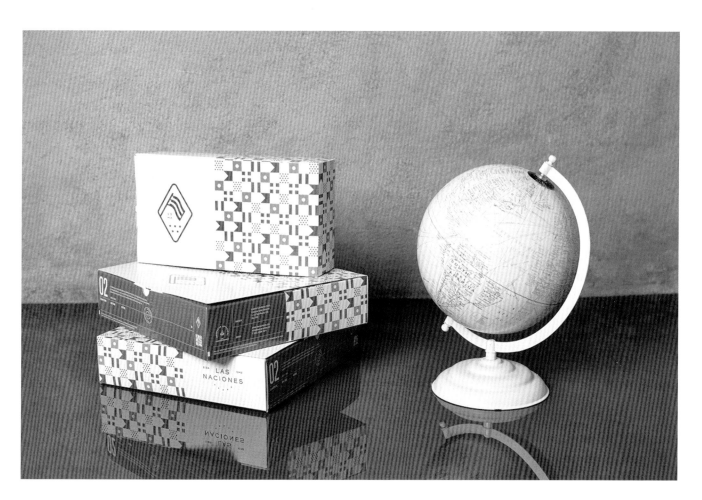

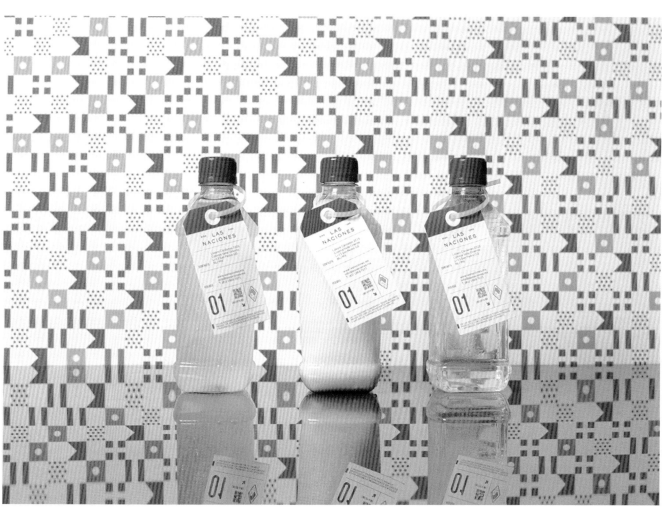

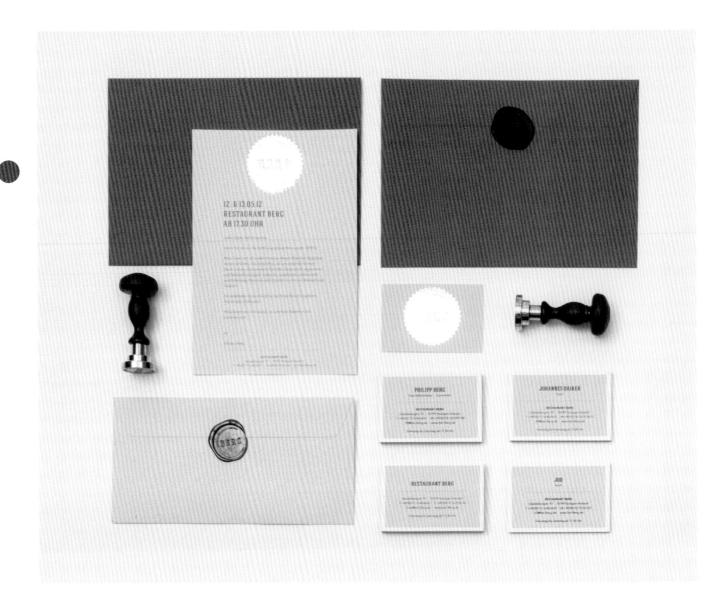

BERG

Design: Christian Vögtlin
Agency: ADDA Studio
Photography: ADDA, Stephanie Trenz

The stylized imprint of a wine glass enfolds the geometrical majuscule letters of the restaurant's name "BERG", a reference to the owners reputation as a sommelier as well as to the focus of the restaurant. The main colors are a bright, vivid orange and a distinguished cool gray. Business cards and 500 invitations are refined with hand embossed gold foil stickers. Their envelopes are sealed with the emblem on a golden sealing wax. Menu and the list of beverages have a blind embossing on their wrapping which is made of Toile-du-Marais linen.

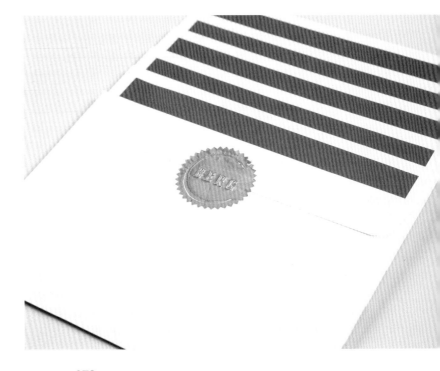

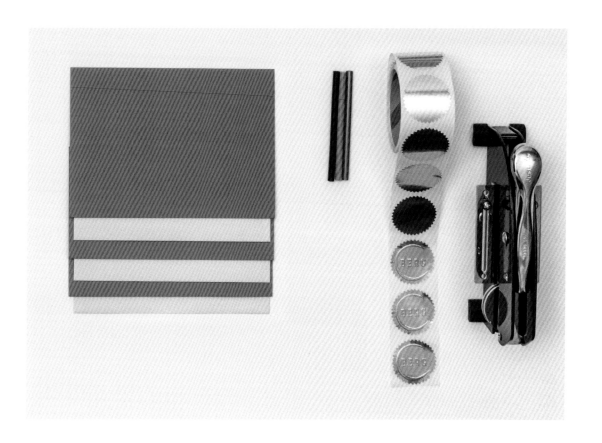

Stories and Stuff

Art Direction: Magdalena Achleitner,
Christina Schinagl
Design: Christina Schinagl
Photography: Magdalena Achleitner

In this art exhibition, five personal stories were told through installations. Throughout the design, the contrast of a vibrant, ripe tangerine-red and a clear and neutral white catches the eye. The combination also indicates the way in which personal stories are transformed into art objects and put into the public space of a gallery.

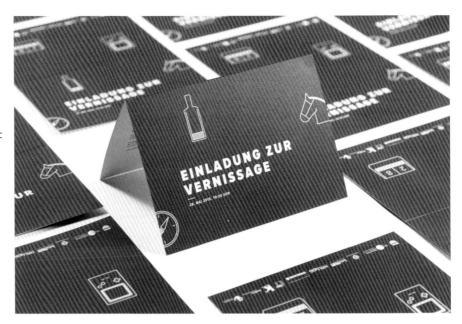

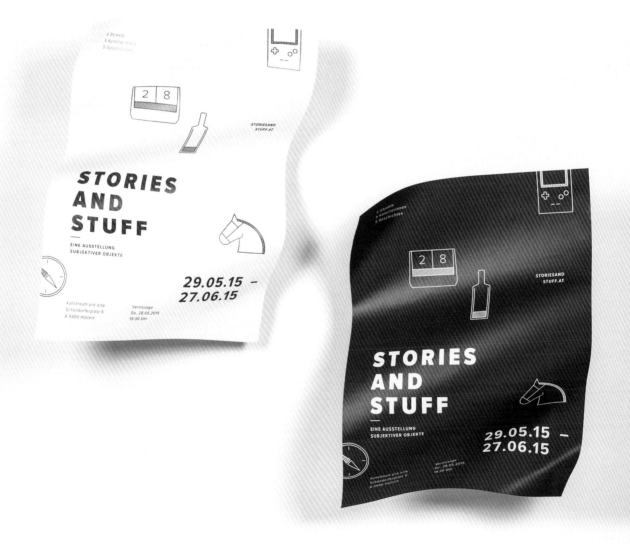

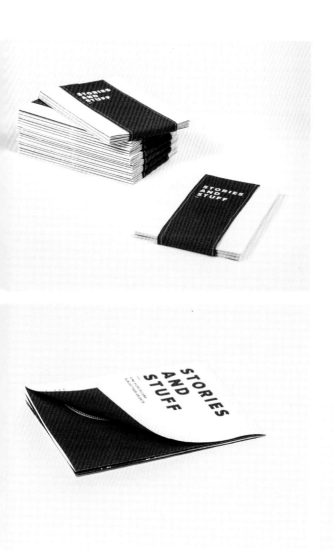

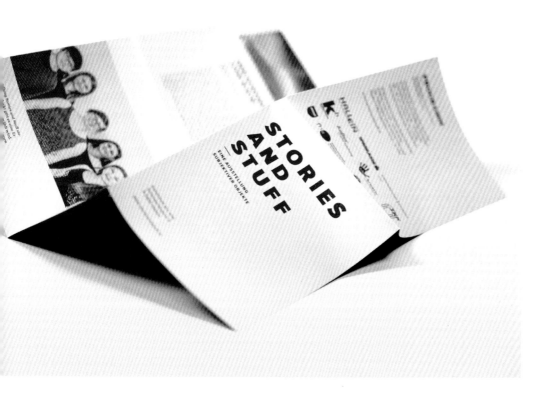

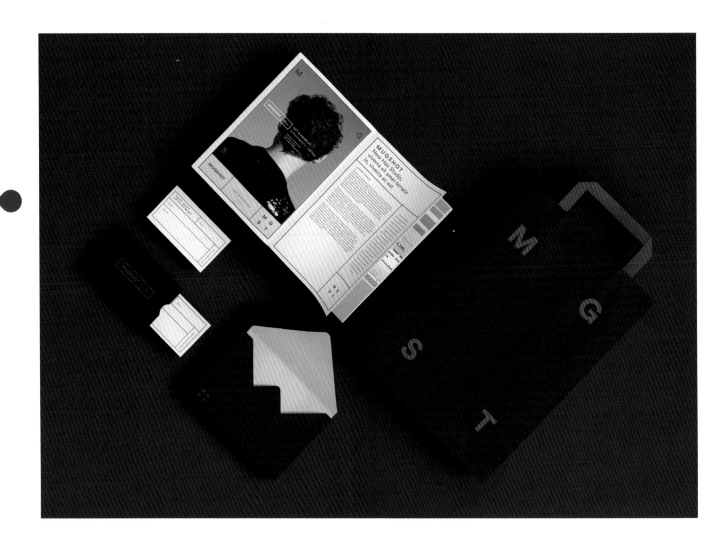

MUGSHOT

Design: The Welcome Branding Group

MUGSHOT Hair Industry is a hair salon based in Monterrey, Mexico. The design concept is inspired in the delinquent mug shots taken for criminal records. Color palette (black & red) is empowered by contrasting nude colors. Materials for the interior design Project, are inspired by the same concept, raw and luxury materials reunited to create a space where lighted up by a high-tech lamps.

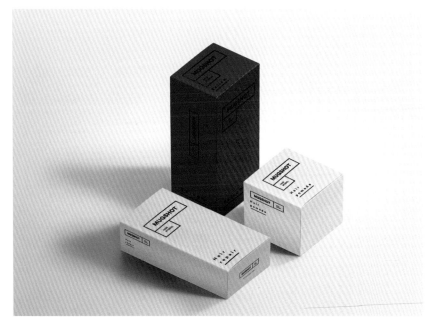

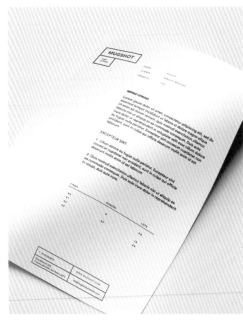

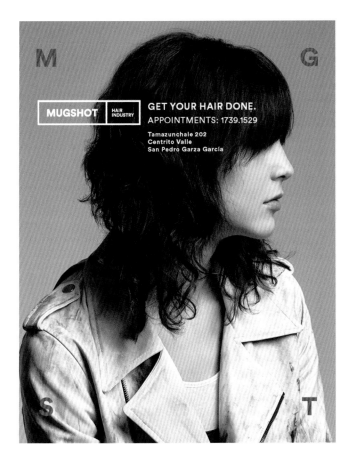

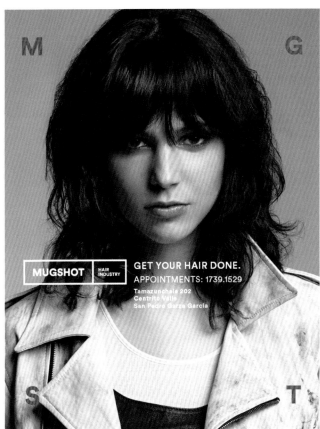

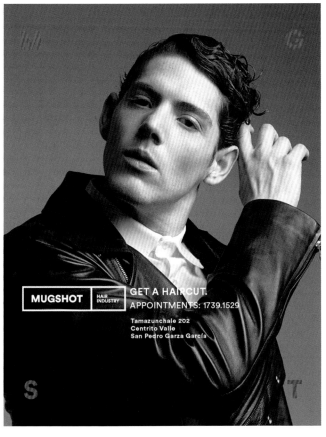

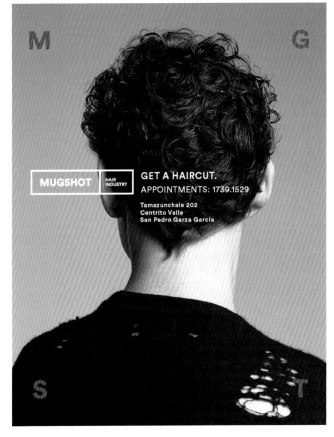

Branding for Studio Bruch

Design: Studio Bruch
Letterpress Studio: Infinitive Factory

The project consists of stationery and a mailing invitation for the opening party of their new office.

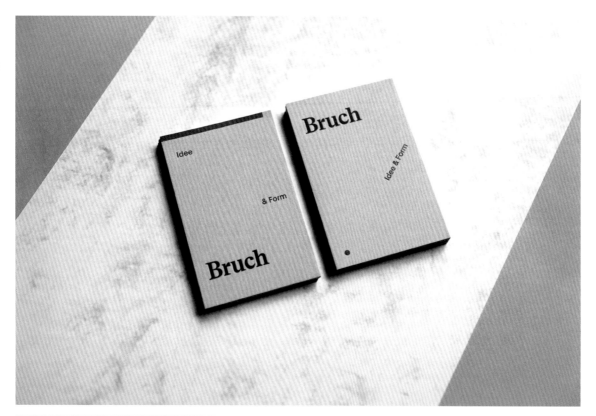

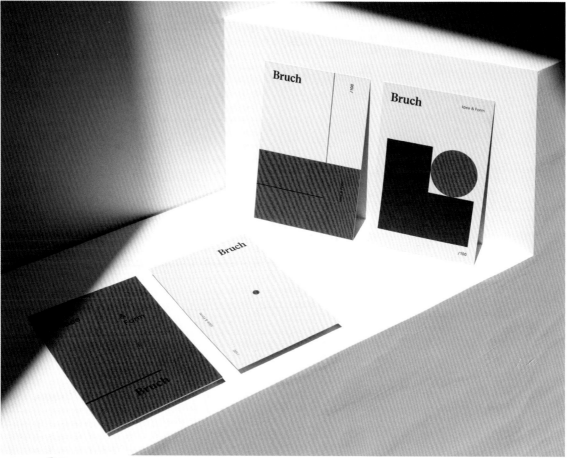

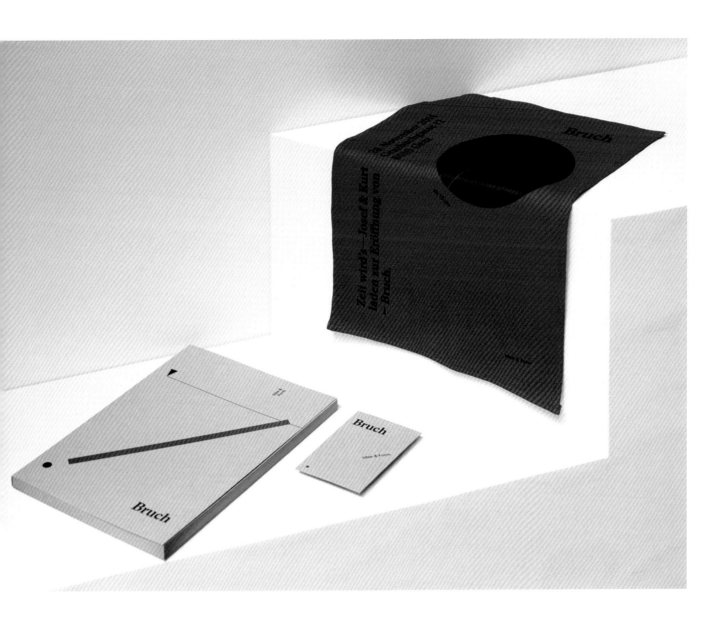

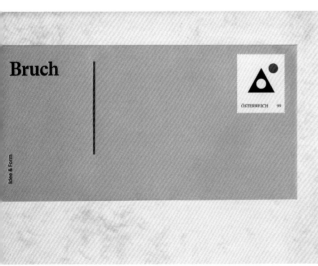

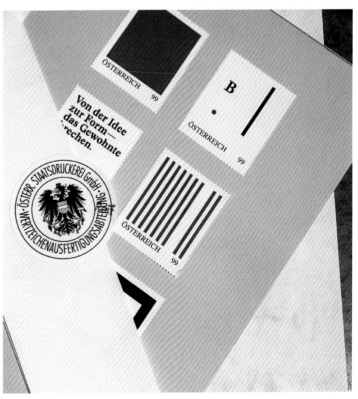

A+ Self-Branding

Design: Abbas Mushtaq
Agency: Alphabet

This self-branding project is developed from an ambition to create an iconic and instantly recognizable brand-mark which promotes key values of simplicity, collaboration, and excellence.

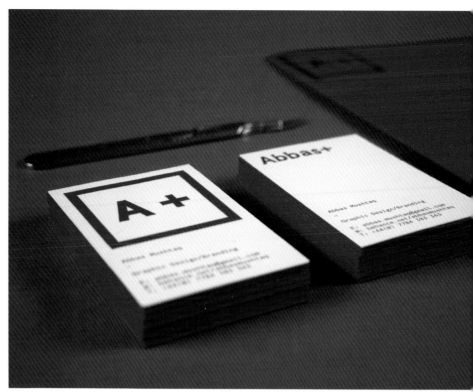

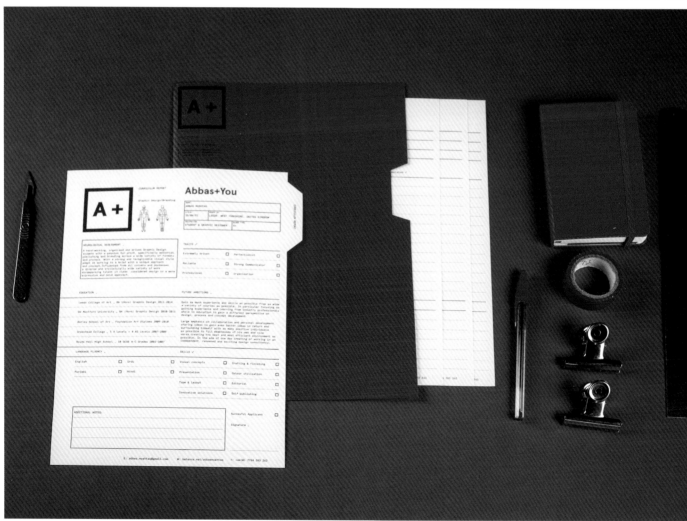

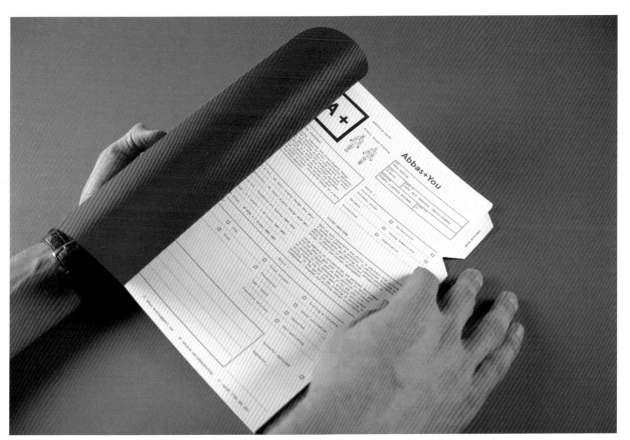

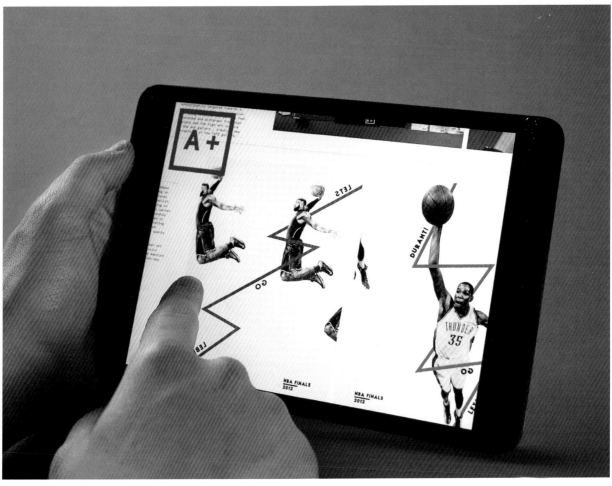

Eternal April

Design: Marcin Markowski

This brochure is a theatrical program and has been prepared specifically for the Polish Theatre in Poznań. It constitutes an artistic frame for a play "Eternal April" of Jaroslaw Jakubowski directed by Agnieszka Korytkowiej-Mazur. This program is inspired by a prayer book of the early twentieth century. As in the play, the program mixes the sacred with the profane being torn picture of Polish society in the context of cultural and religious.

Rosita Rosewater

Design: Camille Jouarre

Rosita is a fictitious brand of rose water. The logo, which is like a seal, and the choice of a serif font give an artisanal look to the product however it is resolutely modern and feminine. The main colors of the flower, red and pink, create an interesting contrast between the softness of the rose petals and the power of their scent. Furthermore, the red attracts the eye thus giving the product a strong visibility. The clean and simple graphic identity showcases the purity of this rosewater.

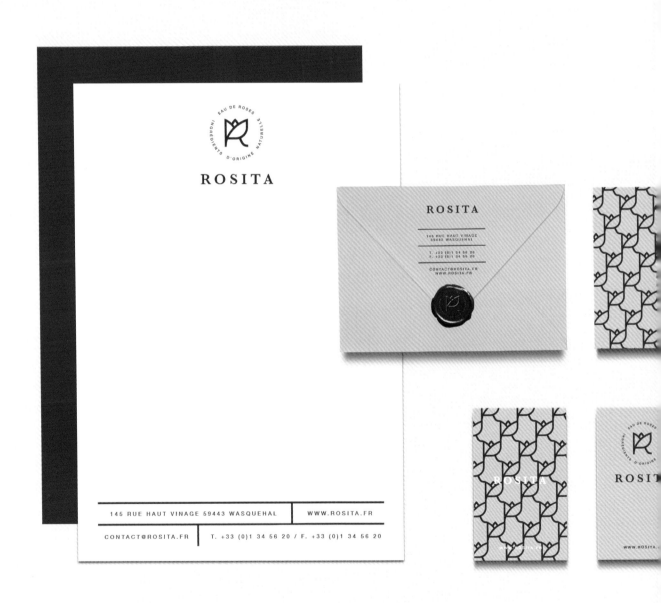

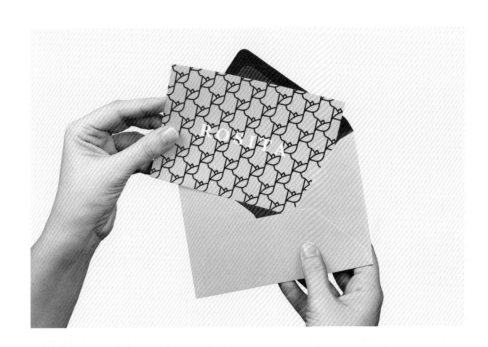

ROSITA

145 RUE HAUT VINAGE
59443 WASQUEHAL

T. +33 (0)1 34 56 20
F. +33 (0)1 34 56 20

CONTACT@ROSITA.FR
WWW.ROSITA.FR

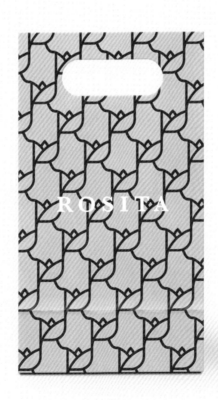

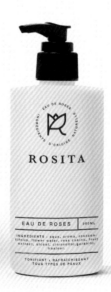

Wa Hing

Design: Au Chon Hin, Lao
Chon Hong, Sandy Chan

Branding design for Wa Hing, an old
noodle brand in Macau with a history
of over 50 years.

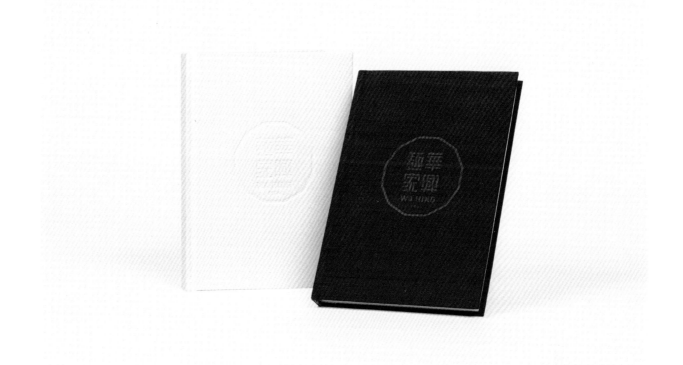

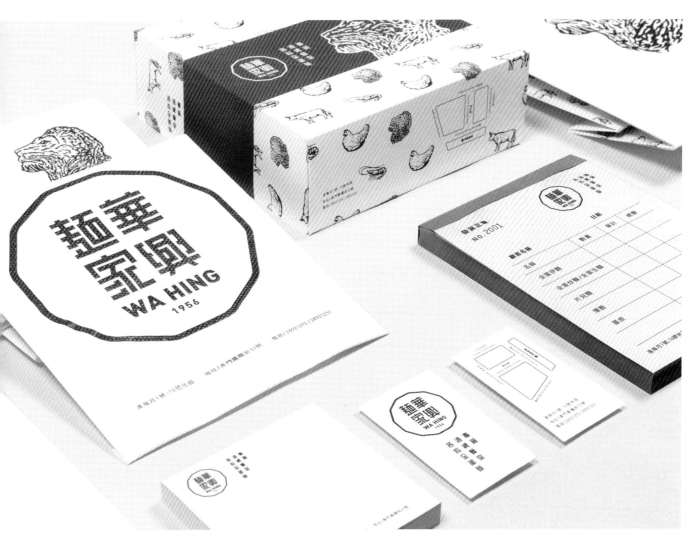

Helvetia Trust

Design: Anagrama

"Helvetia Trust" is a Swiss-Mexican financial banking firm offering business integration services with a global focus. Its naming was inspired by the female national personification of Switzerland as a means to symbolize the notorious Swiss legacy concerning their superior global financial services.

The branding proposal conveys the security and business values of the firm and communicates its Swiss influence with the use of contextual graphics and typographic choices. The brand is complemented with a stylized Greek cross that characterizes Switzerland's flag, a manifestation of its values and origins.

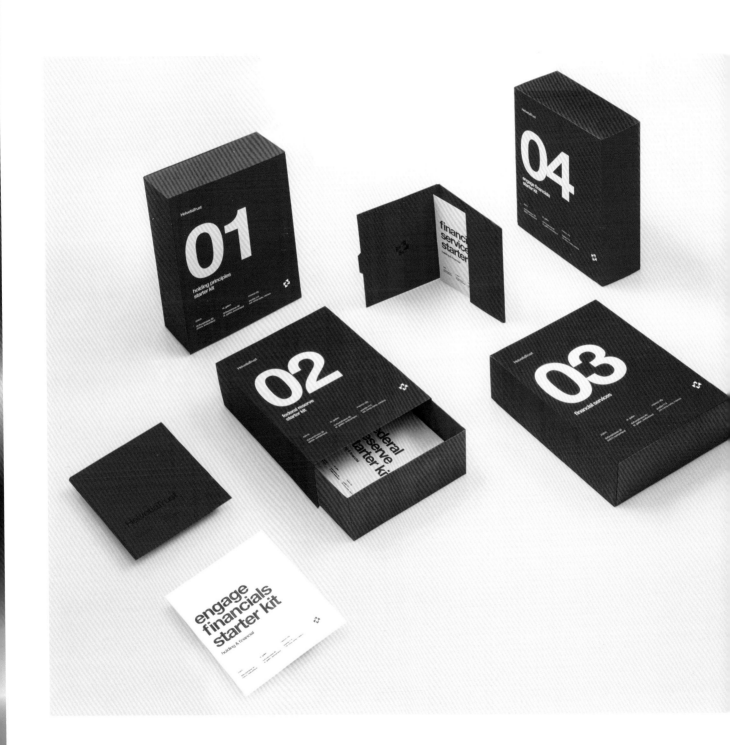

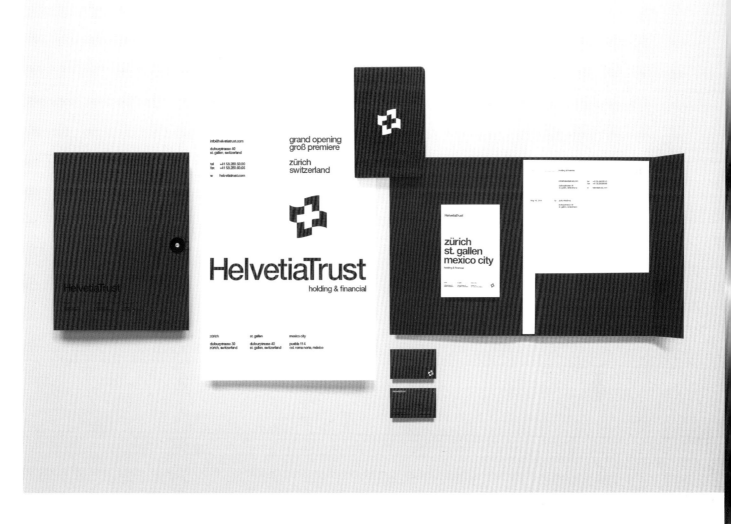

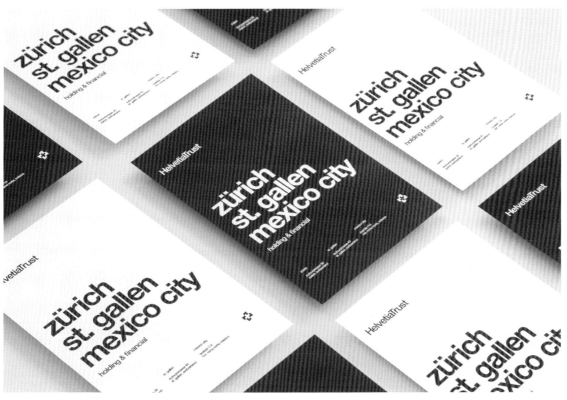

Look Addict

Design: Noeeko Studio

Look Addict is a fashion blog and online store updated daily with new trends, inspiration, and photo shoots. Look Addict allows you to rate and buy outfits from all over the world. With a dedicated team focused on the fashion, art, and visual inspirations, Look Addict is a great place to discover new products from fashionable brands.

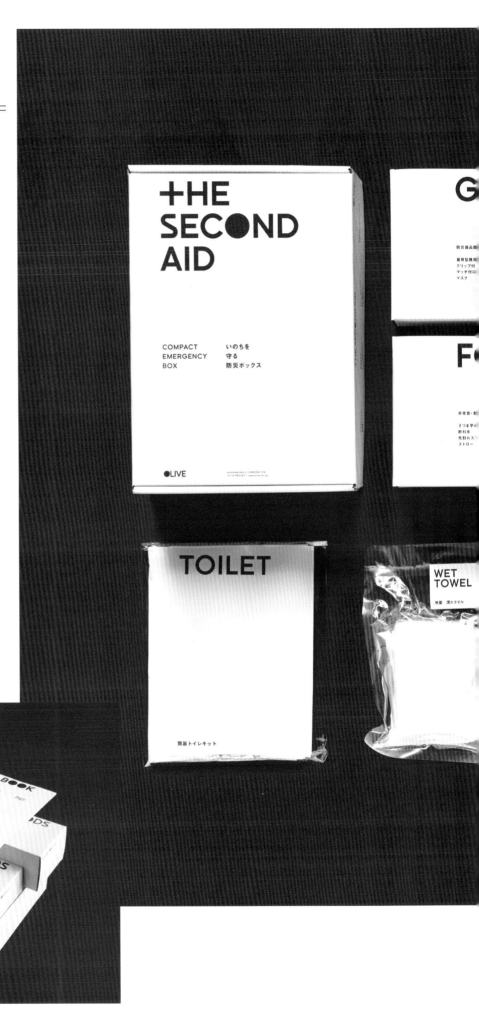

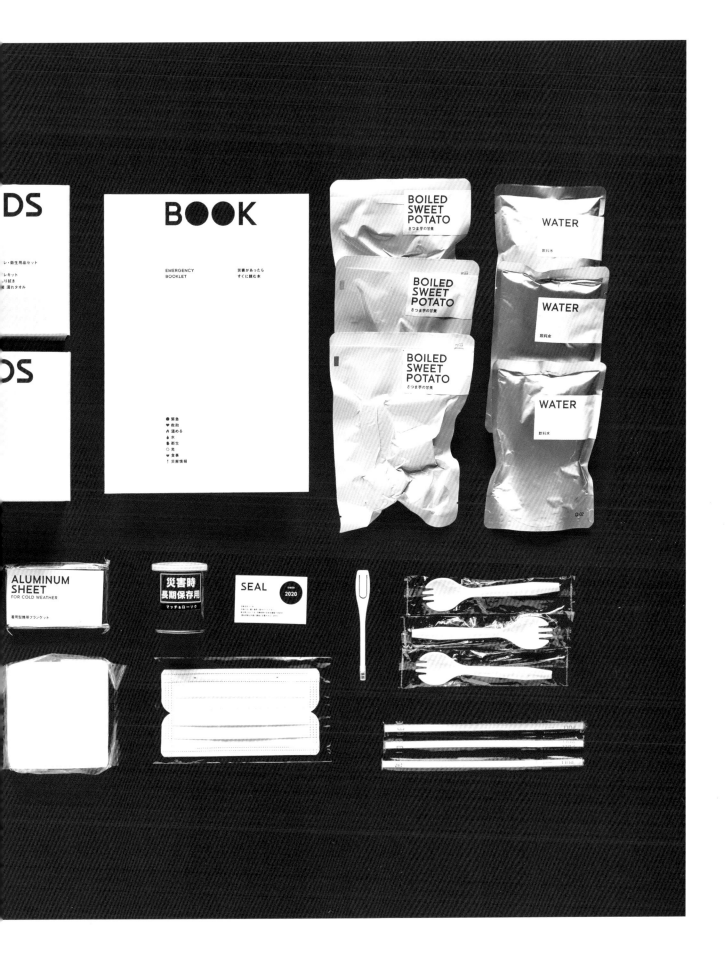

Yon Bike Lamp

Agency: Saad branding+design
Creative Direction: Lucas Saad
Design: Lucas Saad, Carlos Bauer
Photography: Isabela Nishijima, Renan Ferreira

To debut on the B2C market, Nastek needed a brand for a line of trackers of extraordinary features. Meaning "distant but within sight", the chosen name for the line was Yon. The identity was developed under the concept of "all connected" so that Yon friendly suggested movement, speed and connectivity. Several lines cross the logotype and the visual identity connecting letters, words and images. The lines, the colors and the simplicity make it possible for a variety of applications that don't lose the brand's identity but only reinforce its presence as a multifaceted brand.

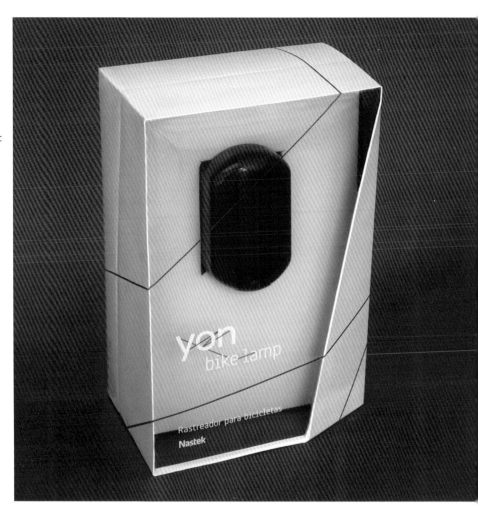

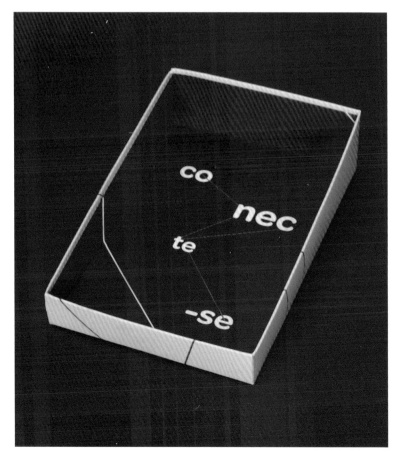

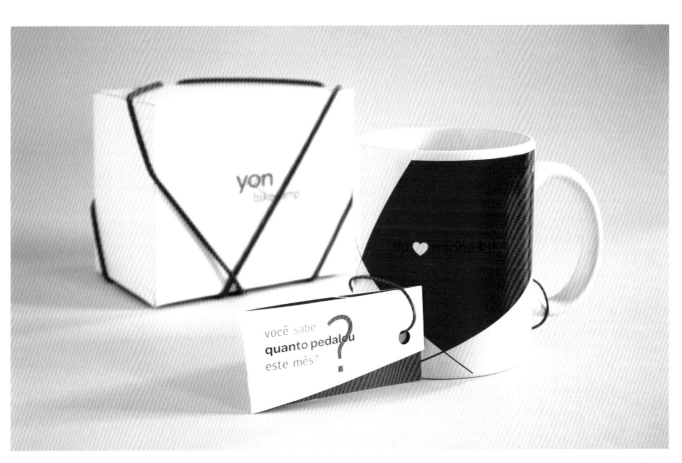

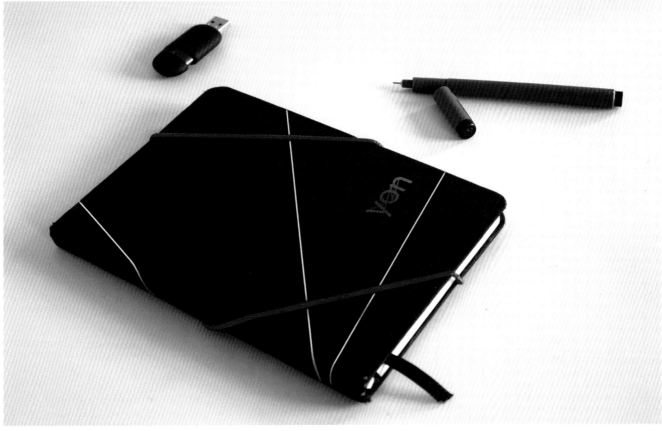

Eighthirty Coffee Roasters

Agency: Butcher & Butcher
Art Direction & Design: Noah Butcher
Photography: David Read, Johnny McCormack

Inspired by the way outside the coffee category in an attempt to "stand out" in a cluttered market, Butcher & Butcher devised strategy, art direction and design for packaging, café interiors, coffee delivery, digital platform, signage, and communications.

The packaging design talks directly to your taste buds, celebrating subtle differences in each flavor, origin and blend. The designers maintained a simple color palette, while the ephemeral typographic treatment allows each pack to have a unique voice, yet change as the coffee flavors and brand evolve over time.

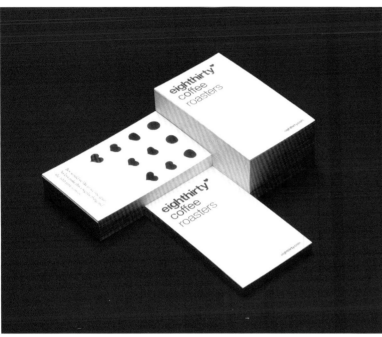

eighthirty♥
coffee
roasters

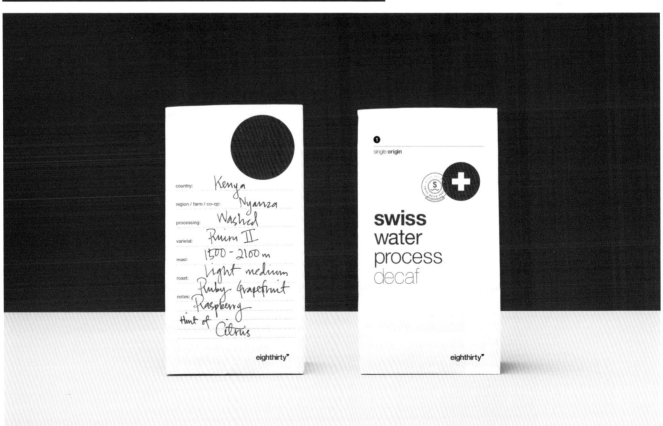

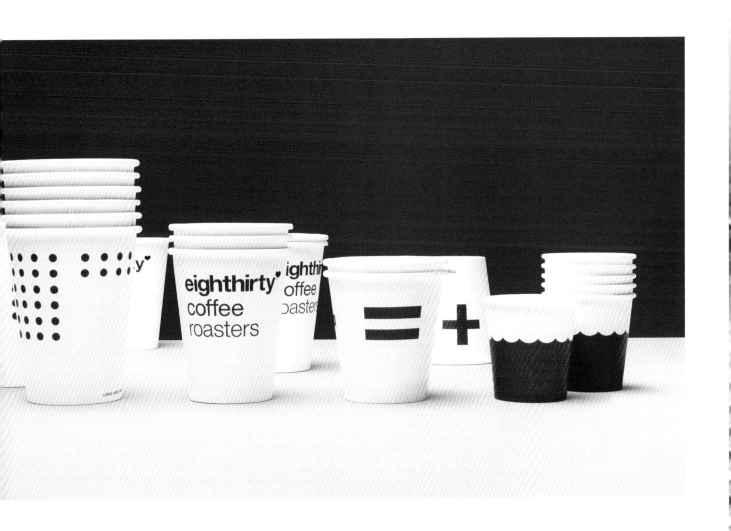

Insidesign

Design: Estudio Yeye

Estudio Yeye initiative is seeking to explore actions from Mexican practices on design. A parallelism between work and thinking, observing and raising issues to be submitted to a consensus around dialogue and criticism. In the first chapter, the designers deliver Behance portfolio reviews, a way to boost the Behance platform between professionals and future designer.

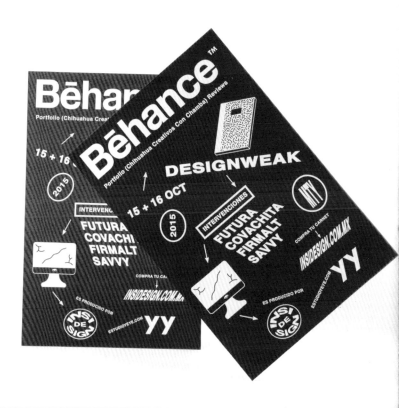

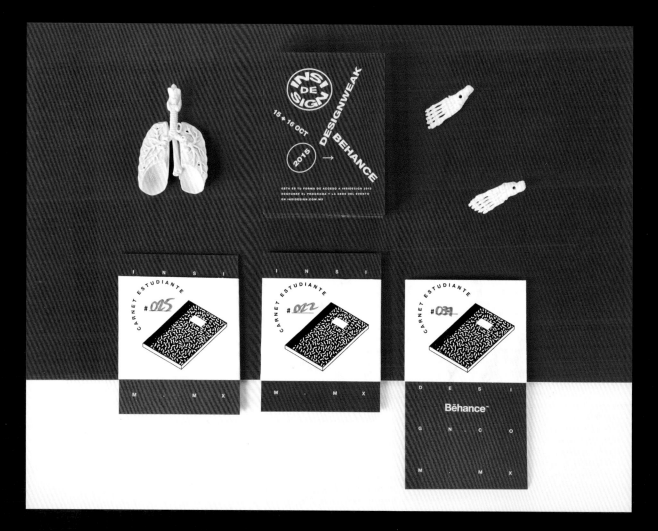

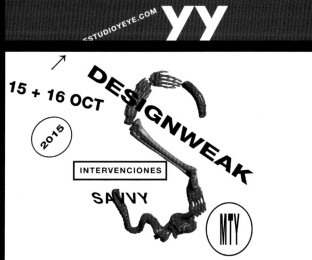

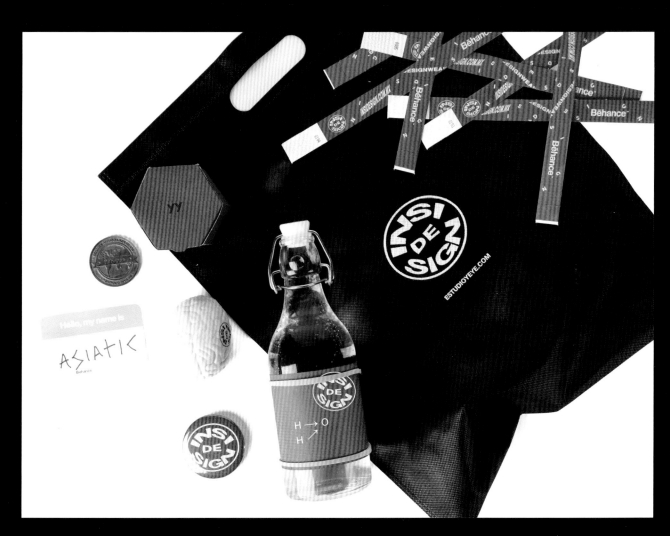

Orchestre National de Lorraine

Design: Nouvelle étiquette

Communication for the 2015-2016 season of the "Orchestre National de Lorraine". To promote the orchestra, the designers chose to highlight those who make it alive: its conductor and its musicians. The brochure is available in four different covers, each concert of the season is symbolized with a pictogram and the designers played with two modern and generous typefaces: Domaine & Founders Grotesk (by Kris Sowersby of Klim Type Foundry).

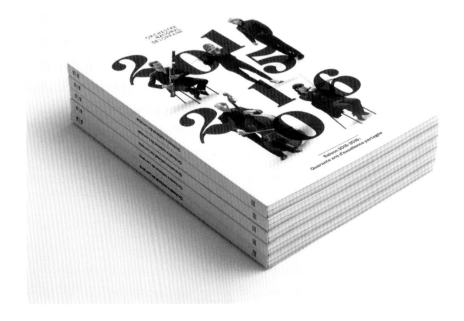

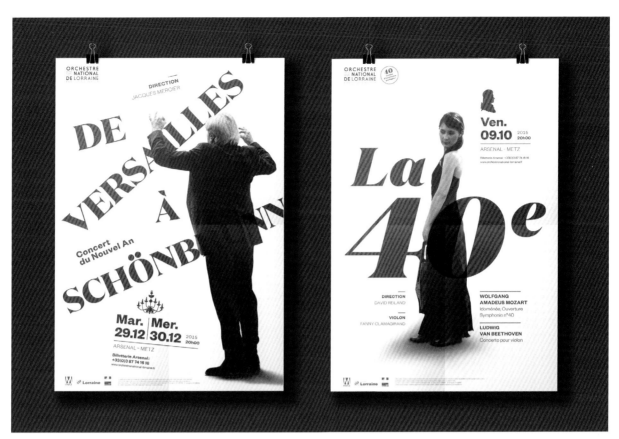

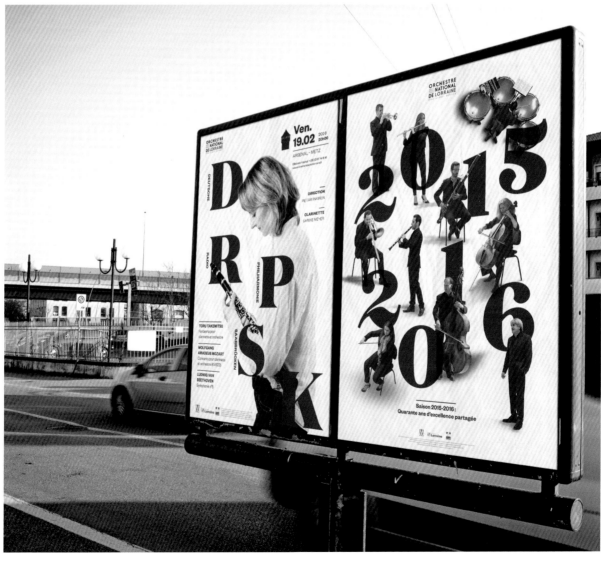

El Postre

Design: Anagrama

El Postre is a pastry boutique located in the municipality of San Pedro Garza Garcia in Mexico, it counts with over 20 years of experience and is widely known in the region. The client was looking to adapt itself to the present market, so the designers gave the brand a lift to achieve a modern look and feel.

The designers took a basic element from traditional bakeries and gave it an abstract form to create an icon that was representative of the brand, and integrated it with a simple typographic selection, resulting in the logotype.

The designers selected a range of red and pink tones to form the color palette as well as the gold foil which is used as an elegant accent. To complete the system, a multiple array of patterns were developed and implemented on each packaging, achieving a unique and authentic experience similar to receiving a special gift.

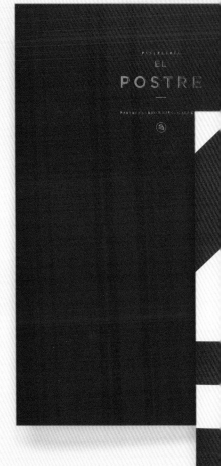

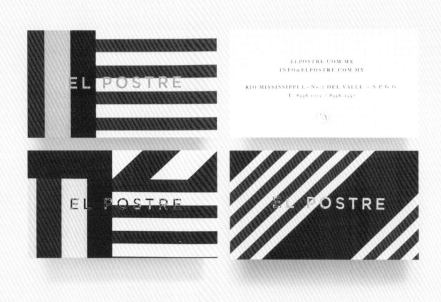

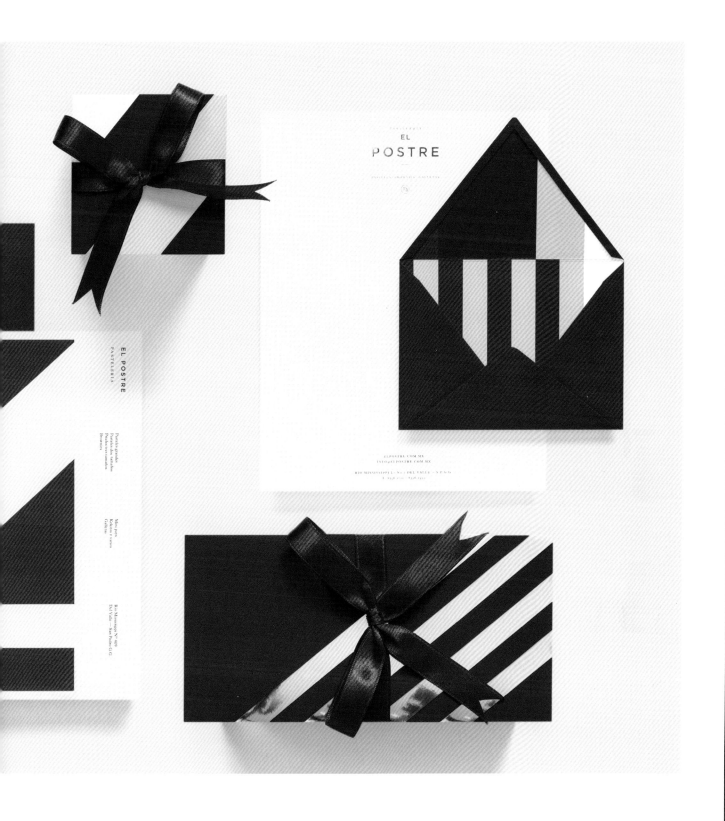

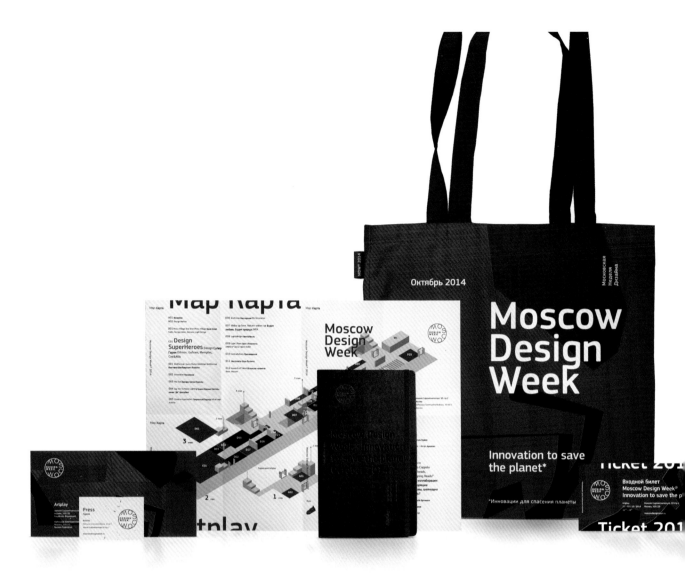

Moscow Design Week

Design: Anton Sharov
Art Direction: Valeri Arenas
Agency: ARENAS® lab

What is Moscow Design Week? During these years the team of Moscow Design Week has presented hundreds of projects from all over the world, has invited important contemporary designers as participants, has introduced talented Russian designers and young talents to the international and local public. Traditionally MDW combines social, cultural and educational missions.

So that year the main Moscow design event celebrated its 5th anniversary. And the history began when ARENAS® lab

won with the best poster MDW that year, then was their meeting with the founder of the Moscow Design Week exhibition. The designers met Alexander and both understood that their vision on MDW style completely coincides. So they began their cooperation and started work hard. At the visual base of the project are such shapes as figure "5" (the fifth anniversary of an exhibition) and modern futuristic architecture. You can easily consider this style from those referents that the designers picked up to the project. It was really

hard and difficult period, they worked day by day without break, spent the night at office for a few weeks because they should provide a lot of brand products. The MDW catalog appeared as one of the most difficult element, because there was about 150 pages and they have short time for it. Thus the copywriter spent the night together with them because the content for catalog was prepared in parallel. Also they have such opportunity to have their own lecture within MDW and to become MDW partners on a long-term perspective.

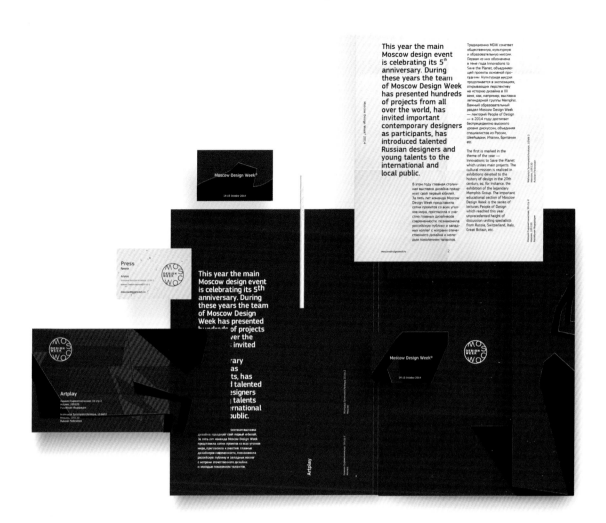

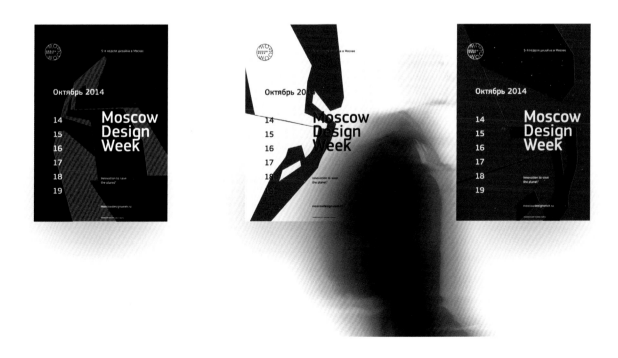

Tagline

Design: Scada

Tagline needed a completely novel,
easily recognizable and modern style.
The approach to its visual design had to
be more organized and neat. The red line
is easily read like the word "line," so the
designers used the primary alternative of
the logo – Tag__. The logo's structure allows
easy branding. Sometimes the second
part of the logo can be found on the other
side. Tagline will be instantly recognized
anytime and anywhere thanks to the red
line. Any studio would be proud to be in
the Tagline ratings.

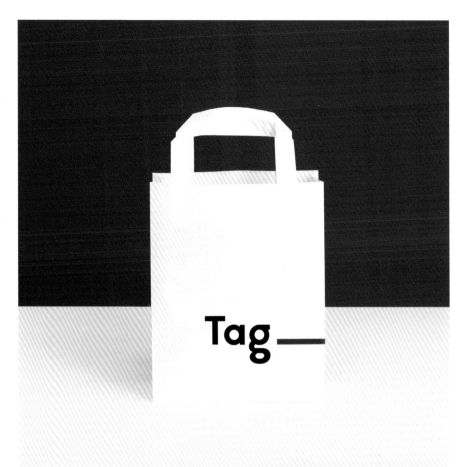

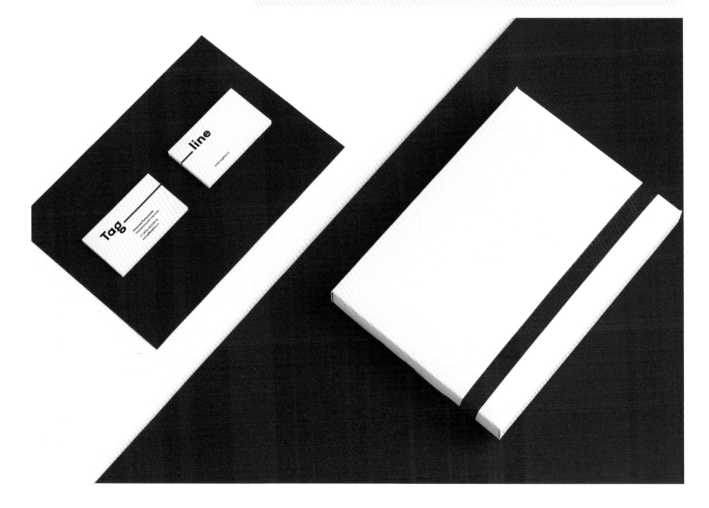

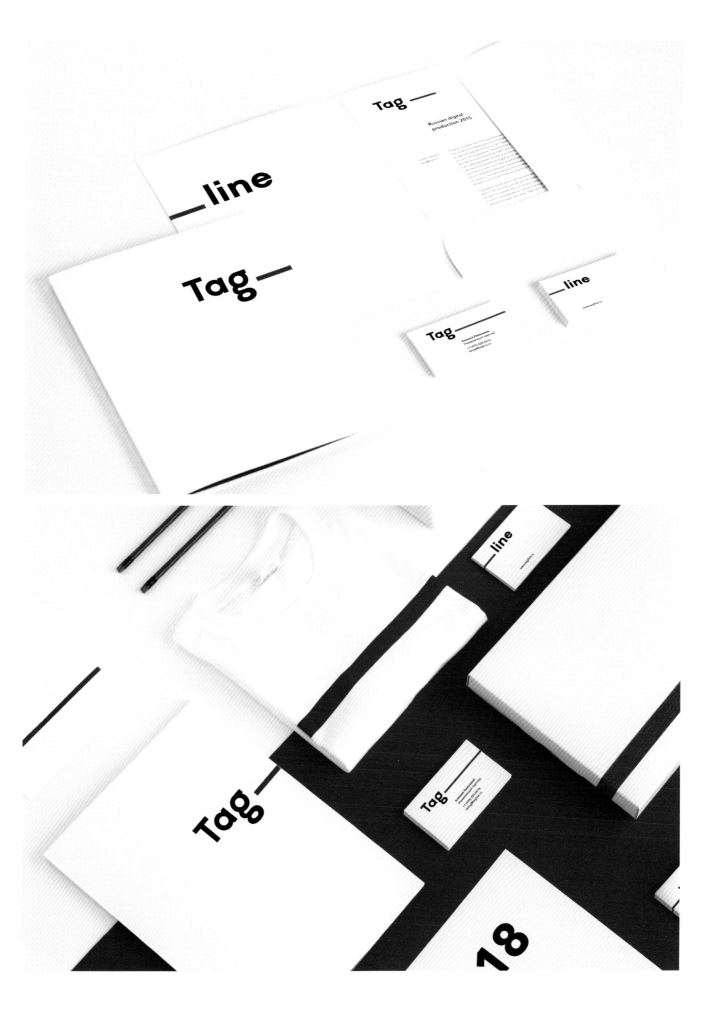

Chiquilin

Design: Philipp Vogel
Creative Direction: Christian Vögtlin
Agency: ADDA Studio
Photography: Frederik Laux

The shape of the Logo refers to the beautiful tiled floor in the restaurant. In combination with art nouveau fancywork, a handwriting and a sans serif type this brings the convivial and nostalgic flair of the great Argentinean coffee-houses into place. The menu is being borne a laser engraved wooden panels. Every information on recipes and letter paper, the designers use a cotton fiber added paper called "Boutique-Wool", is placed there with a stamp. The background of the one-pager is a full screen gallery which shows the interior of the restaurant in a smooth rotation.
Due to a TYPO3-CMS everything can be administered by the client, additionally the page is optimized for the usage on smart phones and tablets.

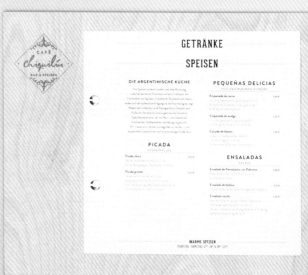

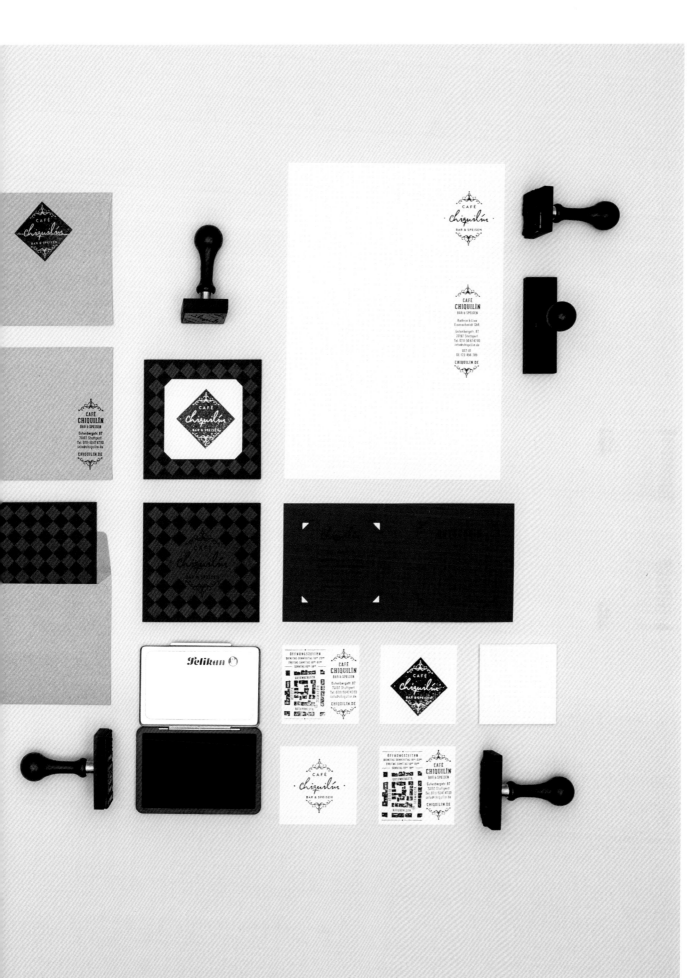

Closerie des Moussis

Design: Nouvelle étiquette

These winegrowers approach the designers to give to their identity a strong creative feeling. The designers chose to express the precision and finesse that their everyday work attest with figures specially designed for being cut, accompany warm, delicate and organic illustrations that characterize each wine. The red color refers here to both the product and region of Bordeaux where they're based and represents a strong identity marker.

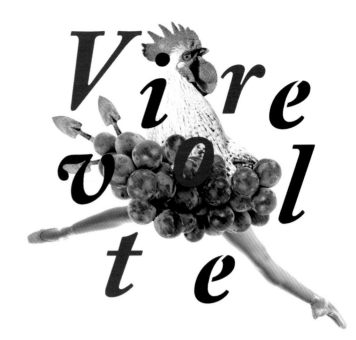

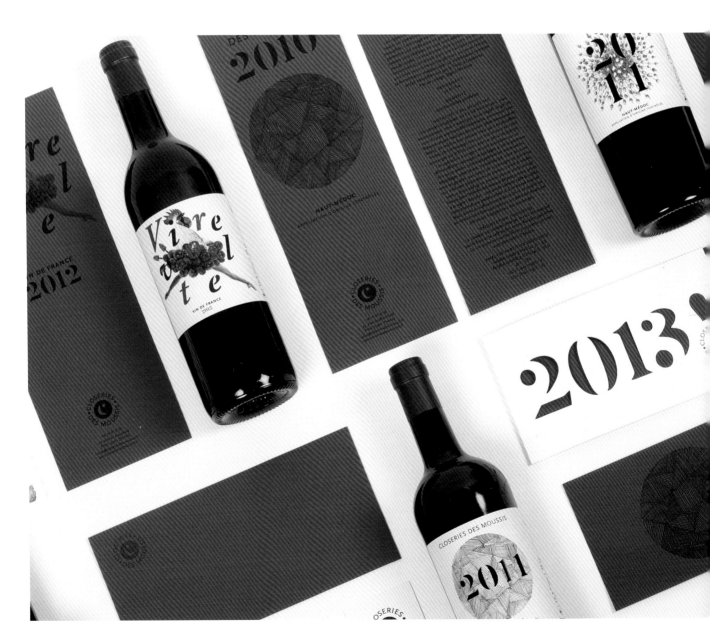

SSU

Design: Snask

Re-branding of Sweden's largest political youth party.

The designers translated the SSU brand platform into a spanking new graphic identity. The identity was launched six months before the Swedish general election, giving 10,000 proud members the right communications tools. Most importantly, the designers unified all members of SSU under one brand and one coherent graphic identity. The graphic identity has so far been used in TV-adverts, by members in the Pride Parade, in printed campaign material and in thousands of campaign activities all over Sweden.

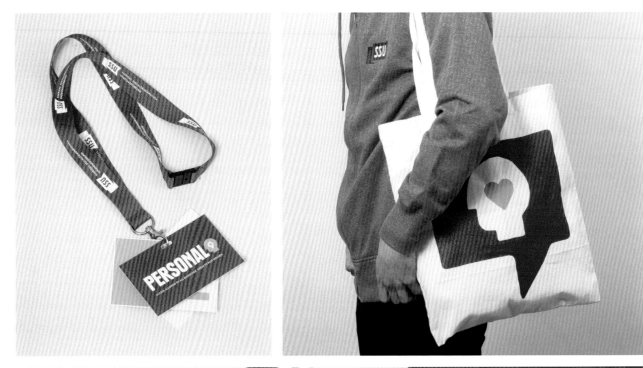

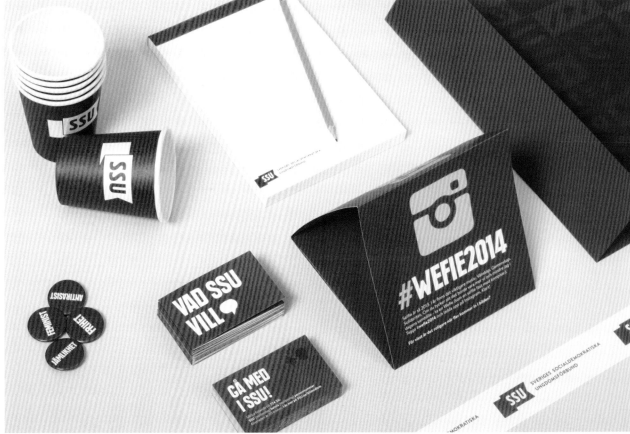

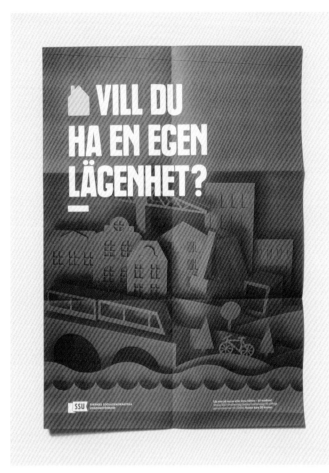

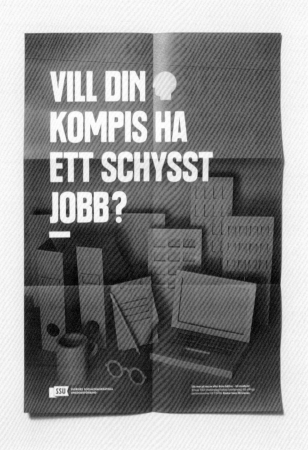

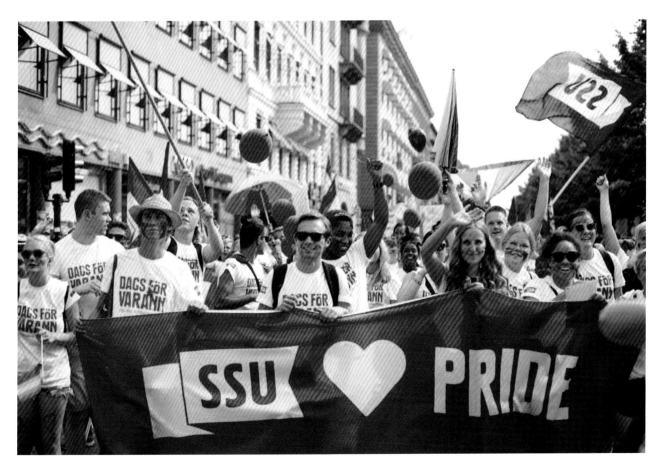

Pizzeria Farina

Design: Glasfurd & Walker

The concept behind the restaurant was a simple one – do one thing really well. The client's aim was to create a simple, community-focused, Northern Italian-inspired pizzeria. The menu is simple, consisting only of pizza and beverages, and the atmosphere is stylish, casual and comfortable. As part of the design, Italian phrases that reflect the ethos of the restaurant are printed largely on stationery and packaging.

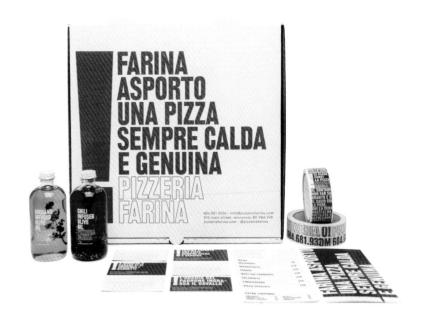

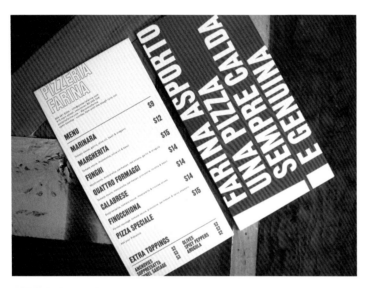

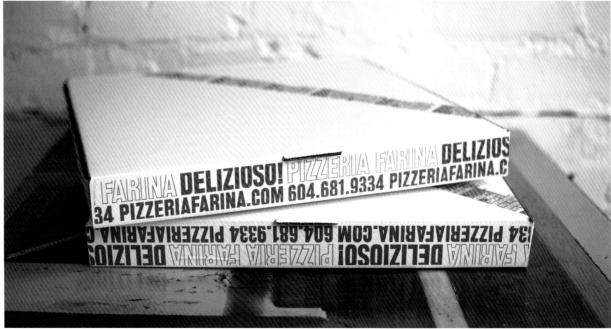

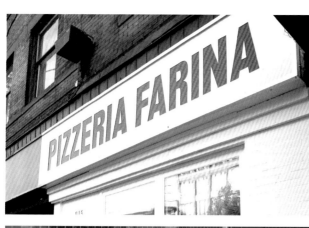

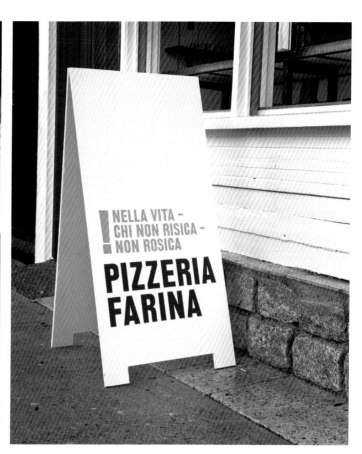

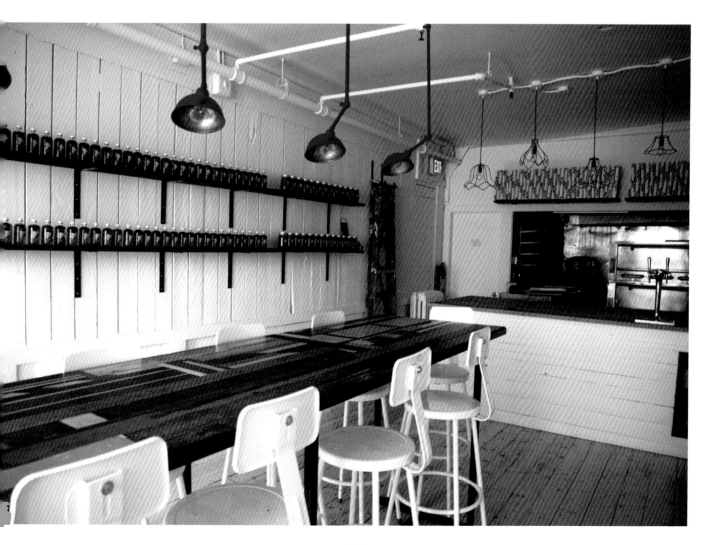

Grand Ferdinand

Agency: Moodley Brand Identity
Creative Direction: Mike Fuisz
Art Direction: Sabine Kernbichler
Graphic Design: Sabine Kernbichler,
Marie Pierer, Viktoria Hohl
Photography: Michael Königshofer

Florian Weitzer draws on the Ringstraße's heyday to revive Viennese elegance at his Grand Ferdinand. Combined with the finest amenities anno now, the redesigned 1950s building on the Schubertring is a harmonious overall composition with 188 rooms, grand culinary artistry and an exclusive rooftop pool. It celebrates tradition by moving forward, not by looking back. Furnished and endowed with designer pieces from Lobmeyr, Gubi or the Wiener Silber the new hotel meets only the highest expectations. Moodley brand identity carried on this graceful approach in the positioning and branding process – with individuality as the primary premise, a touch of Viennese charm and a deeply Austrian claim: Blessed with beauty.

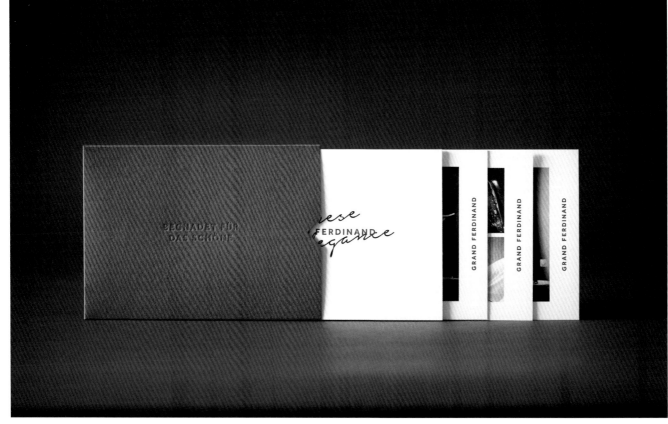

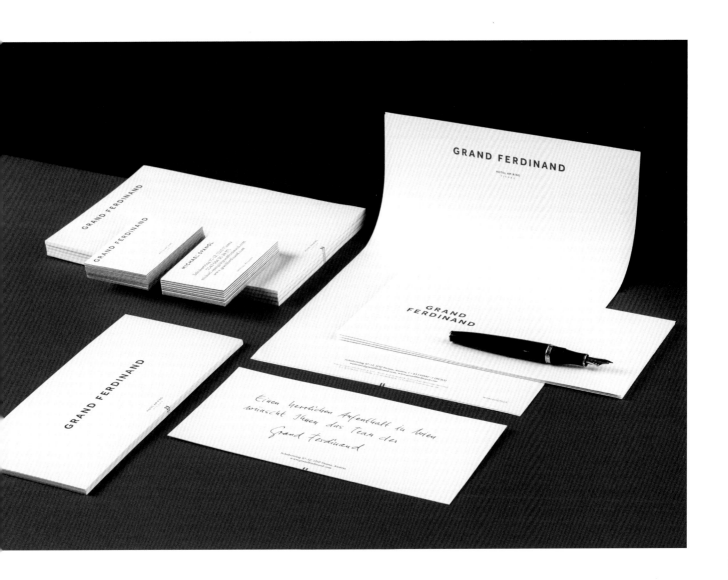

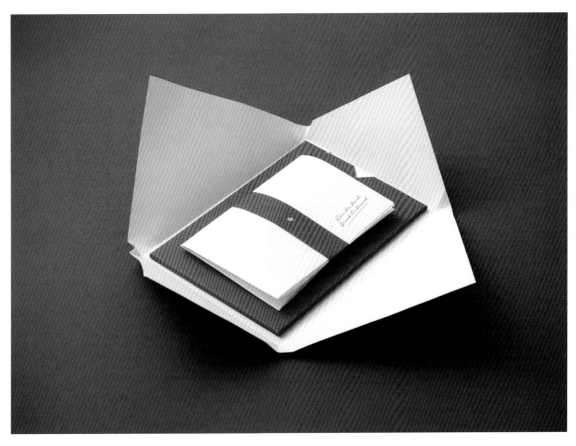

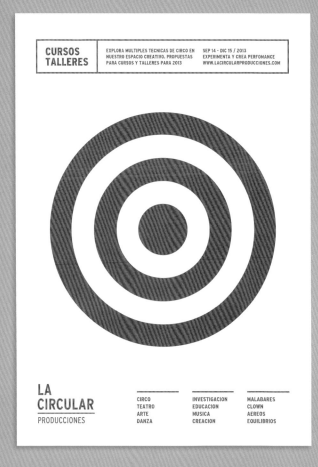

CURSOS TALLERES

EXPLORA MULTIPLES TECNICAS DE CIRCO EN NUESTRO ESPACIO CREATIVO. PROPUESTAS PARA CURSOS Y TALLERES PARA 2013

SEP 14 - DIC 15 / 2013
EXPERIMENTA Y CREA PERFOMANCE
WWW.LACIRCULARPRODUCCIONES.COM

LA CIRCULAR
PRODUCCIONES

CIRCO
TEATRO
ARTE
DANZA

INVESTIGACION
EDUCACION
MUSICA
CREACION

MALABARES
CLOWN
AEREOS
EQUILIBRIOS

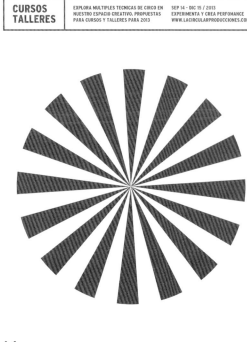

CURSOS TALLERES

EXPLORA MULTIPLES TECNICAS DE CIRCO EN NUESTRO ESPACIO CREATIVO. PROPUESTAS PARA CURSOS Y TALLERES PARA 2013

SEP 14 - DIC 15 / 2013
EXPERIMENTA Y CREA PERFOMANCE
WWW.LACIRCULARPRODUCCIONES.COM

LA CIRCULAR
PRODUCCIONES

CIRCO
TEATRO
ARTE
DANZA

INVESTIGACION
EDUCACION
MUSICA
CREACION

MALABARES
CLOWN
AEREOS
EQUILIBRIOS

La Circular
Producciones

Design: Yinsen

La Circular is a theatre
and circus company with
a wide range of technical
and artistic skills. The logo,
a series of circular shapes,
reinforce the versatile nature
of the company. A dynamic
essence accompanied by a
strong typography compose
the personality of the brand.

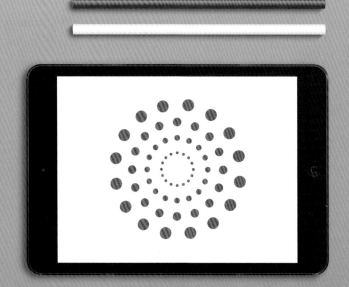

LA CIRCULAR
PRODUCCIONES

Marta Martin
Dirección artística
M. 647 621 382

lacircularproducciones@yahoo.com
facebook.com/LaCircularProducciones

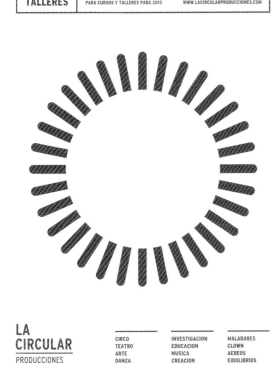

CURSOS TALLERES — EXPLORA MULTIPLES TECNICAS DE CIRCO EN NUESTRO ESPACIO CREATIVO. PROPUESTAS PARA CURSOS Y TALLERES PARA 2013 — SEP 14 - DIC 15 / 2013 — EXPERIMENTA Y CREA PERFOMANCE — WWW.LACIRCULARPRODUCCIONES.COM

LA CIRCULAR PRODUCCIONES

CIRCO / TEATRO / ARTE / DANZA — INVESTIGACION / EDUCACION / MUSICA / CREACION — MALABARES / CLOWN / AEREOS / EQUILIBRIOS

LA CIRCULAR PRODUCCIONES

Marta Martín
Dirección artística
M. 647 621 382
lacircularproducciones@yahoo.com
facebook.com/LaCircularProducciones

LA CIRCULAR PRODUCCIONES

Marta Martín
Dirección artística
M. 647 621 382
lacircularproducciones@yahoo.com
facebook.com/LaCircularProducciones

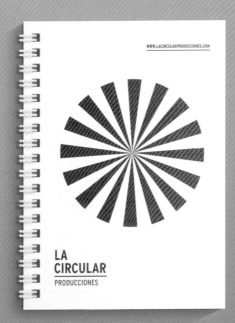

WWW.LACIRCULARPRODUCCIONES.COM

LA CIRCULAR PRODUCCIONES

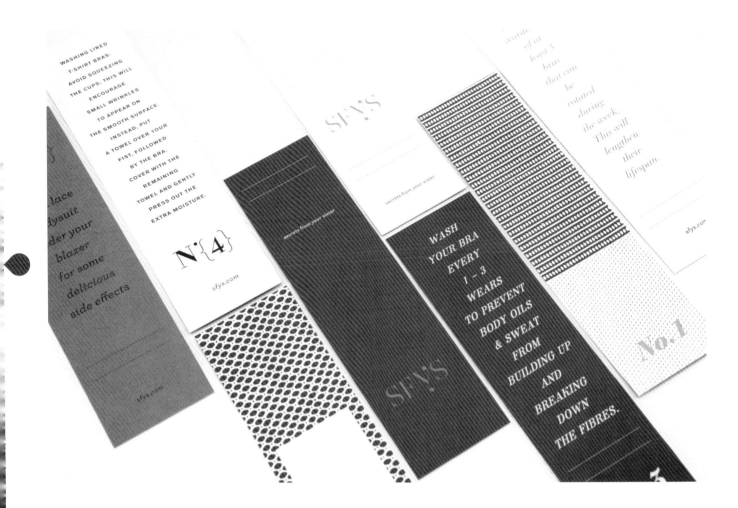

SFYS

Creative Direction: Vanessa
Eckstein, Marta Cutler
Design: Vanessa Ecktein,
Patricia Kleeberg, Kevin Boothe
Agency: Blok Design

Secrets From Your Sister is a bra-fitting boutique
with a highly curated selection of top international
brands. To align the identity with the company's
values and offerings, we re-branded the store SFYS,
then gave it a voice that reflects the brand's quirky
sensuality and celebration of women. Colors,
typography, and finishes mirror the detail and
textures found in the lingerie while texts hint at the
wealth of wisdom to be found in this welcoming
sisterhood. In collaboration with fashion
photographer Anna Wolf, the designers produced
portraits of women just as they are: honest, sensual
and comfortable in their bodies.

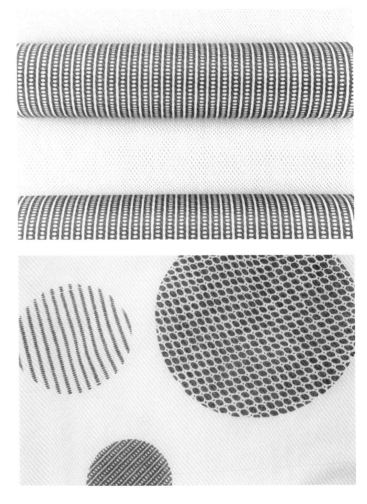

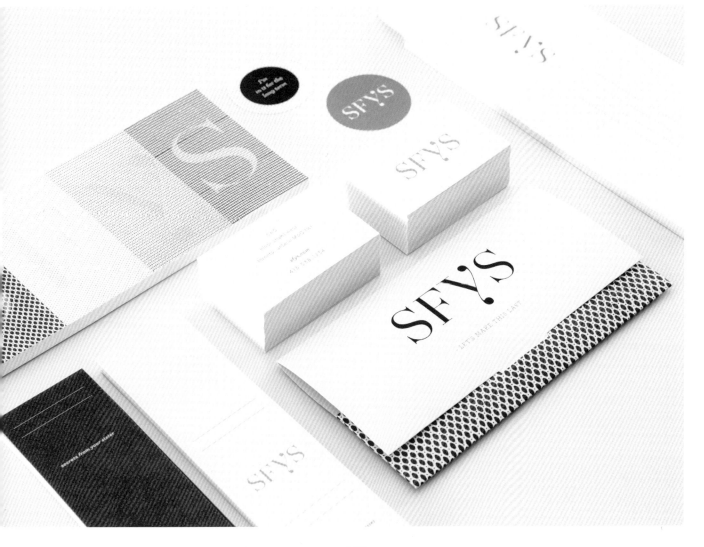

Sustainability Report

Design: Isolde Fitzel, Martha Luczak

The publication shows Standpunkt Liesing in all of its facets and includes the perspectives of all parties who advocate it. In addition to the organizations executing the project, along with initiators and specialists from the fields of spatial planning, traffic planning and free space, business owners from Liesing also have their say, expressing their views on sustainability.

The publication refers to the brick itself, the material of which most of the former industrial buildings, located in that area, were built of.

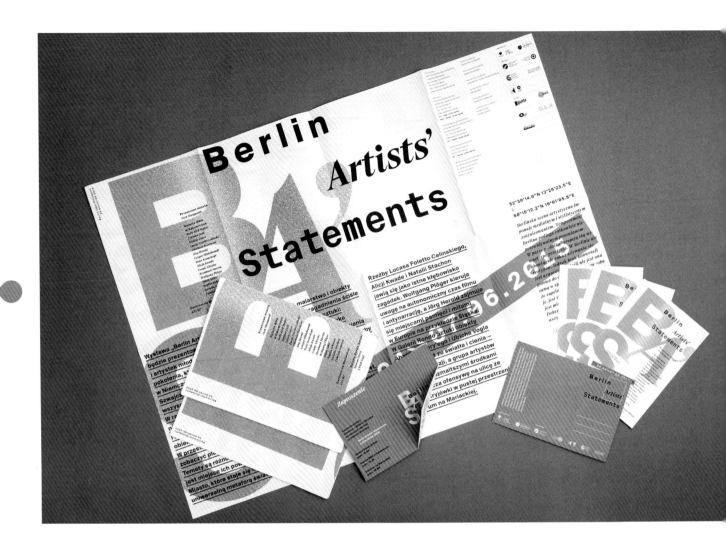

Berlin Artists' Statements

Design: Marta Gawin

Visual identity of the exhibition presenting young Berlin Artists.

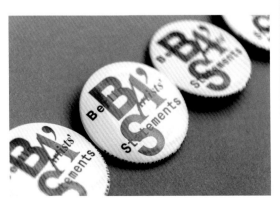

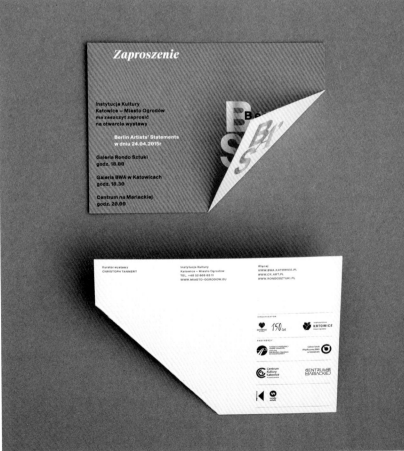

Kitska

Design: Rita Fox

Kitska is an individually run design studio based in London that produces refined visuals and effective communication across multiple disciplines including web and app design, identity and print.

The concept of this identity was inspired by the characteristics of the cat, fox and diamond to suggest sharpness, elegance and adaptability. Pastel colors were used to evoke creativity, warmness and empathy. Simple geometric lines extract the essential from the original sources of inspiration, creating a timeless diamond-like shape.

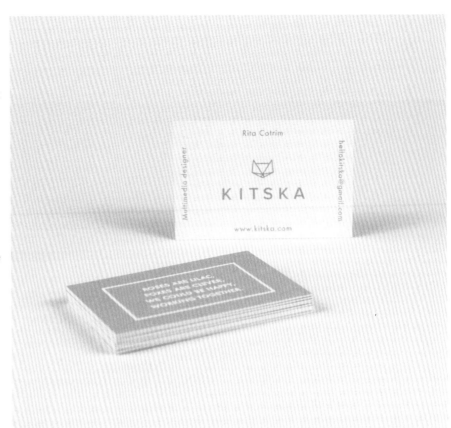

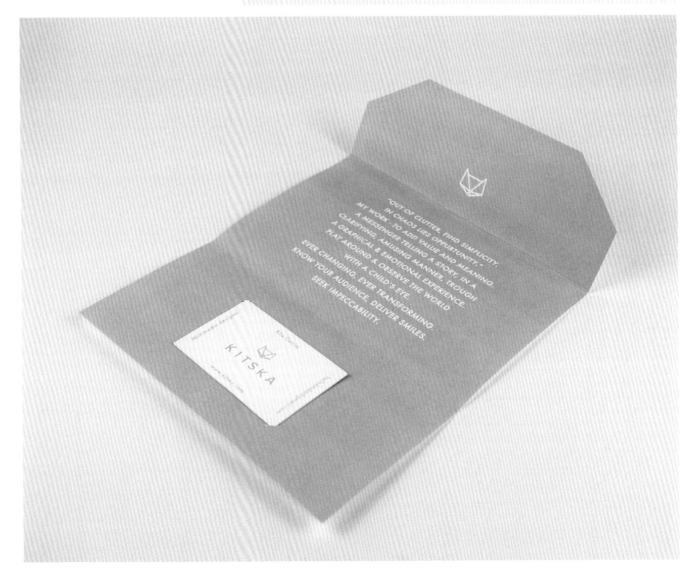

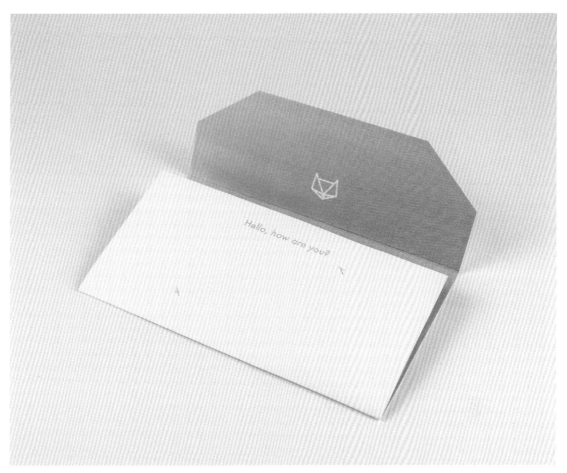

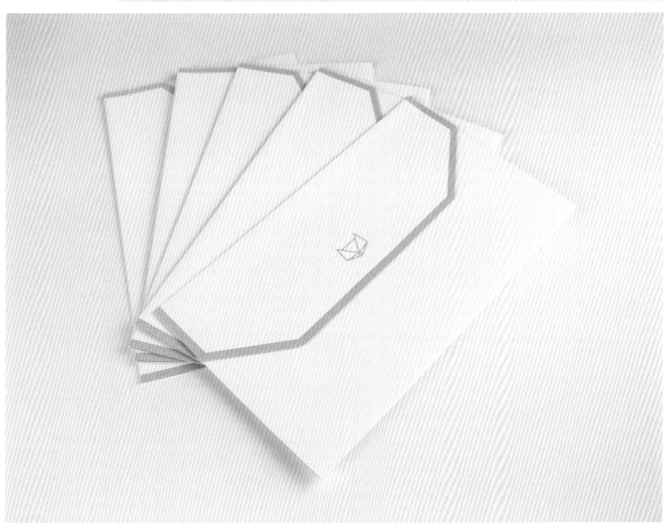

Bijoux

Design: Alejandro Román, Gabriela Salazar
Agency: Menta Picante

It's the redesign of small pieces of fine
jewelry company, with over 10 years of
experience in the market. They have a
style that marks the trend in the Mexican
jewelry scene because of their elegance
and vanguard, therefore their brand identity
would have to reflect those values and
virtues. From the icon to the rest of the
applications, the designers worked in the
concept of exclusivity and femininity and
it's represented by the color palette with is a
light pink and gold, also the icon it's simple
and delicate. This gives the feeling of being
a fine elegant woman who shops exclusive
brands such as Bijoux.

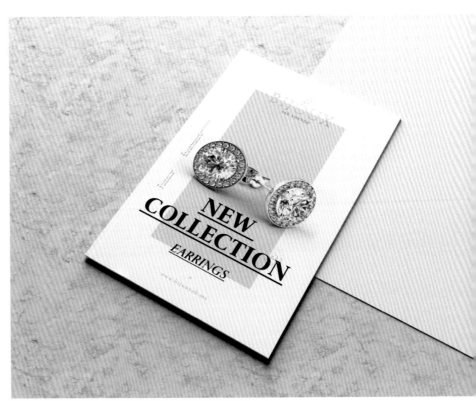

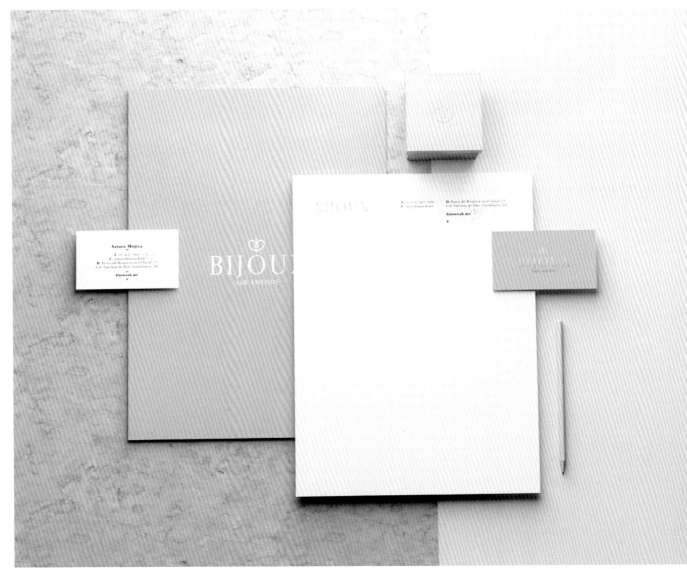

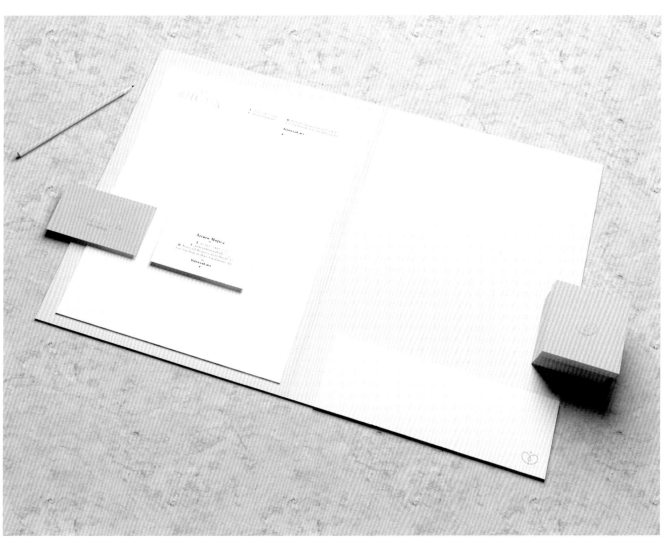

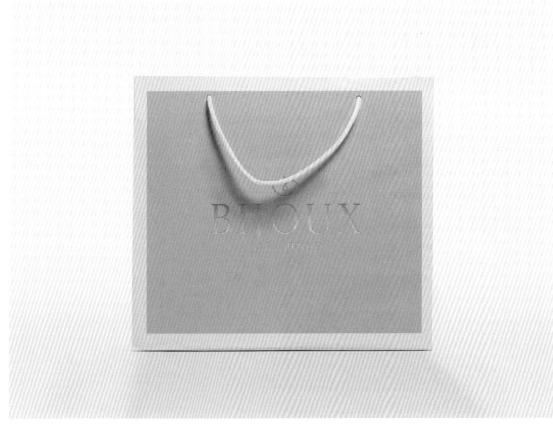

F32

Creative Director: Vanessa Eckstein,
Marta Cutler
Design: Vanessa Eckstein, Monica
Herrera, Kevin Boothe
Agency: Blok Design

F32 is a highly respected trend-watching
company with a reputation for finding
the next artists and brands that will shape
the world's culture. From the name to the
identity, the designers sought to express
the team's singular vision. The name is
drawn from the setting on a camera that
offers the greatest depth of field, while
the identity's subtle play of colors and
finishes pay tribute to their refined, highly
contemporary aesthetic.

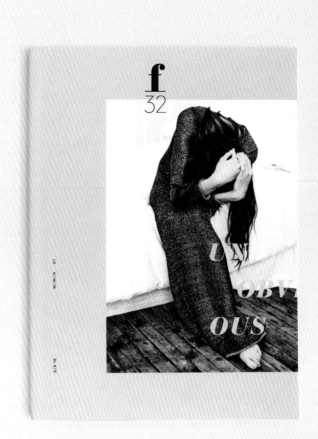

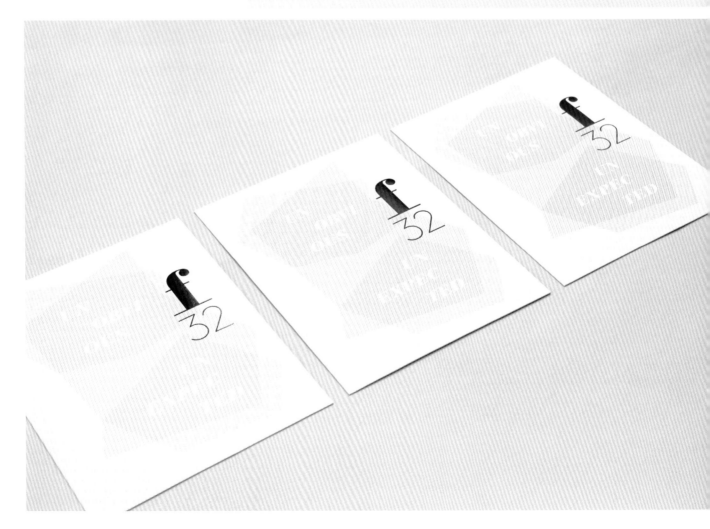

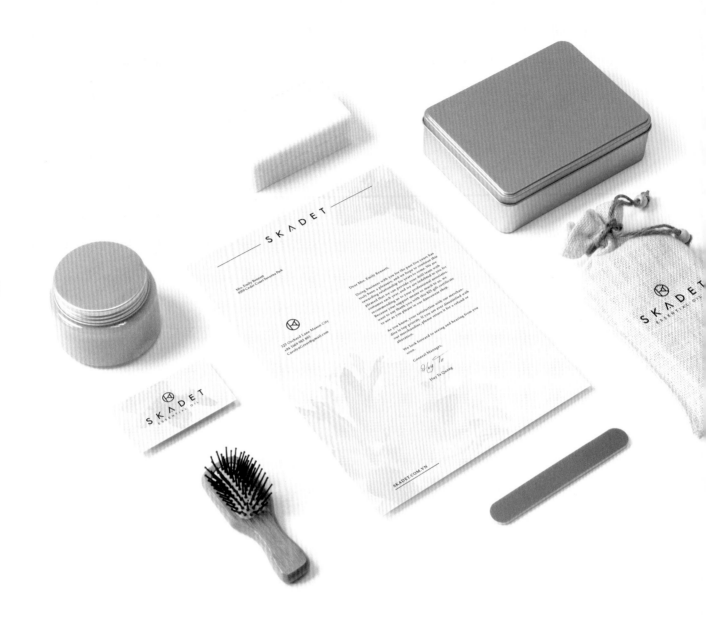

Skadet Essential Oil

Design: Eldur Ta

Skadet is an essential oil company that provide pure plant extracts for woman. The company works mainly on the therapeutic quality of pure oils and also provides treatment for hair and skin using the products. The plants are grown without the use of chemicals or pesticides then harvested and distilled at the optimal time to assure quality and therapeutic value.

The challenge is to create a monogram logo that resembles the company name: SKADET.

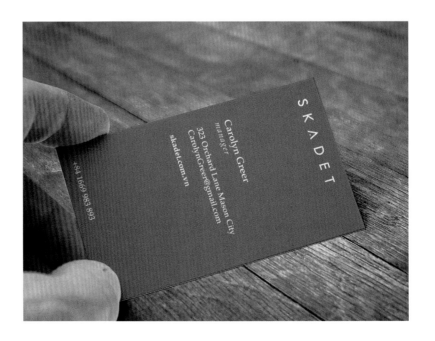

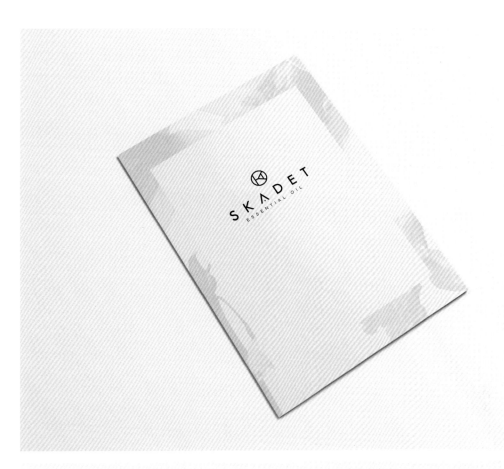

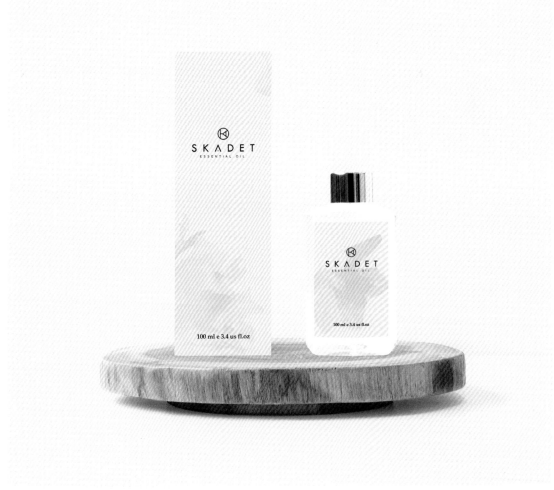

Victoria the Jewelry Box

Design: ZiYu Ooi

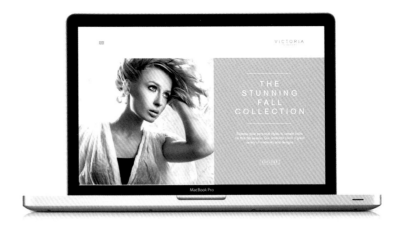

Victoria the Jewelry Box is an online store selling fashion jewelries and accessories. The logo mark draws its inspiration from the classic ballerina in a jewelry box. Sharp edge gem created a distinctive contrast to the soft edge ballerina that reflects a sense of quality and women's subtleness. The purity of white and feminine pink color palette across the collateral deliver elegance aesthetic to the brand.

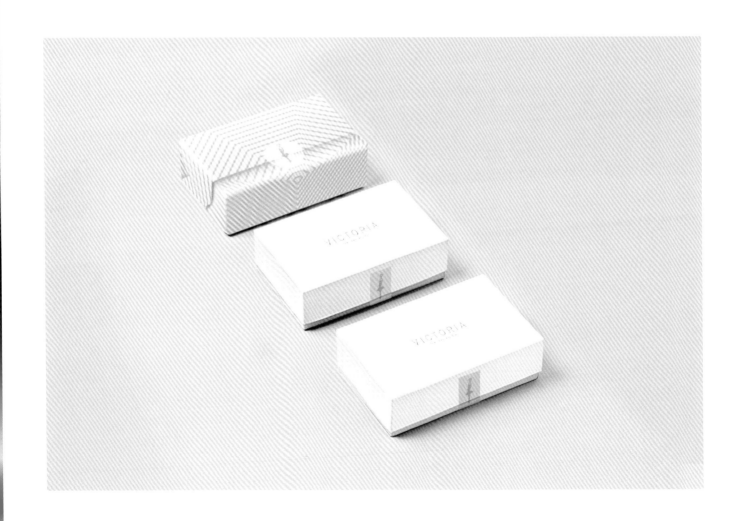

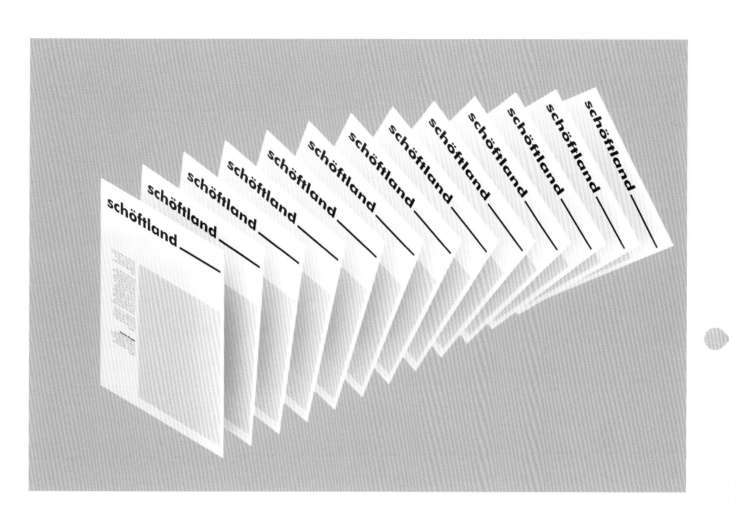

Schöftland

Art Direction: Sebastian Dias
Agency: molistudio

Schöftland, a small Swiss village in the German canton of Argau, synthesize the spirit of early 20th century graphic design. This limited edition born as a natural consequence of Swiss grids and German typography.

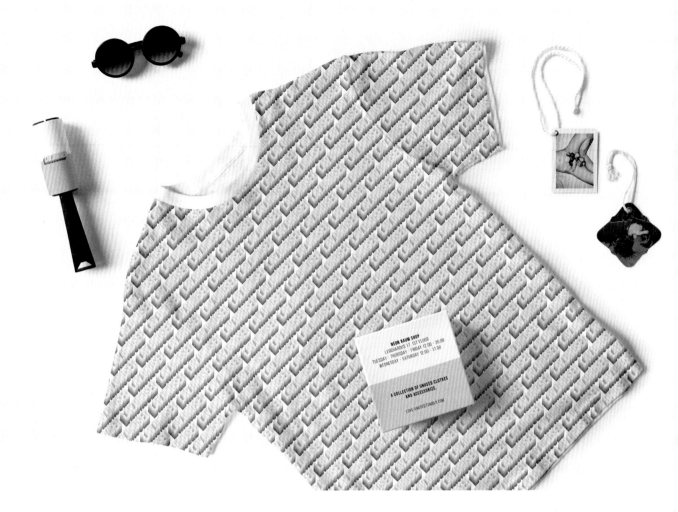

Lav Unused

Design: Anna Trympali

This is a self initiated brand identity redesign for Lav Unused. Lav Unused is a fashion project that brings to life vintage pieces of clothing, not in a retro romantic sense but rather as an ironic mix-and-match contemporary style statement. The designer found the idea behind this project really inspiring, so she attempted a brand redesign based on her interpretation of Lav Unused.

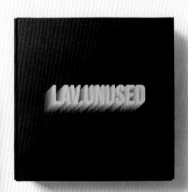

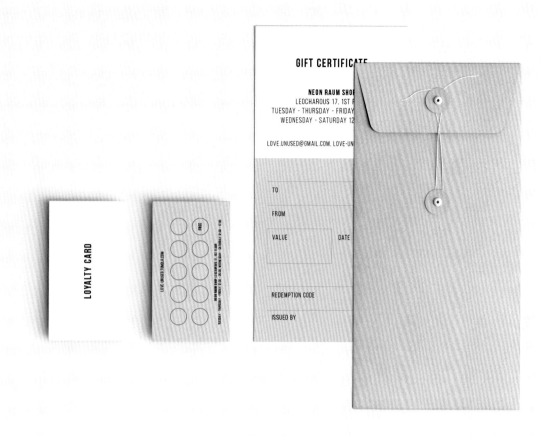

GIFT CERTIFICATE

NEON RAUM SHOP
LEOCHAROUS 17, 1ST F
TUESDAY - THURSDAY - FRIDAY
WEDNESDAY - SATURDAY 12

LOVE.UNUSED@GMAIL.COM, LOVE-UN

TO

FROM

VALUE DATE

REDEMPTION CODE

ISSUED BY

LOYALTY CARD

FREE

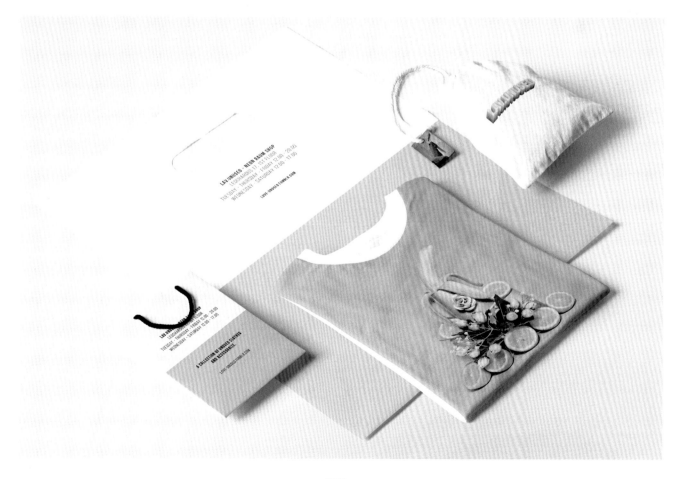

Lé Pastel

Agency: Buenas Design Studio
Design: Claudia Argueta
Photography: Diego Castillo, Claudia Argueta

Lé Pastel is a high-end pastry shop with a variety of delicious desserts. The shop's new identity was designed with one objective, to express quality within the whole brand and each of its touch points. The idea was to take disparate elements and unify the minto whole systems that represent a fresh and playful attitude towards customers. The color plays a big role in this project, since it was meant to create emotion and trigger a sensation of warmth to each and every customer. The combination of neutral colors and pastel colors makes the perfect balance for a clean and sober design. The outcome is a sweet but modern execution for a fresh and fun brand that looks as sweet as it tastes! Bringing happiness in every glance and every bite.

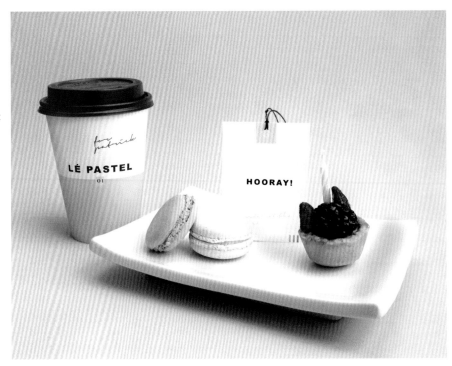

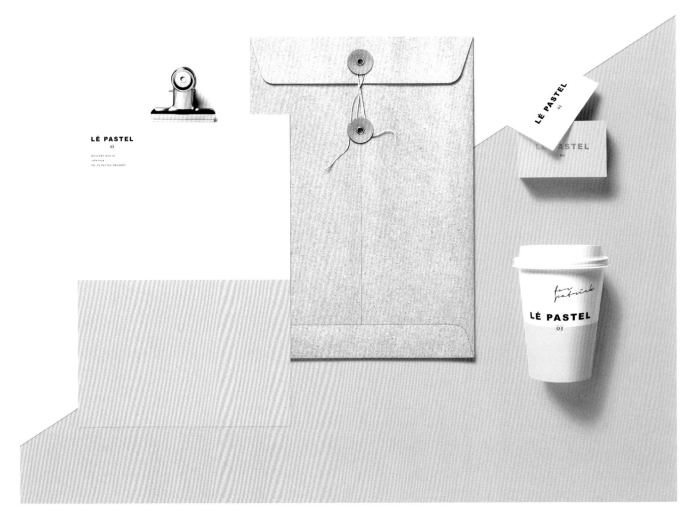

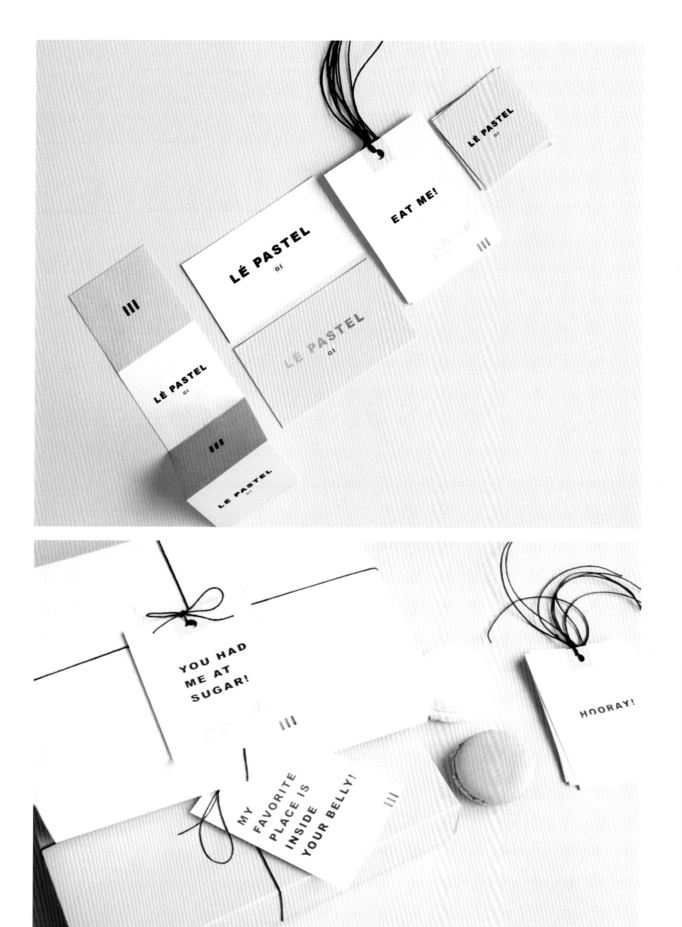

Aria "Beauty Studio"

Design: Natalia Cejudo, Cristina Góngora
Agency: PURO DISEÑO

Aria is a beauty salon located in Merida, Mexico, which offers hair and nail services. Their main goal is to provide a memorable and unique experience for clients. The brand is inspired in the different types of hair and its movement. The straight and wavy lines represent harmony of the brand and the services that the salon offers. The main color is pink because the target audience is women and it represents beauty, tenderness, and femininity. It is mixed with black to make a more modern look for the brand.

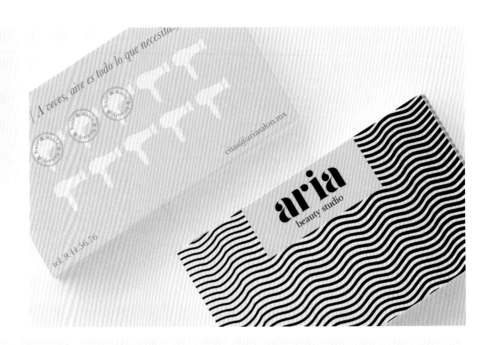

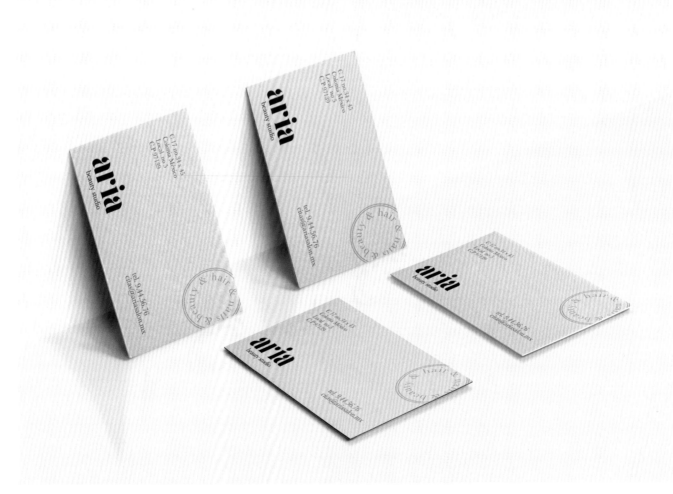

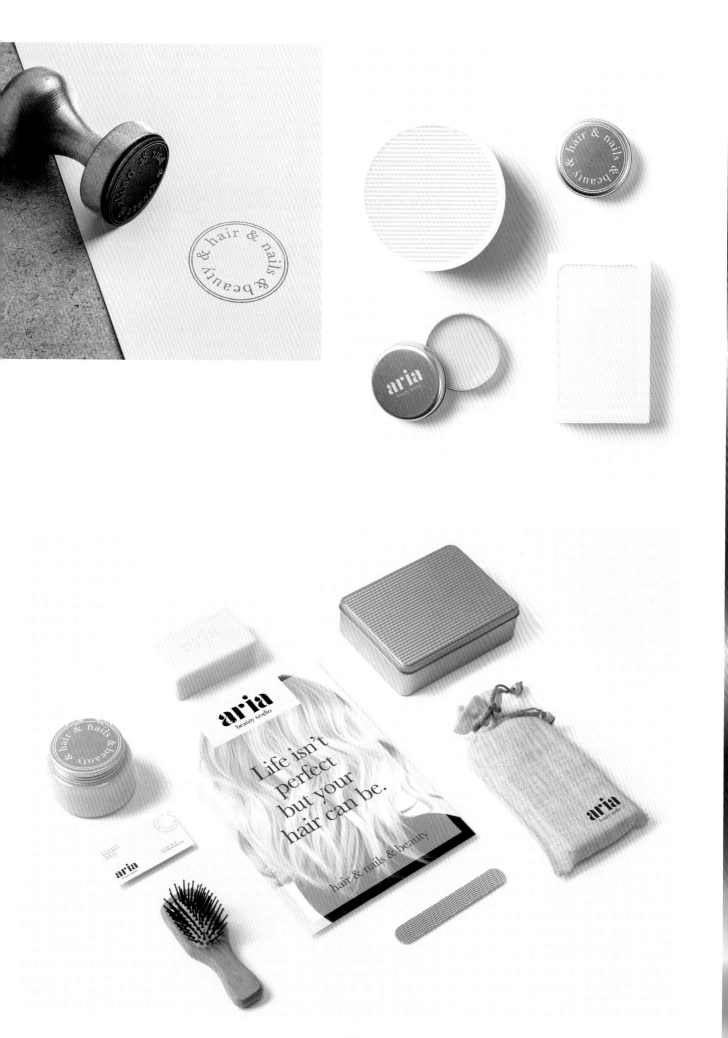

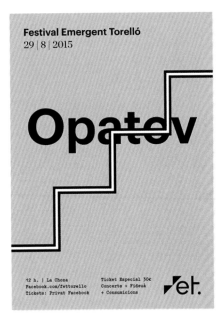
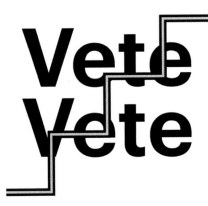
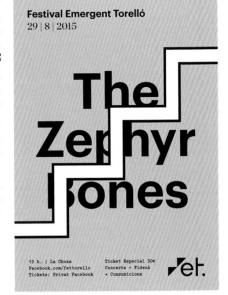

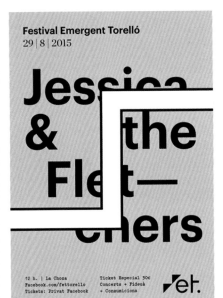

Fet Estiu

Agency: Requena design office
Art Direction: Andrés Requena
Design: Virginia Pol, Andrés Requena
Photography: Koldo Castillo

Identity and graphic code for Fet
(Festival Emergent de Torelló). The
image was made by using a very simple
metaphor for emerge, a staircase.

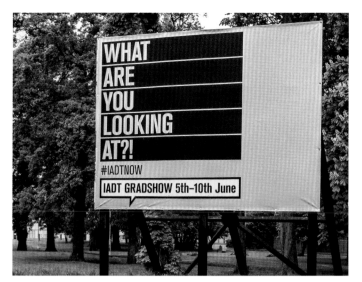

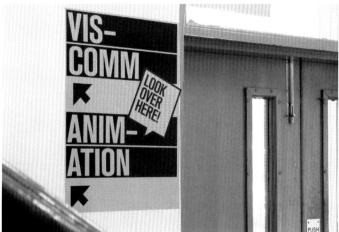

IADT Gradshow

Design: Eric Lynch, Axel McHugh

This was a collaborative project, designed over a two-week period by Axel McHugh and Eric Lynch, it was overseen by tutors from the Visual Communication Design programme, at IADT. The brief required the design of a flexible identity for the Graduate Exhibition.

A key consideration required the signage system to be cost-effective and easy to implement across the college campus. We achieved this by designing "slap-up" style, vinyl signage – smaller call-to-action speech bubbles reinforced the message.

The identity was well received – footfall for the graduate exhibition increased on the previous year, growing from 750 to 1,400 visitors on opening night.

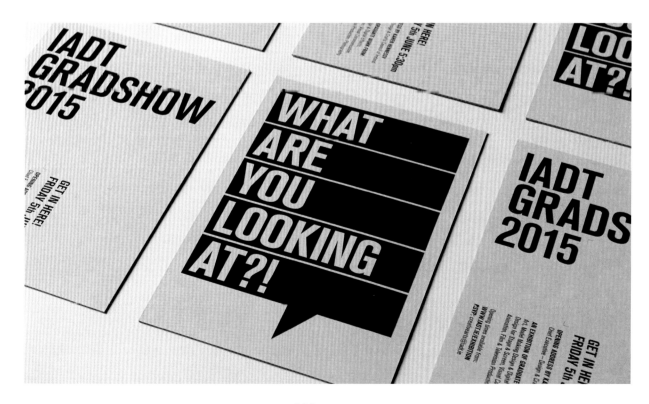

Aranymarha Bár

Design: Edina Fazekas

The project has been created as an adaptation of Victorian aesthetics. The Hungarian word aranymarha means golden cow in English. The main feature of the visual appearance refers to the original function of the building, where the bar is located. Earlier it was a slaughterhouse which is why it includes associations, so the designer decided to apply it in the branding. The final design combines elegant style with grotesque spirit to create a memorable appearance.

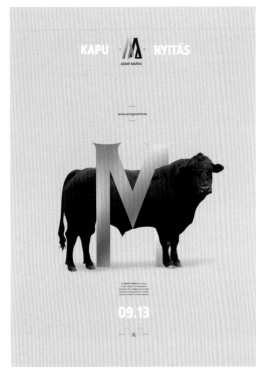

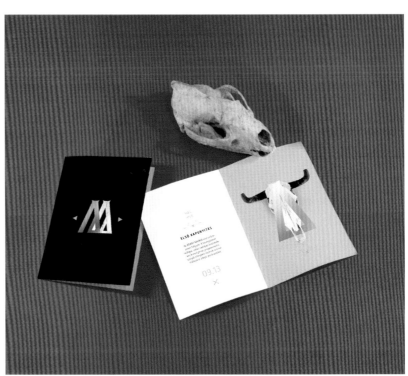

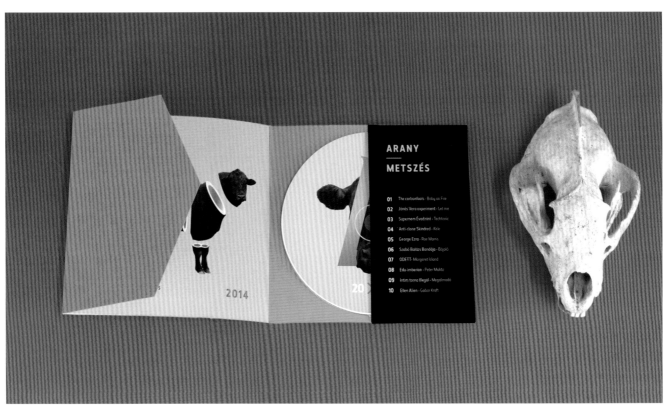

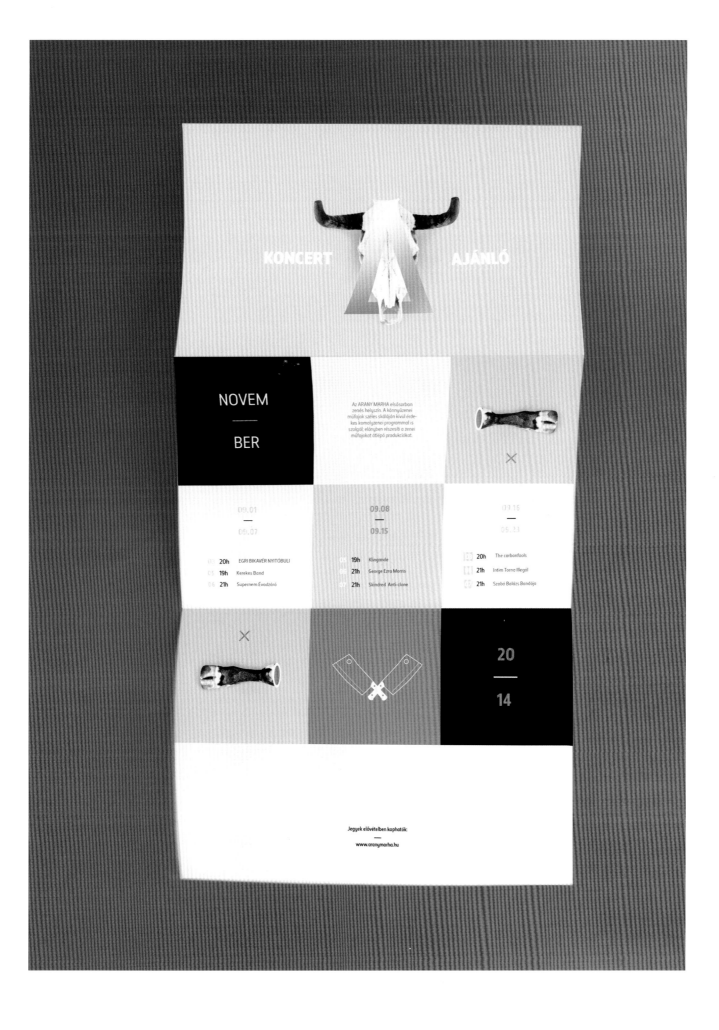

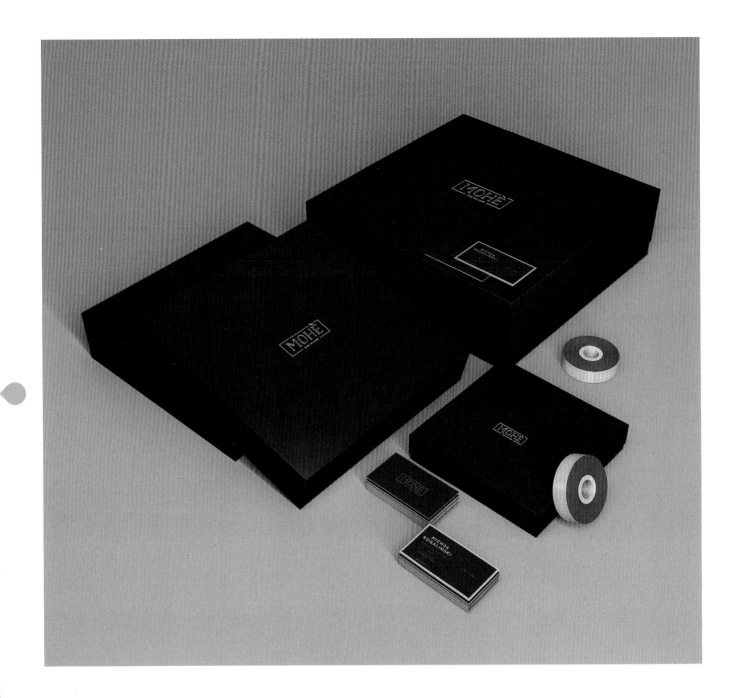

Mohé – Etre Une Dame

Design: Gosia Zalot, Wojciech Zalot

Mohé is a fashion brand dedicated to women that are not afraid to break rules in daily outfit. Inspired by past decades – from the 20's to 90's – Mohé represents sophisticated combination of vintage and modern style. The brand embodies chic and elegance in everyday street wear fashion making the final product unique and original.

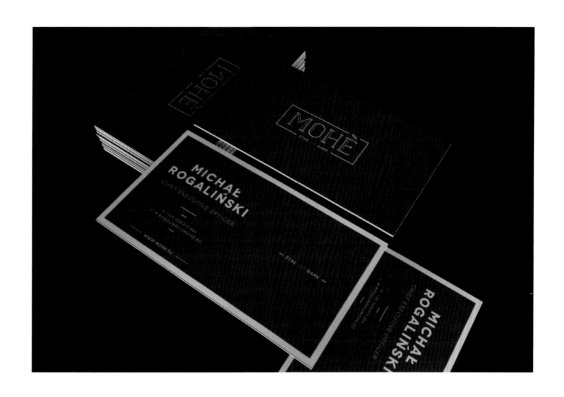

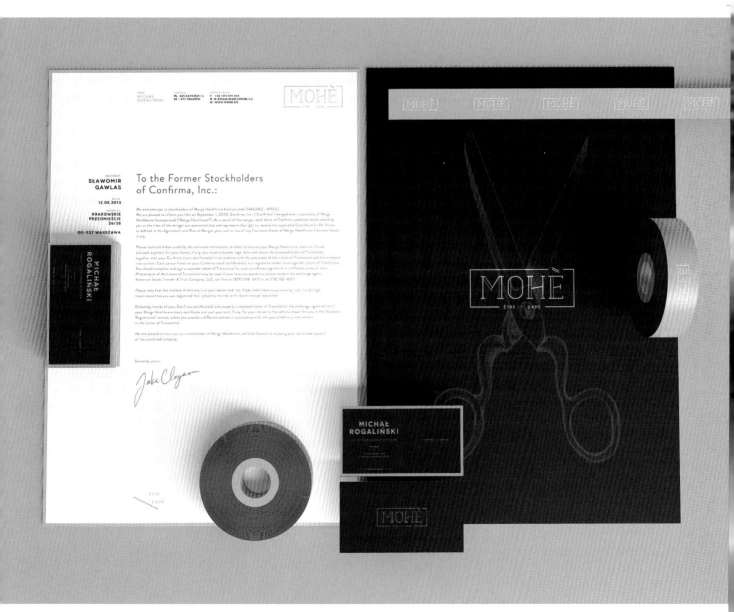

Leigh Folk Festival

Design: Charlie O'Halloran

Leigh-On-Sea is a typical British seaside fishing town. But for four days each summer, thousands flock upon the beaches and cobbled streets to experience the Leigh Folk Festival. This project was an academic brief in which the task was to create both promotional and packaging branding concepts for the festival. The use of black and white photographs signifying the typical dreariness of British weather brought to life when the festival comes to town, pouring life and color into the world. The use of a bold and vibrant spectrum of color represents the celebration and eccentricity that the festival brings. "Leigh Folk Festival bringing color to Leigh-on-Sea!"

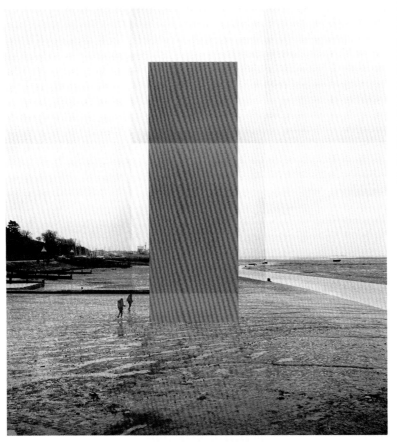

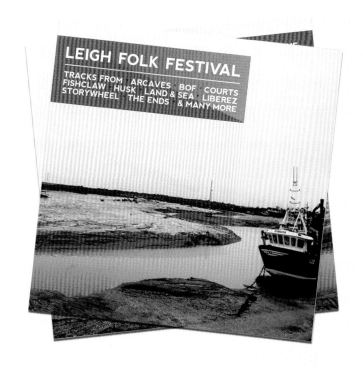

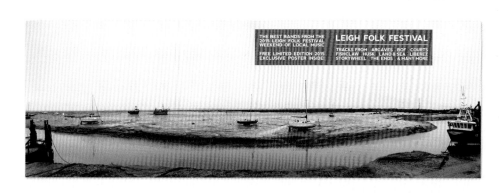

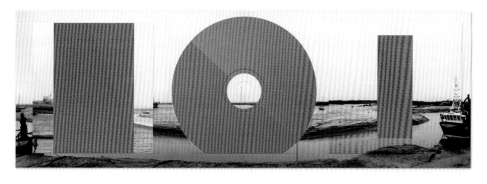

Artefactory

Design: Futura

Artefactory is a concept store that offers a selection of design products from different brands that have in common the fact that they all solve usual problems in a very inventive way. At the same time, it has a little restaurant inspired on a soda fountain. The general concept is based on being an industrial factory and toy shop, with a little bit of fiction.

The graphic solution was inspired on that fantasy. The emblem was based on a character that seems to be taken from the imagination of a little boy but it's real, Laika, the Russian dog that was the first animal to orbit the Earth. The designers also created a special typography for the project with a very experimental technique, seeking to reflect the artistic aspect of this place.

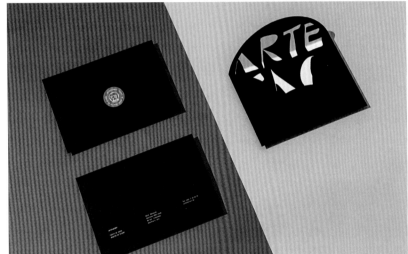

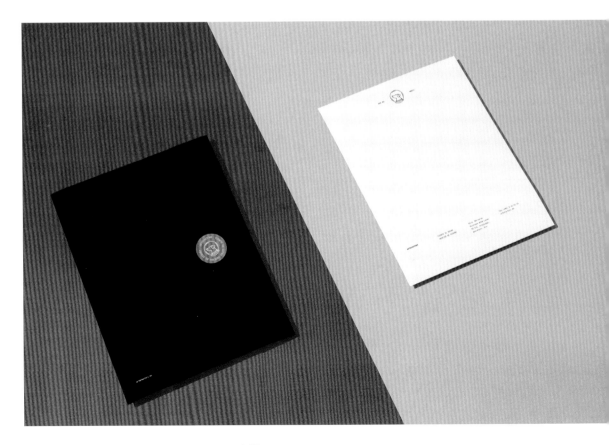

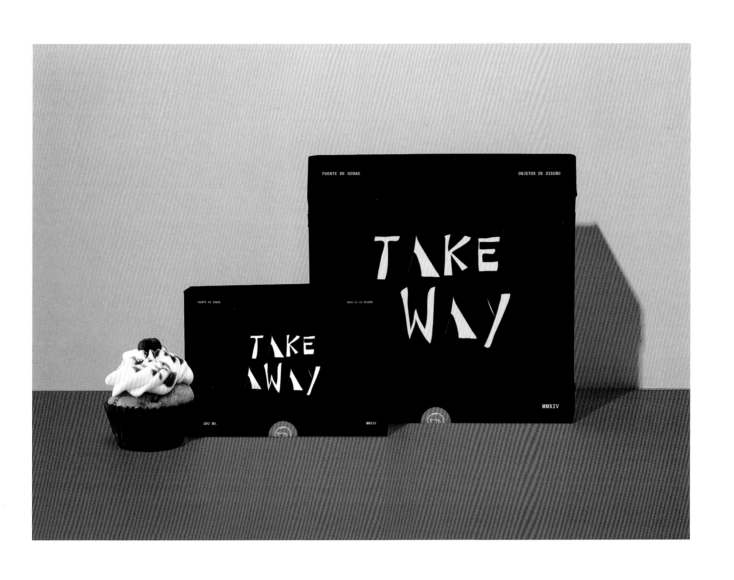

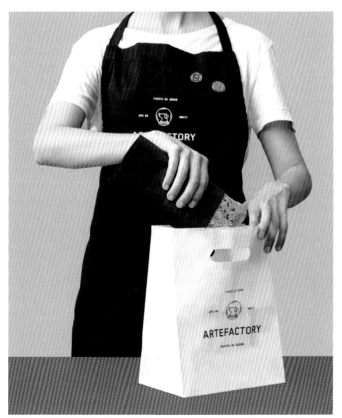

Territorio Creativo

Agency: La Metropolitana
Design: Luis Quiroz
Photography: Issamel Moreno

Territorio Creativo is a project developed by Design Week México, in which the main purpose is to support and boost contempotary Mexican design. The graphic material developed for Territorio Creativo in Wanted Design NYC was inspired by the physical and social context of each of the design studios that participated in the fair. These locations were transformed into abstract shapes to create a harmonic composition.

MTC brought together for Wanted Design the perfect blend of well established and up-and-coming talent from designers, architects, artists and artisan craftmen, gathering their ideas on design that is profoundly shaped by its role on the present day.

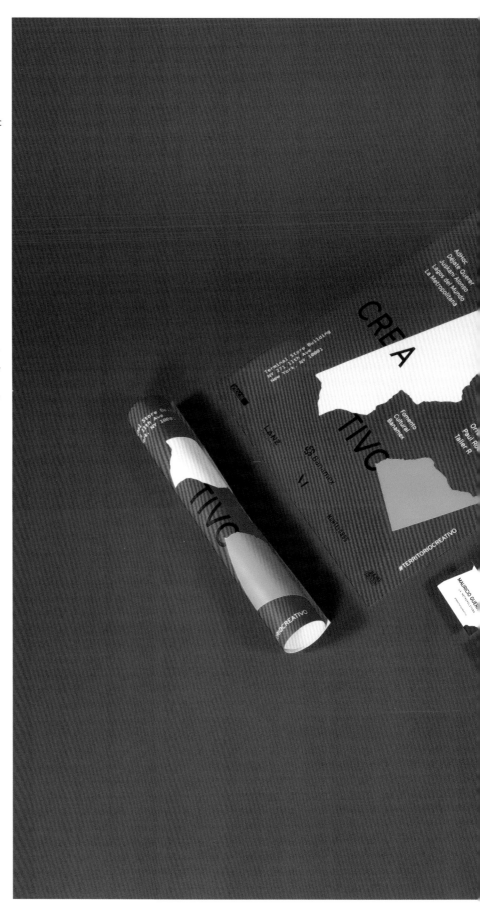

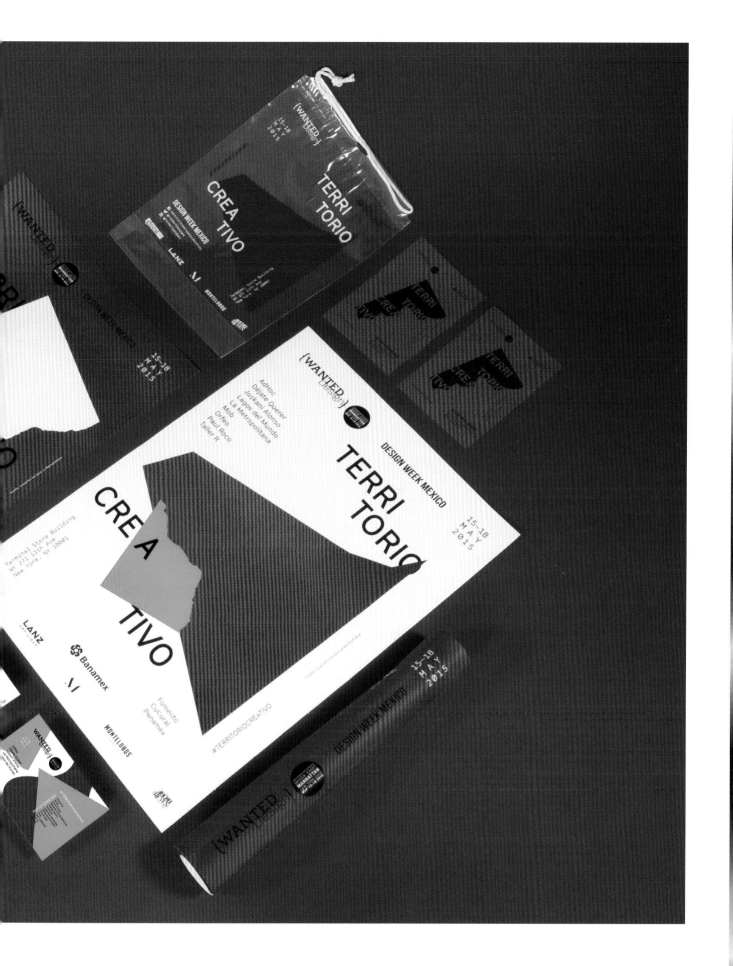

Shorts Film Festival

Design: Robert Gutmann, Tim Kaun

For the international film festival "Shorts" in Offenburg, the designers developed the visual appearance, as well as the campaign. The Festival presents short films, animations, experimental films and documentaries. The aim of this year's campaign: the city of Offenburg and its inhabitants should be more integrated. As the campaign's theme was intended to build a bridge distinctive faces of the city were casted. The designers handled the whole project from the concept stage, the screen idea, photography and silk printing to full graphic implementation.

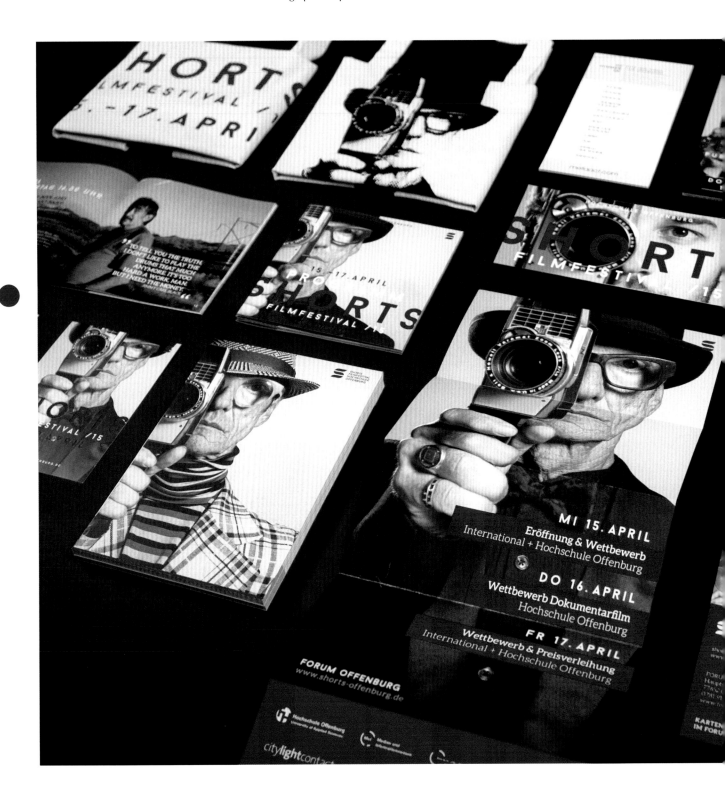

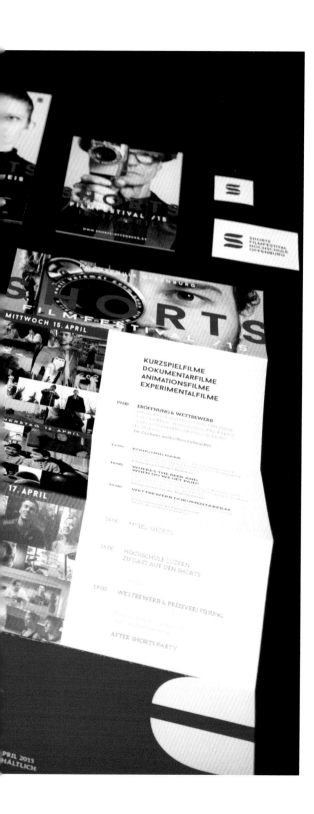

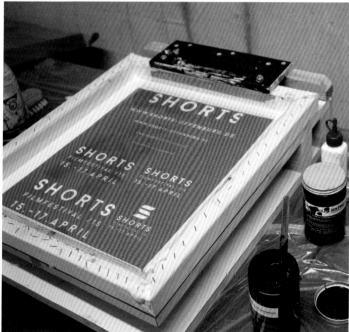

Sundsvall Business Awards

Agency: Accidens
Design: Mattias Sahlén

Sundsvall Business Awards is an annual gala and awards ceremony honoring business achievements in the Sundsvall region. Through simplifications and stylizations of landscapes and landmarks associated with the city, the new symbol presents the letters S, B and A and is also composed by this initialism – in a jewel inspired shape to add some glamour. The nifty symbol lays the foundation of a fresh, clean and bold visual identity that balances between playful and formal.

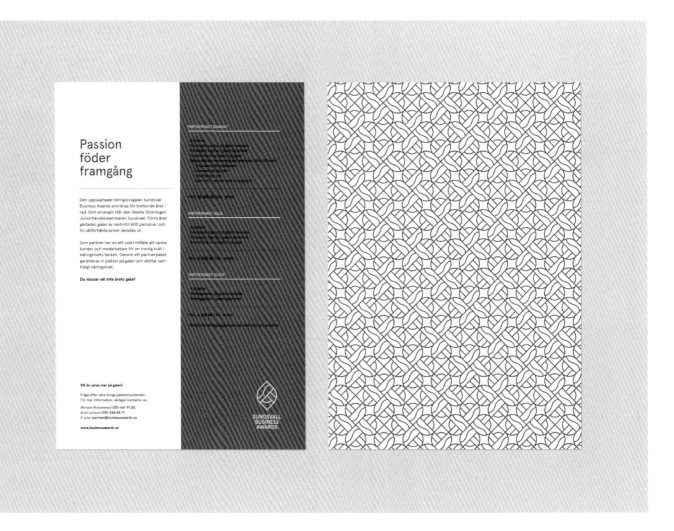

Meny

Förrätt

Laxroulad med gräslöks-
färskost, syltad gurka, forell-
rom och kavringskrutonger

Varmrätt

Mörad oxfilé med oxkindragu
serveras med potatis- och selleri-
mos samt madeirasås

Dessert

Chokladgâteau
med ganache och
färska hallon

KVÄLLENS VIN

FÖRRÄTT
SINCLAIR ESTATE – CHARDONNAY SAUVIGNON BLANC (VITT)

VARMRÄTT
SINCLAIR ESTATE – SHIRAZ CABERNET (RÖTT)

Kvällens underhållning

Loreen slog igenom med sin vinst i Eurovision Song
Contest 2012 och vinnarlåten "Euphoria" blev en
världshit som nådde förstaplatsen på topplistorna i
hela 21 länder. Med mer än 1,2 miljoner sålda exemplar
världen över och 100 miljoner streams har "Euphoria"
blivit en global klubbhit. Samma år som segern i Euro-
vision vann Loreen pris i MTV Europe Music Award för
Best Swedish Act, två Rockbjörnar för Årets Kvinnliga
Artist och Årets Låt.

Loreens kritikerhyllade debutalbum "Heal", som inne-
höll singlarna "My Heart Is Refusing Me" och "Crying
Out Your Name", toppade listorna i flera europeiska
länder.

Vi är oerhört glada att kunna presentera Loreen som
en del av kvällens festligheter.

18

LOREEN

COSRX Apple Zone Power Patch

Art Director: Kisung Jang
Designer: Kisung Jang, Yenny Kim
Agency: TRIANGLE-STUDIO

COSRX Apple Zone Power Patch is hydrogel type patch for under eyes and cheeks. The goal was to describe a function of the patch and catch the customer's eye on the store. The designers expressed it by simply graphics on the front. The background was applied their own graphic patterns by silver color. The best point of this packaging is fluorescent pink color. It effectively helped attract the customer's eye.

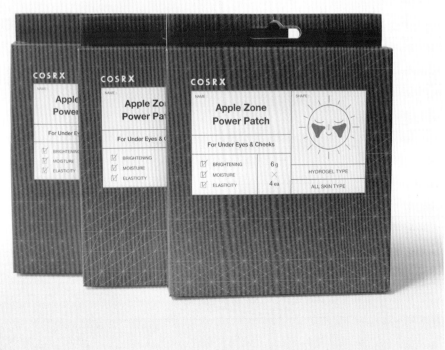

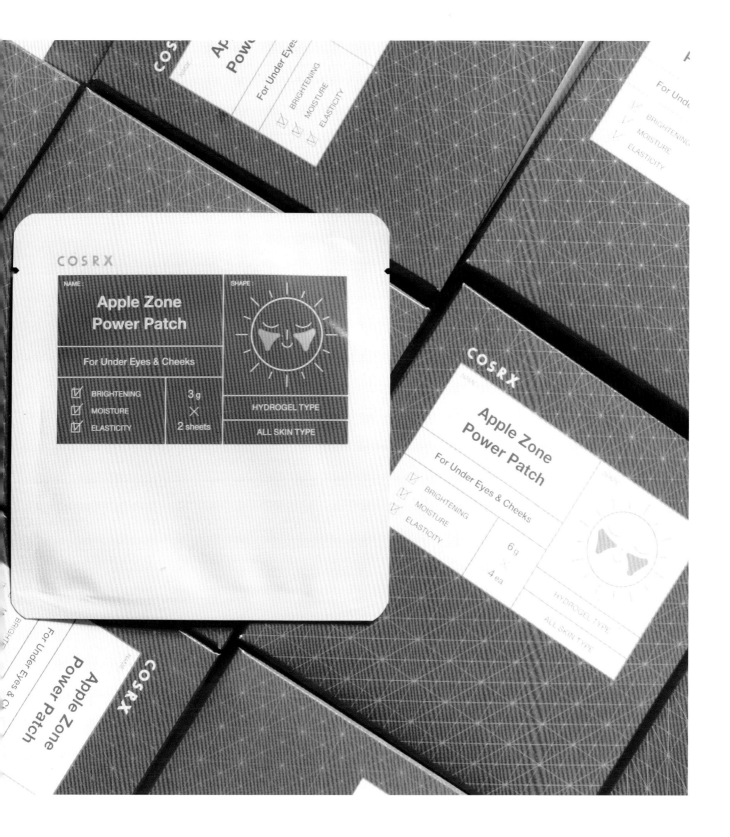

COSRX

NAME :		SHAPE :
Apple Zone Power Patch		
For Under Eyes & Cheeks		
☑ BRIGHTENING	3 g	
☑ MOISTURE	✕	HYDROGEL TYPE
☑ ELASTICITY	2 sheets	ALL SKIN TYPE

Nippon Connection
Festival Design

Design: Il-Ho Jung

For the 15th anniversary of the Nippon Connection Film Festival, a collection of 15 sheets with traditional Japanese pattern were created. In the center of the composition there is a circle, which is derived from the Japanese flag and the Nippon Connection Logo. The sheets are folded around the circle and shaping an eye in a origami-esque appeal.

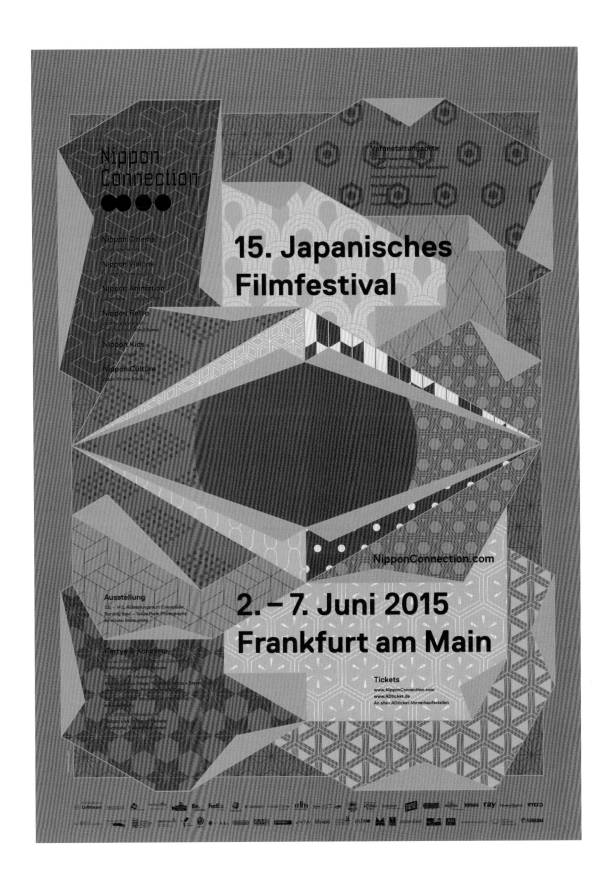

Scheu' S Essen & Trinken

Design: Janick Neundorf, Michael Adolph,
Nadine März, Thomas Martin
Creative Direction: Christian Vögtlin
Agency: ADDA Studio
Photography: Frederik Laux

When creating a communication-concept for the bar "ray lemon" in Heilbronn, the designers generated two constants: the color yellow (in combination with the grey of the visible concrete) and the fictional character "Ray." From now on he appears in every dialogue and even established his own friends, which are easily recognizable by wearing their lasered marks. The invitation to the event "Menu in Gelb" is furnished with spices used in the current menus, the origami folding-technique generates a valuable and individual character.

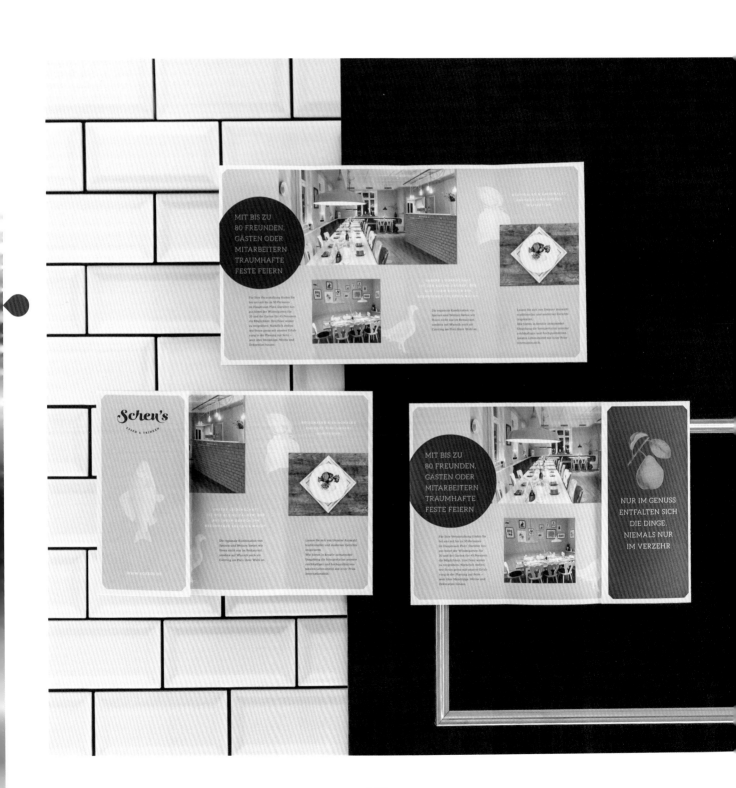

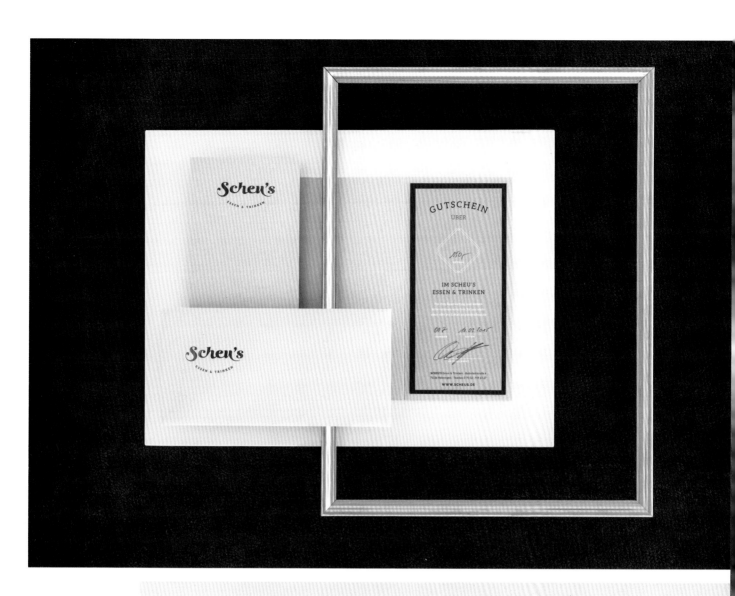

Stephanie Trenz
Fotografie

Creative Direction: Christian Vögtlin
Agency: ADDA Studio

Corporate Design for Stephanie Trenz
Fotografie.

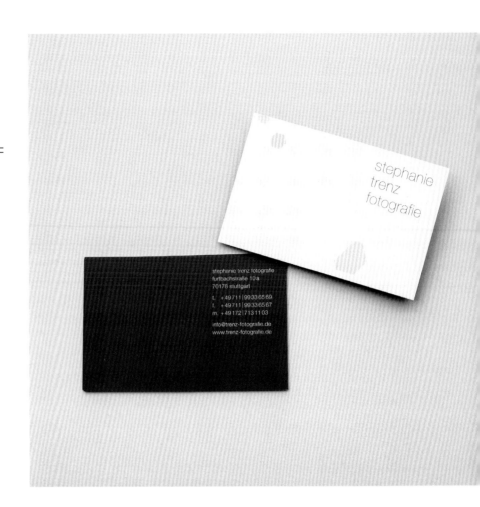

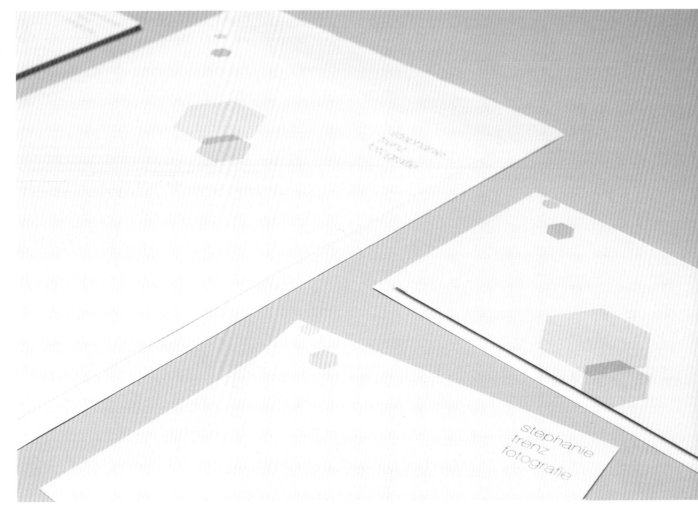

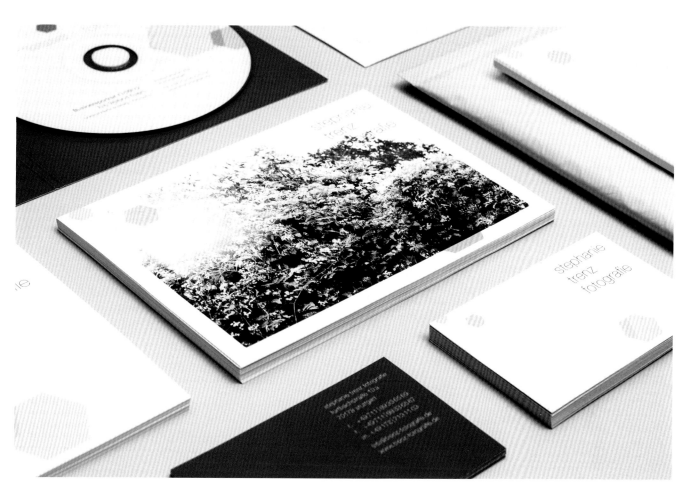

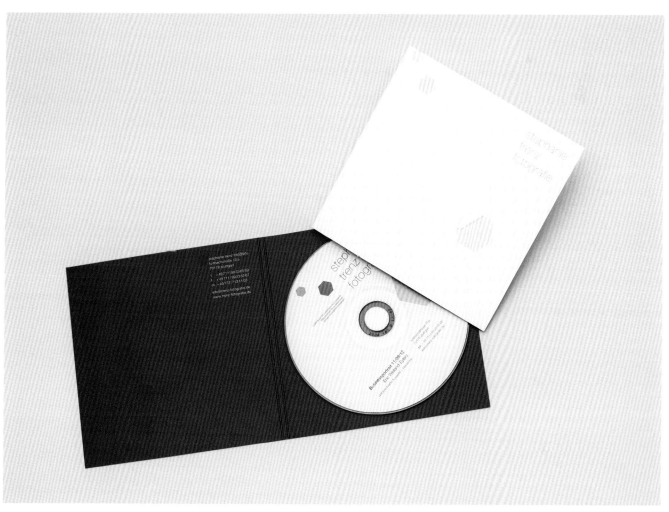

Van de Rutter Tattoos

Design: Benjamin Hösel, Agentur Lux
Letterpress/Hot Foil Studio: Infinitive Factory

The color purple combined with black makes up for a perfect match for a tattoo parlor.

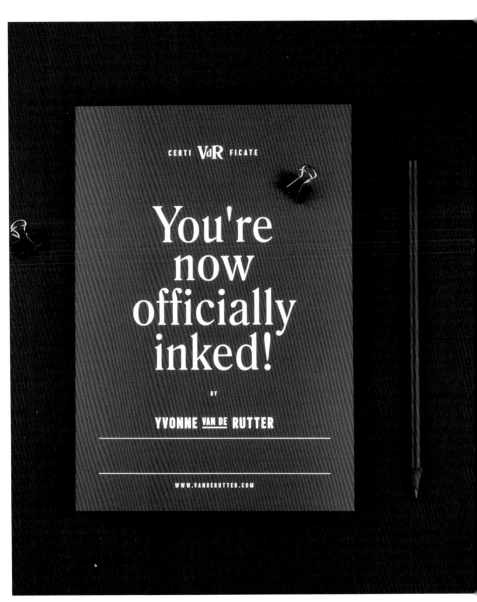

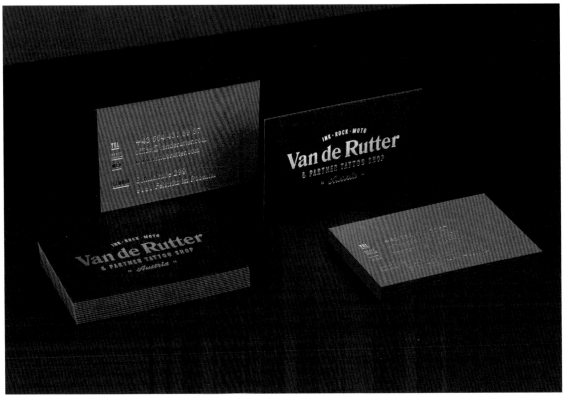

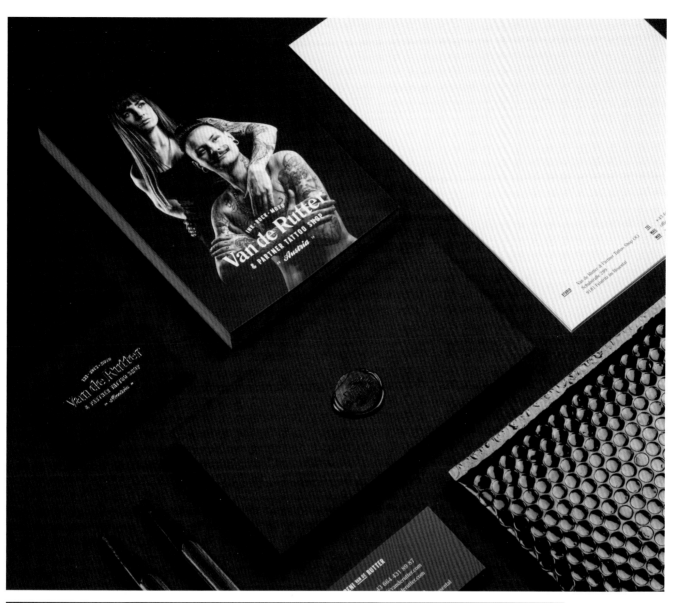

Farmácia Marvone

Design: Joana Gala

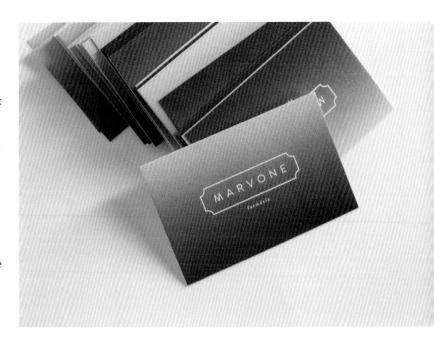

An old village pharmacy wants to get updated. This new identity is a gift to the older traditional costumers and, on the other hand, is a call for new informed millennial's families that also live and work on this little village on the Portuguese coast. They want a service that is attentious and competitive at the same time that it is the one they can rely on. This identity refresh was very welcomed.

Purple, a client request, is the obvious color as it is the color for the pharmacy studies in Portugal. The shape comes from the old pharmacy labels that were used to identify the typical bottles, jars and cans that still decorate the walls of Farmácia Marvone these days.

A strong deep elegant color with a clean vector logotype creates this memorable yet fresh identity.

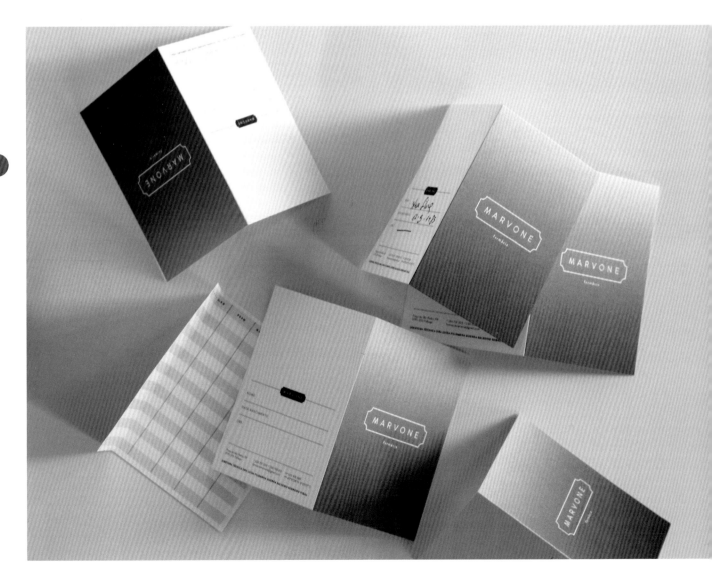

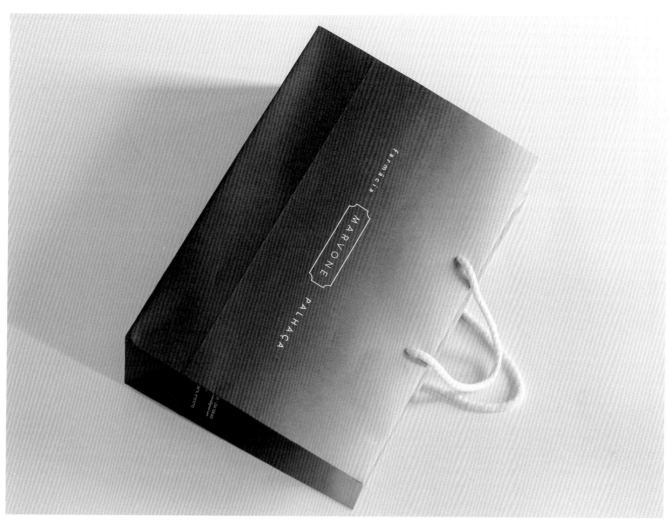

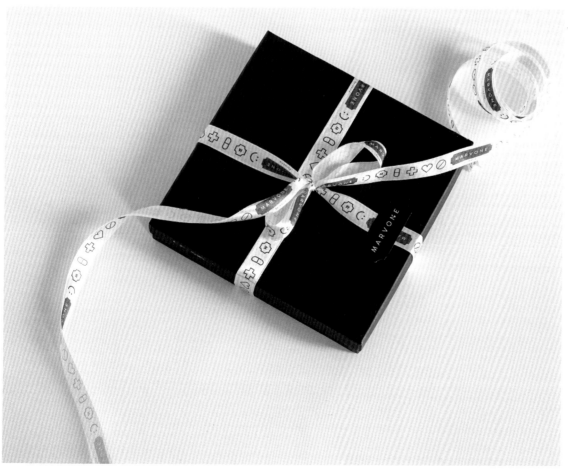

INGRID Jewelry

Design: Yuliia Galchenko

INGRID is a new brand that produces jewelry, designed for young families. The basic idea behind the brand is to create a non-standard approach to the traditional accessories.

The combination of pretty colors and rough faceted stone shape textures symbolize sculpting their marriage and the creation of a strong union. Graphics emphasizes the tenderness and reliability, which carry the product brand.

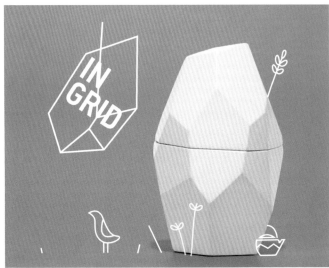

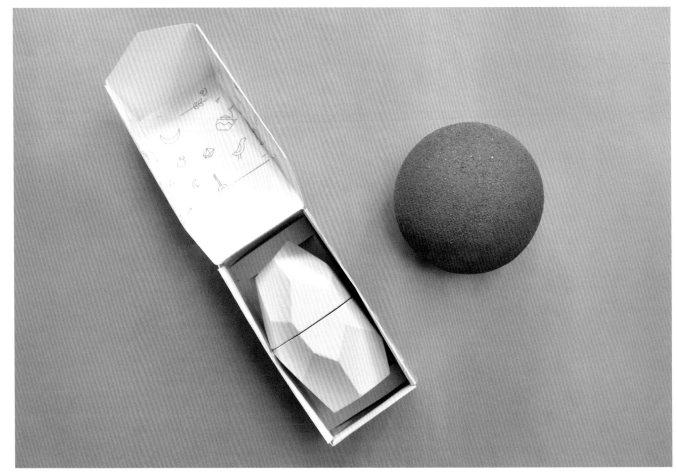

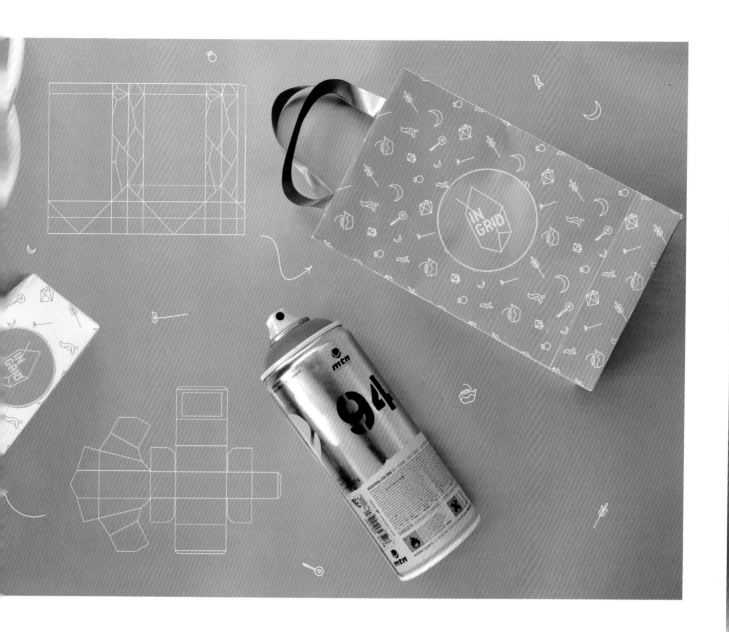

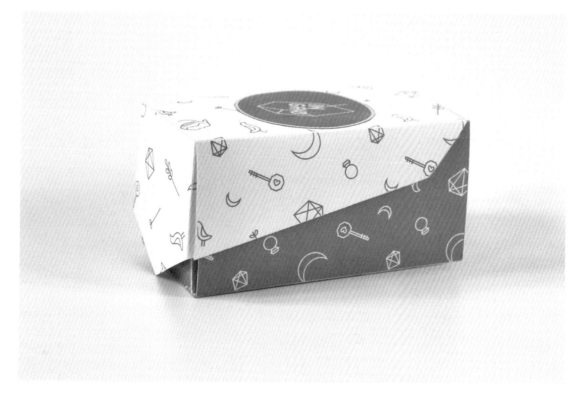

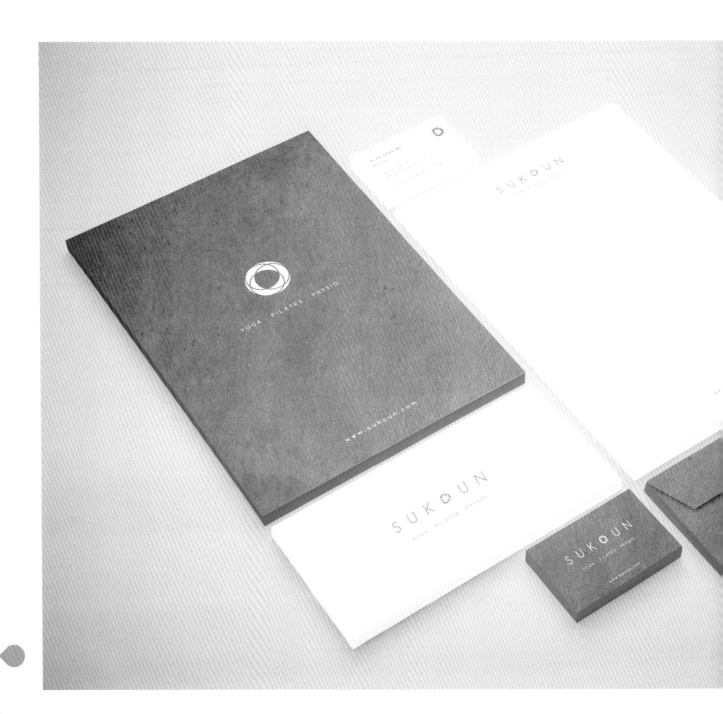

Sukoun Wellness Center

Design: Haya Al Jamal

Brand development for Sukoun Wellness Center,
a yoga, Pilates, and physical therapy center in
Riyadh, Saudi Arabia. The client wanted a design
that represents the services of this wellness center,
combined with the word "sukoun" which means
peace in Arabic.

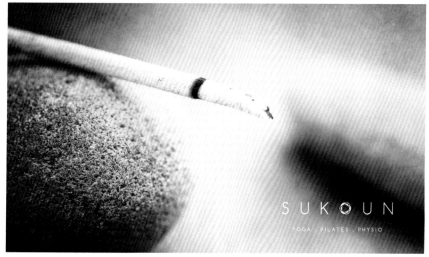

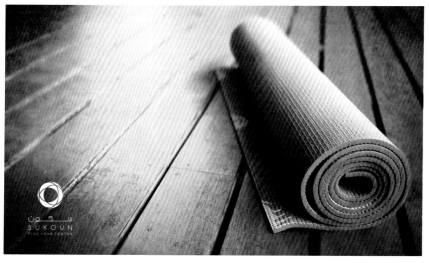

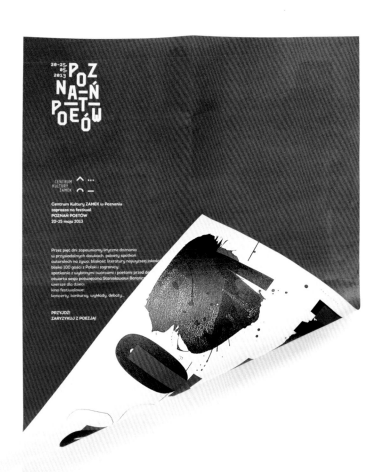

Poets' Poznan

Design: Marcin Markowski

Poets' Poznan is an international poetry festival which is held every two years in Poznan. Visual identification of the last edition was based on a letter that as the main medium of poetry and literature lent itself well to the creation of visual identification of the festival. All promotional activities were related to letters and typography.

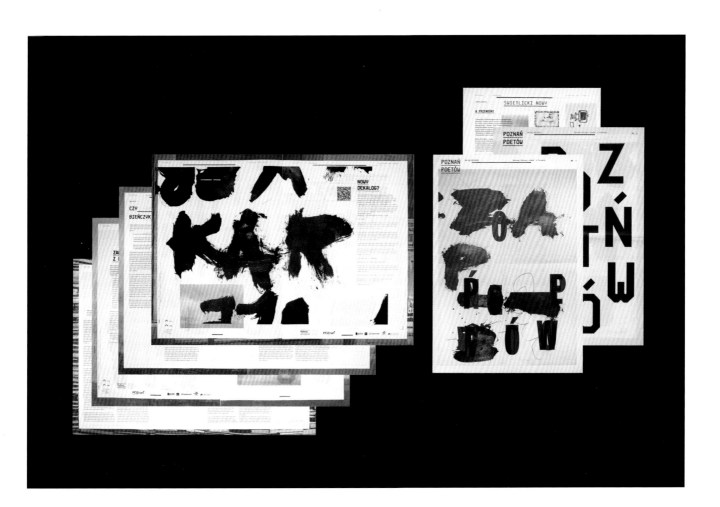

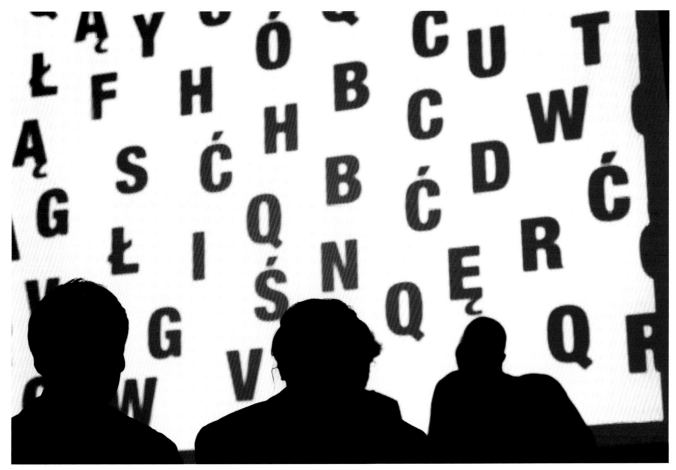

Coffee House London

Agency: Reynolds and Reyner
Design: Alexander Andreyev, Artyom Kulik

Launching a new coffee brand in today's very competitive market is hugely challenging. You have to offer something truly unique, of the highest quality, along with great atmosphere. You really have to stand out in a crowd.

London is a city deeply rooted in its traditions, history and architecture. Loyalties are formed in childhood and honored for a lifetime. So the task is not just to show the outstanding benefits of the product but to weave these assets into the larger culture and themes of London culture, combining the heritage of coffee drinks with the distinctive, one-of-a-kind pleasures of London House coffees.

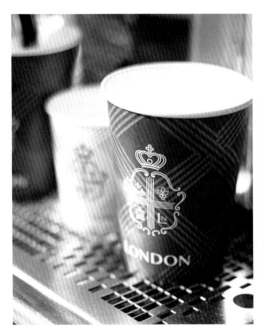

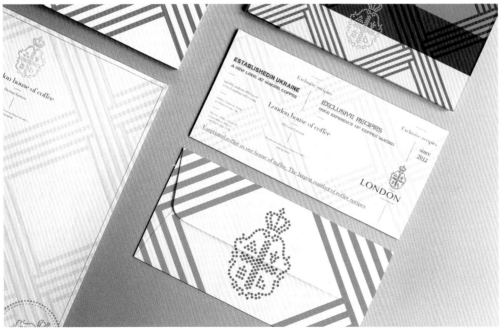

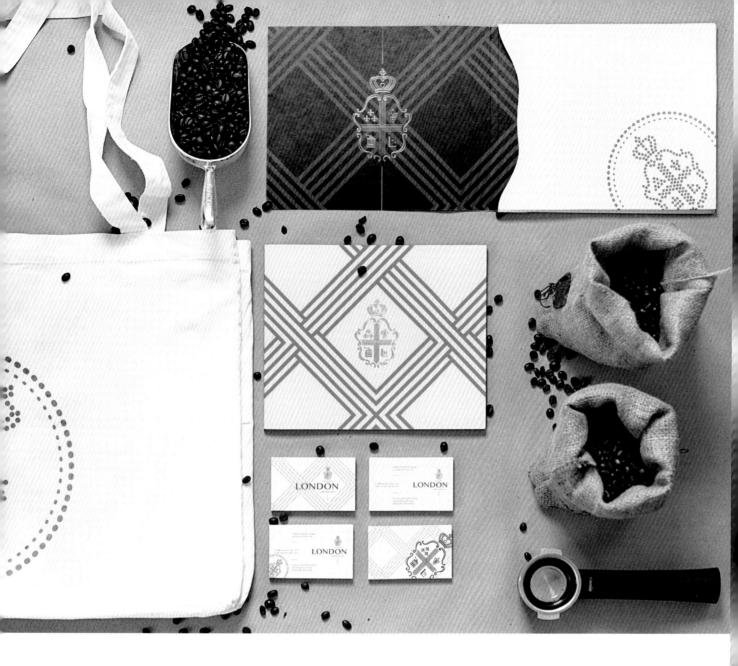

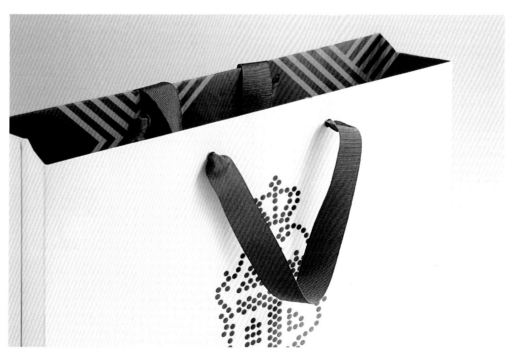

Nymbl

Agency: Big Fan®
Creative Direction: David Robinson

The designers set about designing an identity system that would feed Nymbl's appetite for play. A platform upon which they could test, demonstrate and show off their skills. Two dots, one representing work, the other play formed the foundations of the brand. Integrated within the bold logotype and supported by a brave two-colour palette, the resulting collateral and website have served up fresh inspiration for the internal team and is proving to be an effective selling tool.

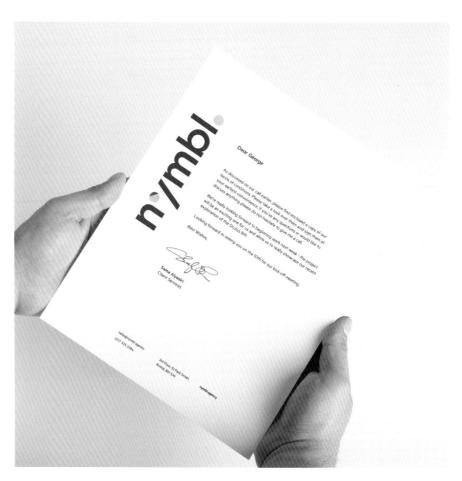

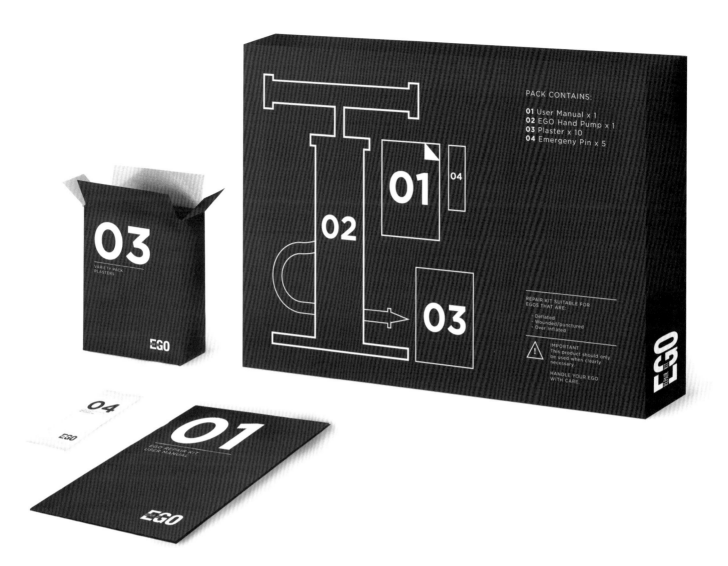

PACK CONTAINS:

01 User Manual x 1
02 EGO Hand Pump x 1
03 Plaster x 10
04 Emergeny Pin x 5

REPAIR KIT SUITABLE FOR
EGOS THAT ARE:

- Deflated
- Wounded/punctured
- Over Inflated

IMPORTANT
This product should only
be used when clearly
necessary.

HANDLE YOUR EGO
WITH CARE.

Ego Repair Kit

Design: Grace Coakley

The Ego Repair Kit is an imaginary invention which allows the user to make adjustments to their "deflated/wounded" ego. The digital world, relationships, successes and failings can have a profound effect on the delicate ego.

The approach to the design of the kit is clinical in nature due to the circumstances of its use. However the use of color is important. This kit is for personal egos, human emotions and their care, so it needs to feel accessible and reliable. The designer wanted to bring some natural energy to the kit and the color purple achieves that.

99U Conference Branding Collateral

Design: Raewyn Brandon, Matias Corea
Agency: Behance

All of the 99U Conference materials get re-imagined and re-designed by the Behance Team every year. For the conference's sixth edition, we used the bold combination of black, white, and purple. The designers also experimented with new typographic treatments contrasting sans-serif and serif fonts Trade Gothic Bold Cond. 20, Adobe Caslon Pro, with accents of the elegant font AW Conqueror. Simple, bold, geometric shapes punctuated the materials where the designers created subtle optical illusions through the manipulation of lines and depth of field.

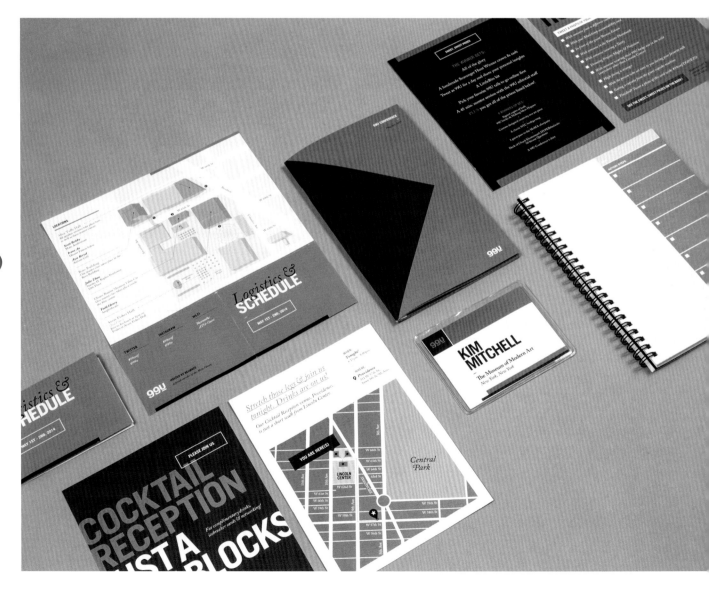

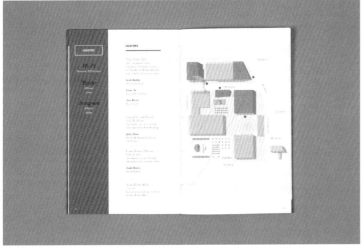

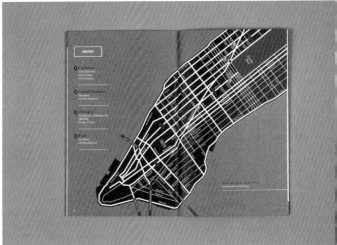

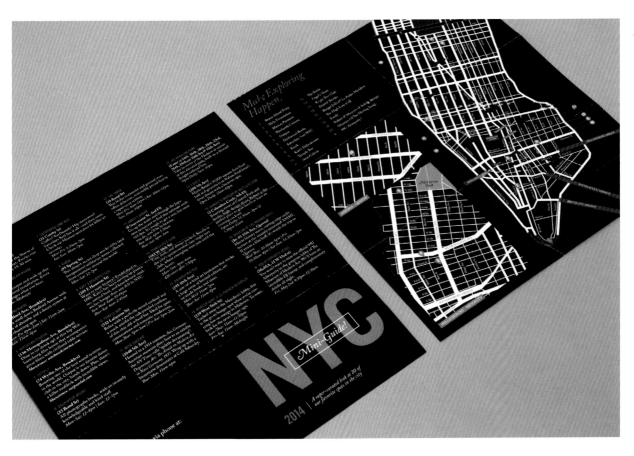

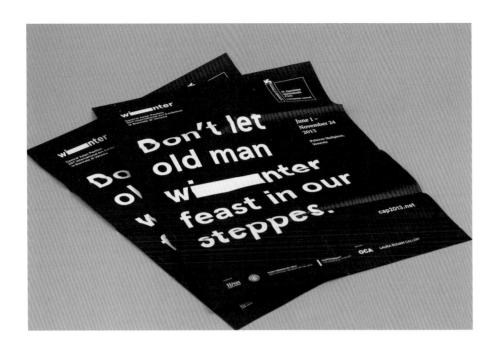

Winter – Central Asian Pavilion at La Biennale di Venezia

Design: v-a studio
Photography: Nikolai Nekh, Pedro Nogueira

Winter is a communication project that was conceived for the Central Asian Pavilion, as part of the International Art Exhibition – La Biennale di Venezia. The curators of the exhibition wanted to bring back to the contemporary era a Kazakh poem from the XIX century, Winter by Abai Qunanbaiuli, which addressed several social justice issues of its time. As part of the communication project, the designers created the posters, invitations, flyers, vinyl stickers, a press kit, a tote bag as well as a controversial book documenting some of the most relevant socio-cultural issues to the public in Central Asia.

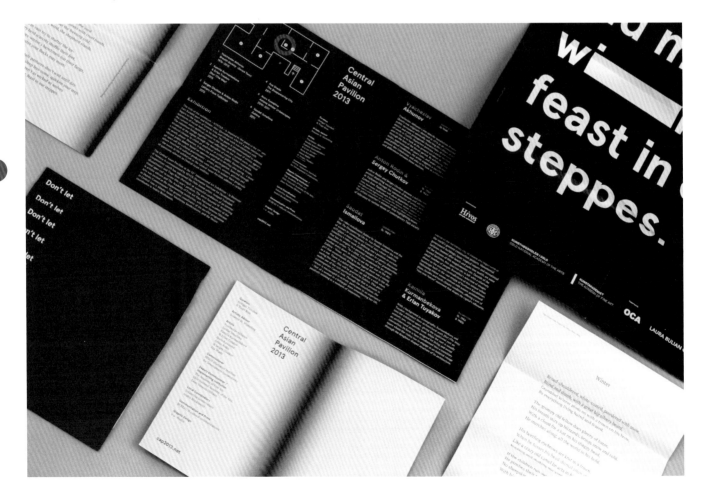

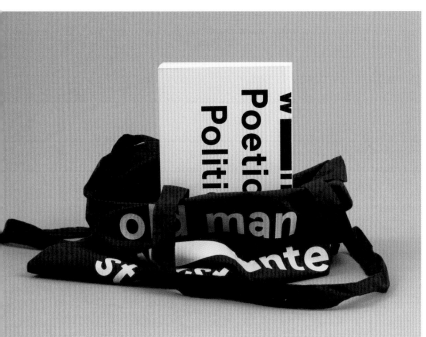

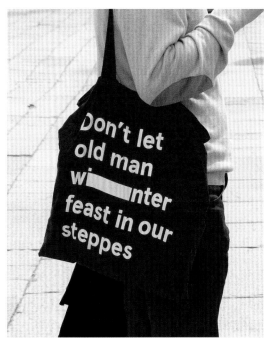

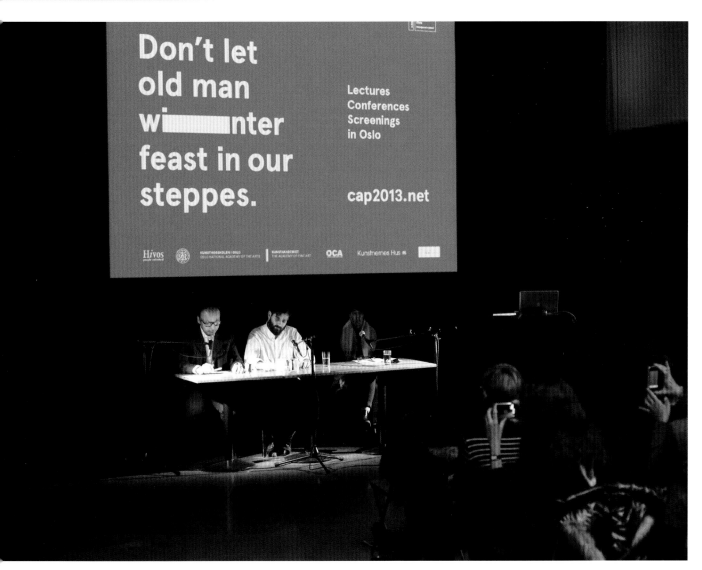

Confideri

Agency: ARENAS® lab
Design: Irina Hasselbusch
Art Direction: Valeri Arenas
Photography: Irina Svetlichnaya

It is corporate identity for Confideri company. Confideri offers in-depth solutions to corporate, legal, tax, and financing issues, regarding organization, ownership, management of assets, and securing family and business wealth.

The designers tried to unite old traditions and the modern art. In a basis of visual part there is a pattern of strips. The two main contrast colors are blue violet and orange, they are unique for this segment of the market, it allows the company to be remembered easily, to be impressive and not similar to others.

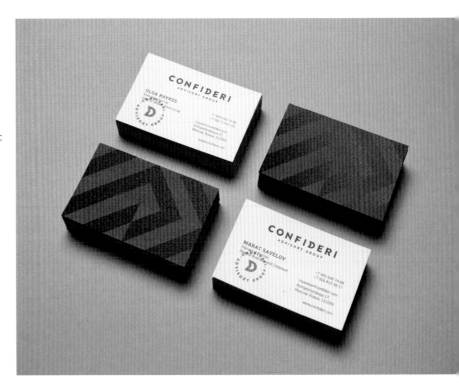

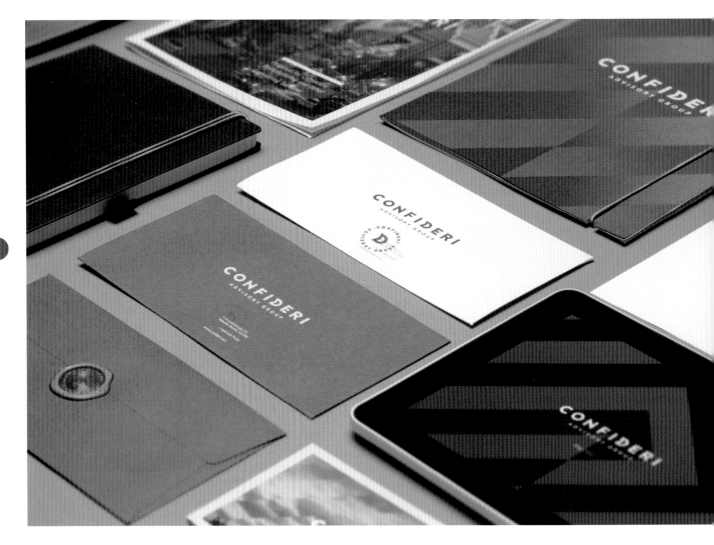

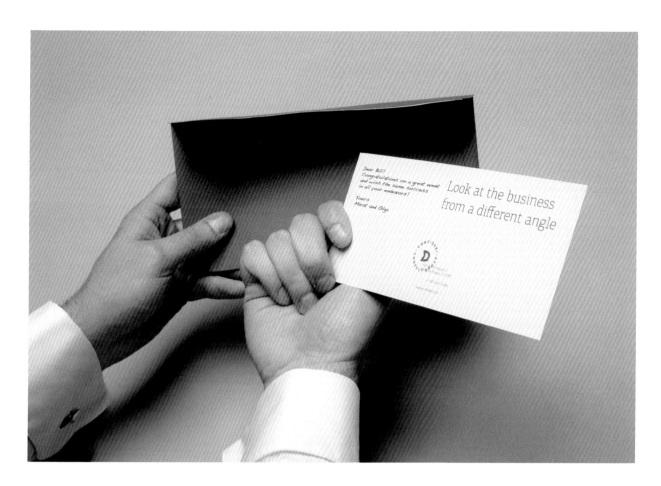

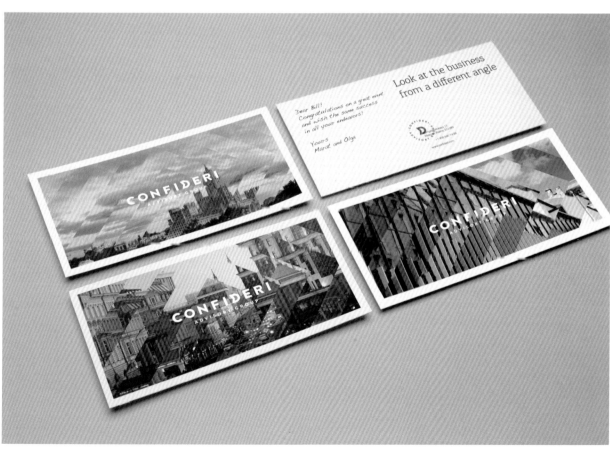

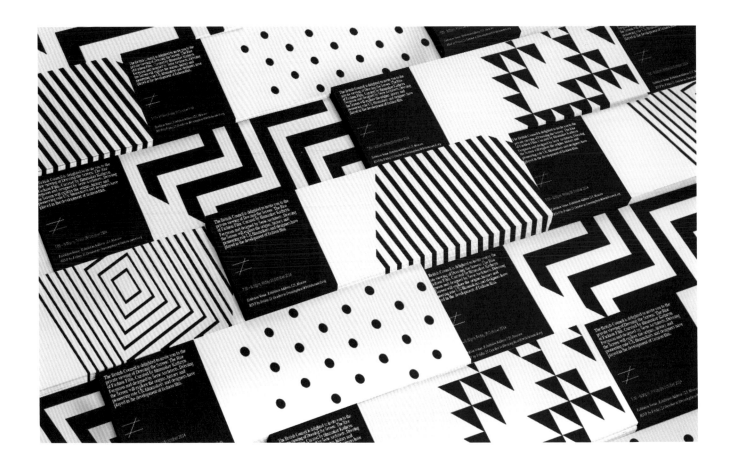

Dressing The Screen

Art Direction: Sebastian Needler
Agency: Alphabet

Dressing The Screen: The Rise of Fashion
film is a D&AD winning concept for an
international touring exhibition by the British
Council. The exhibition opens in Moscow
and then tours onward to Brazil, China
and finally Mexico. The exhibition brings
together some of the world's most innovative
fashion designers and film-makers from the
last 75 years.

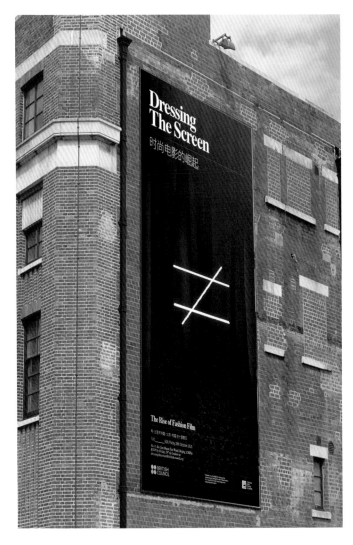

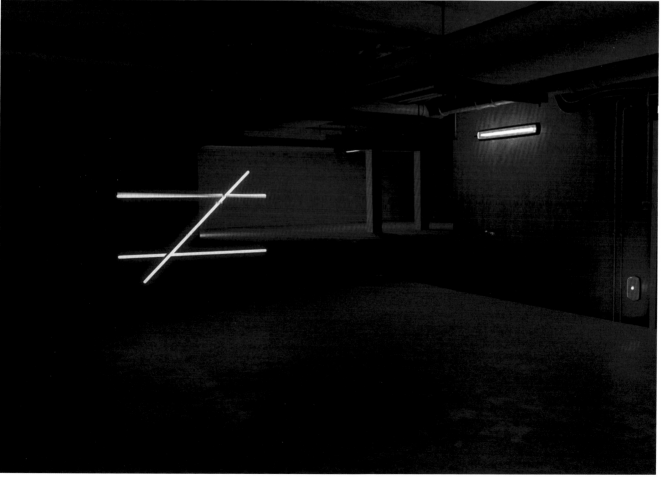

Pneus da Cidade

Design: César Moura
Agency: Up Studio

Rebranding for a tyre garage, based in Oporto, Portugal.

Made from an analogic method: letterpress.

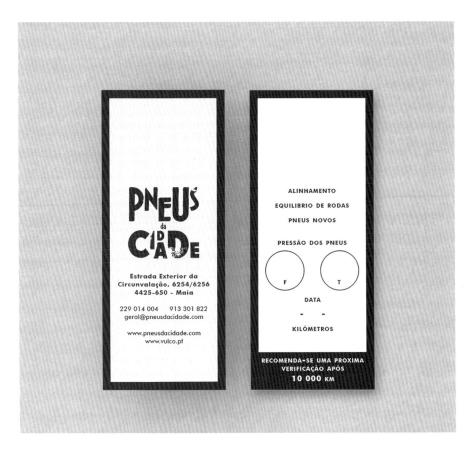

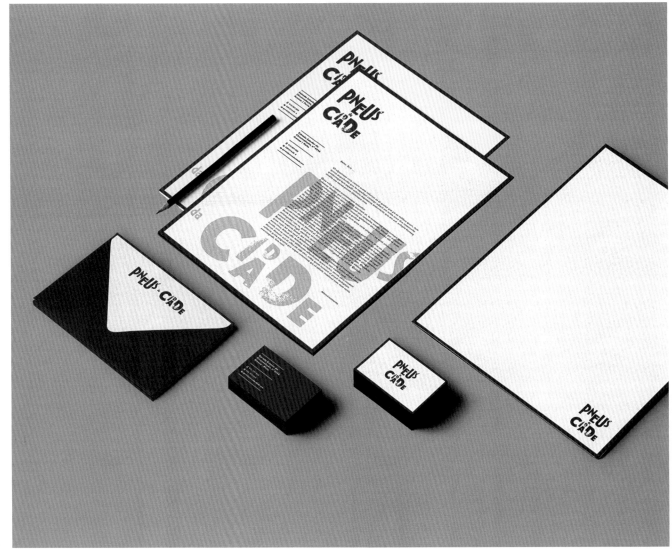

Abraham Mateo

Design: Jan Gallego

Logo design for Abraham Mateo, Spanish music artist. Sony Music commissioned the designer to created the logo of one of the revelation of the moment artists: Abraham Mateo. It had to appear in a multitude of elements: album covers, t-shirts, pendants, and caps, etc. A distinctive logotype whose simplicity guarantees to be very versatile. It can be traced with strokes of paint, spray effect, or drawn by hand, and is always going to be recognizable.

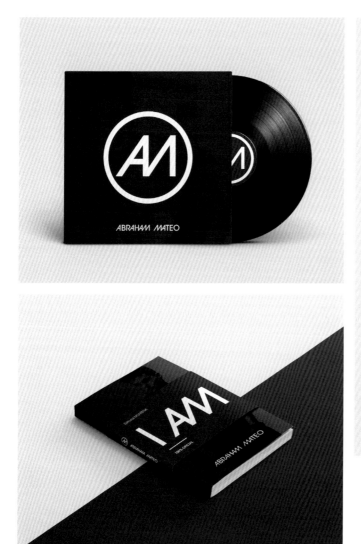

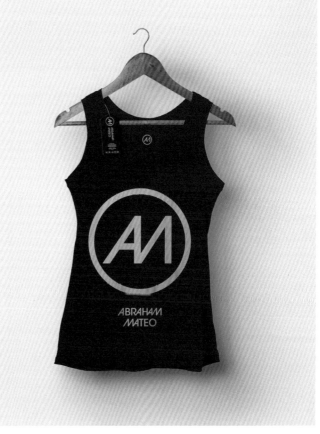

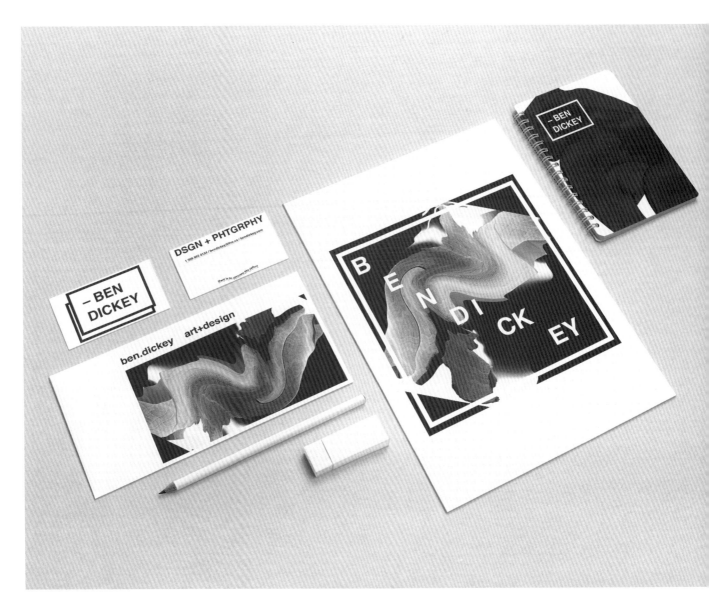

Ben Dickey
Personal Branding

Design: Ben Dickey

This rebrand by Ben Dickey is meant
to be a vivid interplay, of color,
abstraction and form. Manipulated
images of paper texture were warped
to create a pallet of abstract textures
and shapes. These were paired with
a white and blue color scheme and
font selection to create and engaging,
contemporary look.

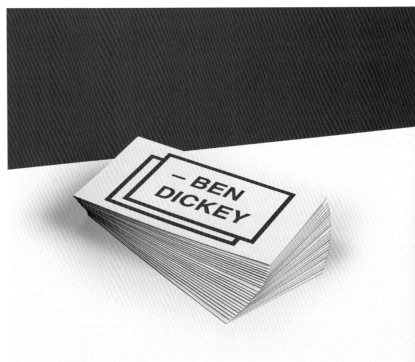

Sushi 17

Agency: Mooz Branding & Design
Design: Daniel Edmundson, Lucas Bacic

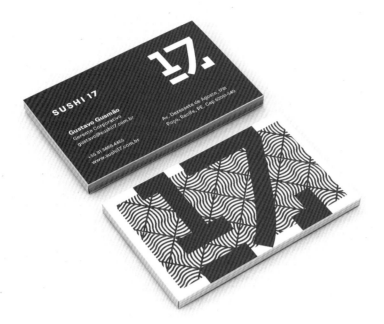

Sushi 17 is a sushi bar located in Recife, Brazil. The designers were asked to develop their visual identity, aiming to attract the attention of the public, both young and adult. The biggest challenge was to make the brand stand out among the traditional Japanese restaurants, being identified as a bar.

The geometric forms of the brand translate strength and stability. The designers also used oriental culture elements as a reference to create a fresh and yet sophisticated identity.

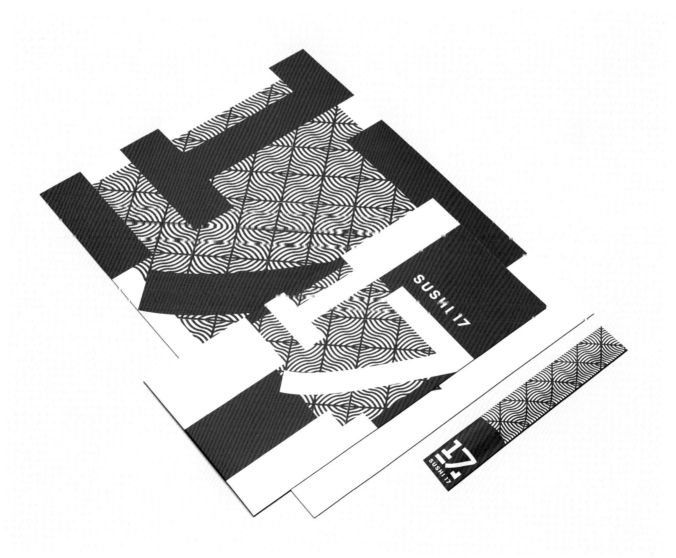

A / Personal Identity

Design: Aaron Canning

The "A" symbol embodies Aaron's approach
to design. It is reduced and no more than it
needs to be, a simple representation of his
work. The color electric blue offset against
the brown paper creates impact. While
a typographic visual language is utilized
throughout. A photograph of Aaron as a child
gives the identity a more personal touch.

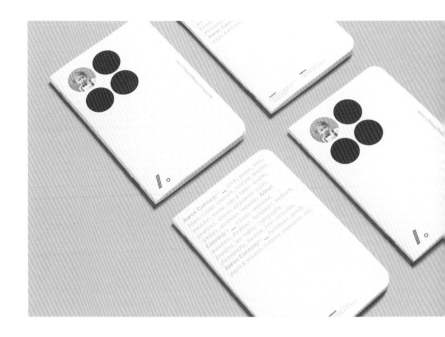

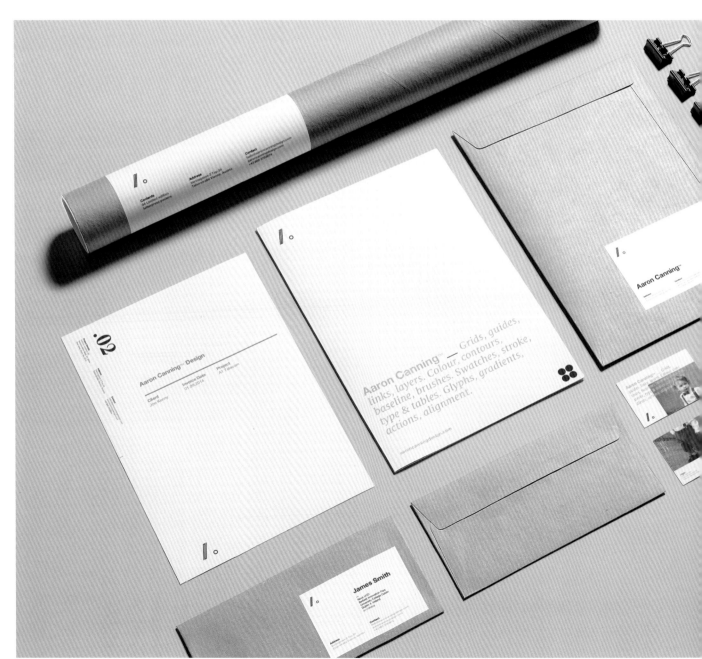

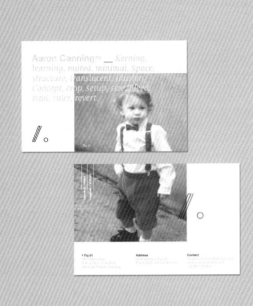

Aaron Canning™ __ *Kerning, learning, muted, minimal. Space, structure, translucent, illusion. Concept, crop, setup, size. Bleed, read, ruler, revert.*

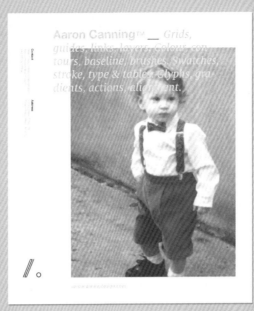

Aaron Canning™ __ *Grids, guides, links, layers. Colour, contours, baseline, brushes. Swatches, stroke, type & tables. Glyphs, gradients, actions, alignment.*

Aaron Canning™ __ *layers. Colour, contours, Swatches, stroke, type, gradients, actions, al symbols, attributes, v* **Canning**™ __ *Clien document, deadlin foundrys, late nig photography, linotyp* **Aaron Canning**™ __ *pages & printers. Par*

Aaron Canning™ __ *Kerning, learning, muted, minimal. Space, structure, translucent, illusion. Concept, crop, setup, size. Bleed, read, ruler, revert.*

Aaron Canning™ __ *Grids, guides, links, layers. Colour, contours, baseline, brushes. Swatches, stroke, type & tables. Glyphs, gradients, actions, alignment. Styles, symbols, attributes, variables.* **Aaron Canning**™ __ *Client, command, document, deadlines, Pathfinder, feedback, foundrys, late nights. Typography, photography, linotype, Lens correction.* **Aaron Canning**™ __ *Pathfinder, proofs, pages & printers. Pantone, monotone, mac.*

Aaron Canning™ __ *Grids, guides, links, layers. Colour, contours, baseline, brushes. Swatches, stroke, type & tables. Glyphs, gradients, actions, alignment.*

65°

Taste

Design: Il-Ho Jung

Taste is a people and lifestyle agency from Hamburg. They promote models, talents and influencer. The center of the Taste branding is the initial letter "T," which is shaped as a outstretched tongue. It expresses a bold and fresh attitude. The tongue is surrounded by a frame, which emphasizes the striking character and creates a lifestyle appeal of a fashion label. An endless pattern, inspired from the structure of a tongue surface, colored in lollypop-blue was built as part of the branding.

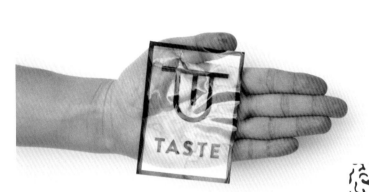

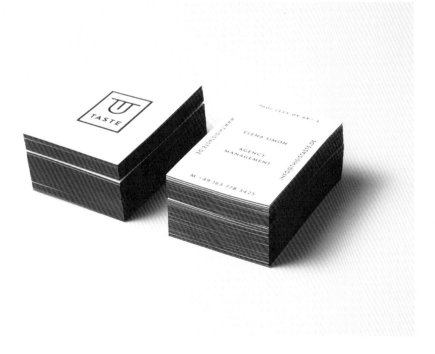

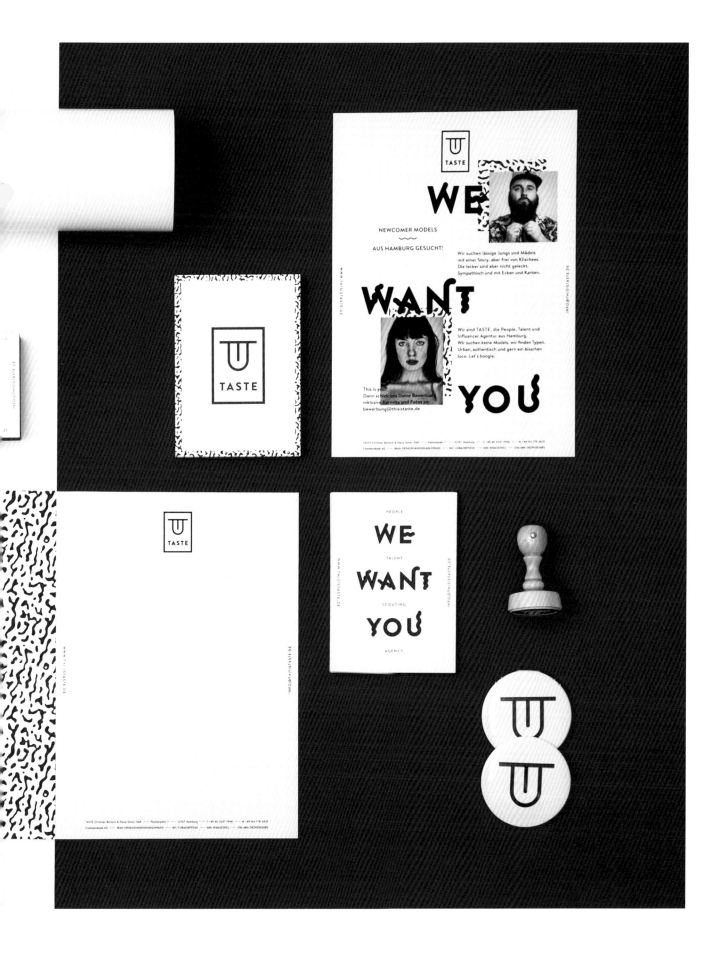

Dearboleda

Agency: Siegenthaler & Co
Art Direction: Oliver Siegenthaler
Design: Maria Angélica García

Dearboleda is a family run antique shop. The designers wanted to create a symbol where the family names Arboleda & Wartenberg were represented. Thus they complemented this with illustrations of all the different things they sell in the shop, all with a romantic and vintage esthetic.

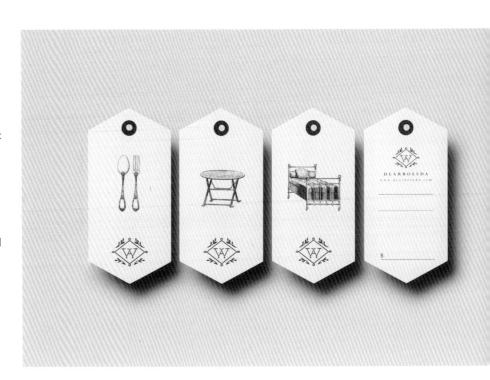

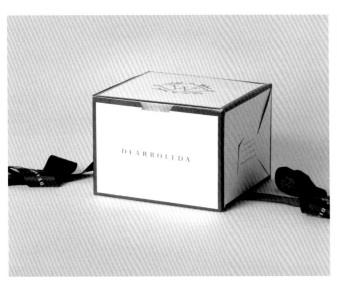

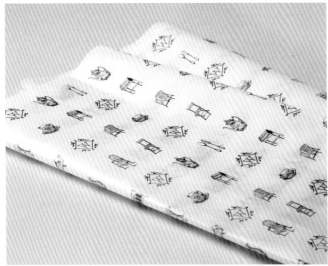

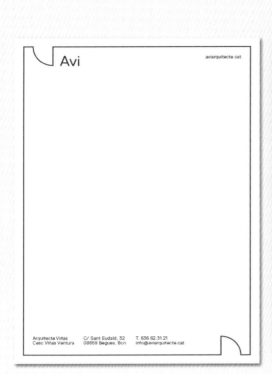
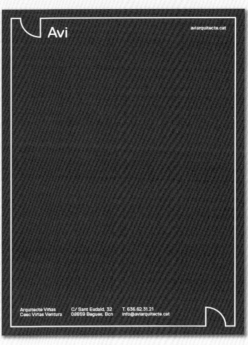

Avi – Arquitecte Viñas

Agency: Requena design office
Art Direction: Andrés Requena
Design: Virginia Pol, Andrés Requena
Photography: Koldo Castillo

Identity and naming for Avi. Arquitecte Viñas. The image was born of typographic game between the "V" and "A" visual similarity with the doors in the classical architectural plans.

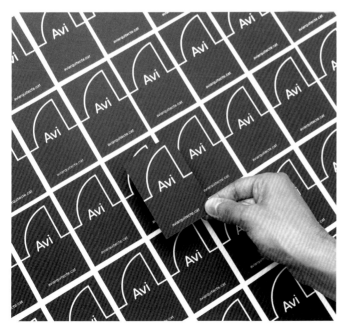
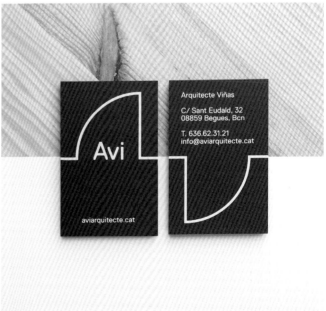

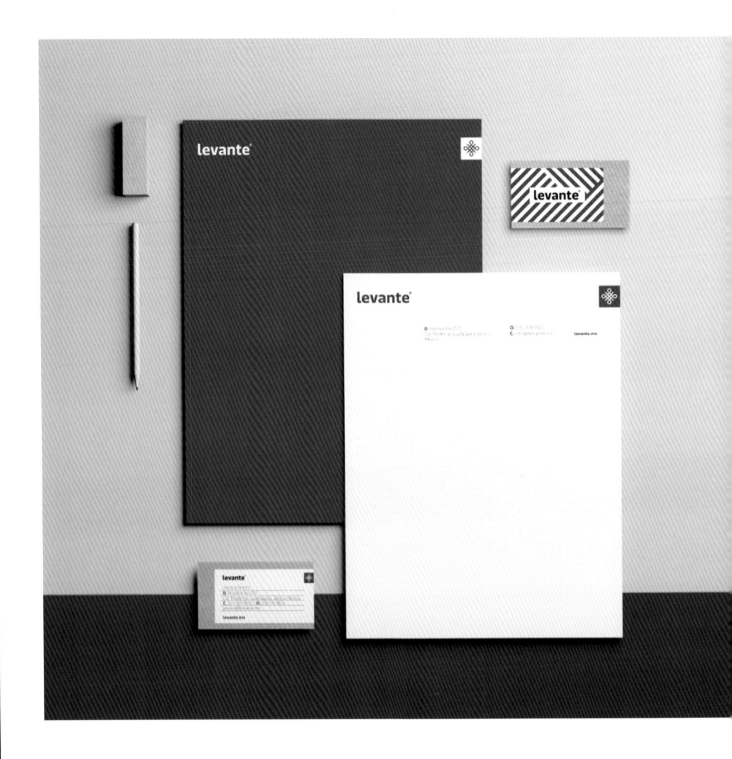

Levante

Design: Alejandro Román, Gabriela Salazar
Agency: Menta Picante

Levante is a new real estate company located in Guadalajara.

The designers worked in an icon inspired in cardinal points, using this concept as a reference since lands and estates are located in location coordinates, a well known concept to them and in which they feel related. The typographical selection makes a great combination with the icon by being a minimalist and sans serif typography, doesn't steal the attention to the icon, both elements represent the luxury and vanguard that represents this company without losing the warm approach with the clients.

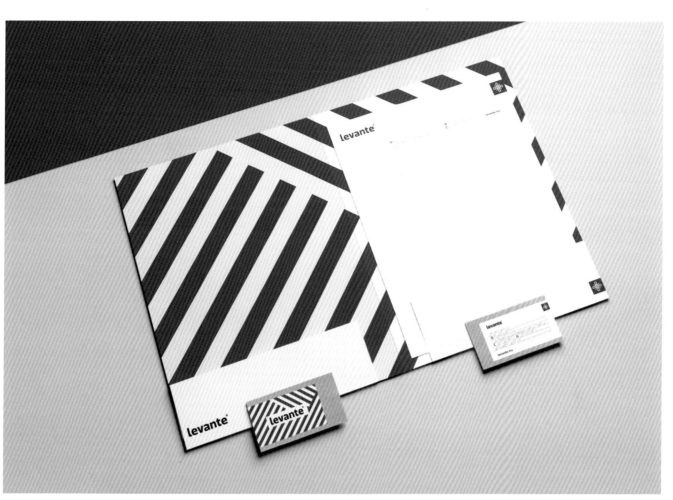

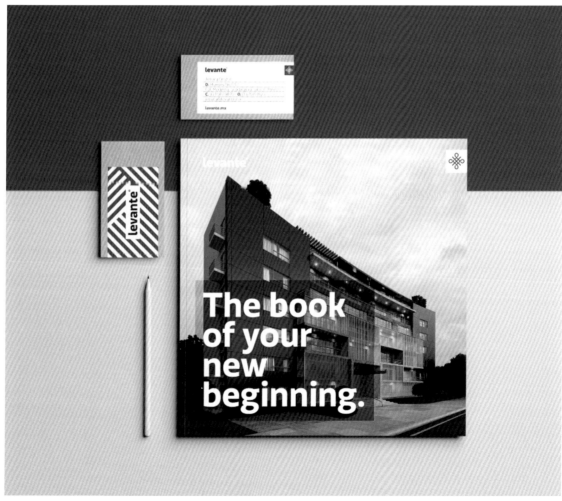

Memovoco Calendar

Design: Martha Luczak, Kathy Scheuring

MEMOVOCO stands for MEMO (something, that should be remembered) + VOCO (esperanto for "voice"). So MEMOVOCO collects thoughts – one for every day – illustrated by artists, designers and typographers from all over the world. The tear-off calendar features young talents and rewarded designers. It captures the spirit of the age and is tied up to the long tradition of gathering quotes. It unites short notes, opinions, people. Every issue is dedicated to a particular topic. MEMOVOCO is all about life. Artists were asked about what inspires them, what motivates them, what makes them laugh or what they are struggling with.

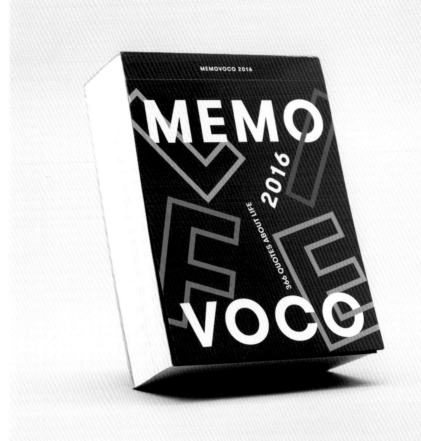

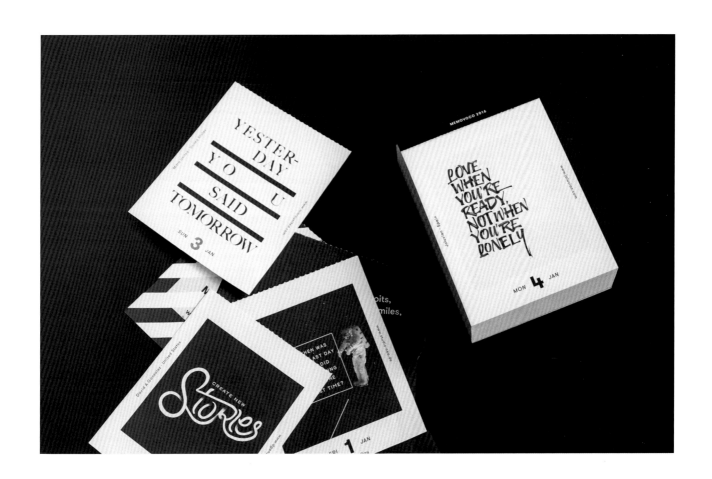

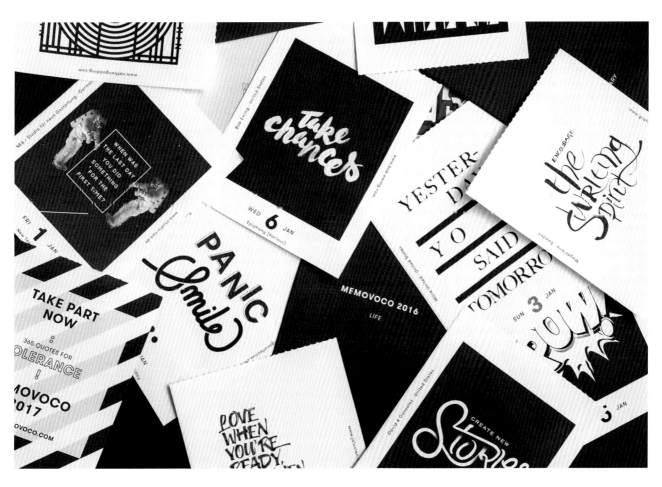

Mind Boggling Questions

Design: Tadas Bujanauskas

Mind boggling questions. Simple Answers. Read books, find out more.

A set of 8 Postcards, envelope and brochure for Read more Books campaign at the local library. A design proposal with the concept of raising simple questions and encouraging library visitors to read more books and find out more. It especially targets the young audience.

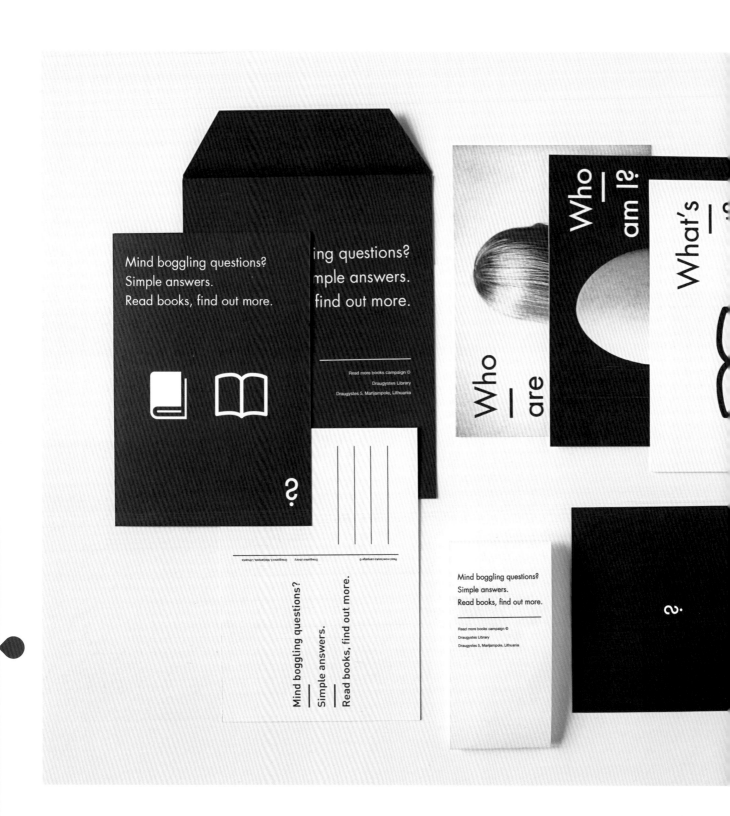

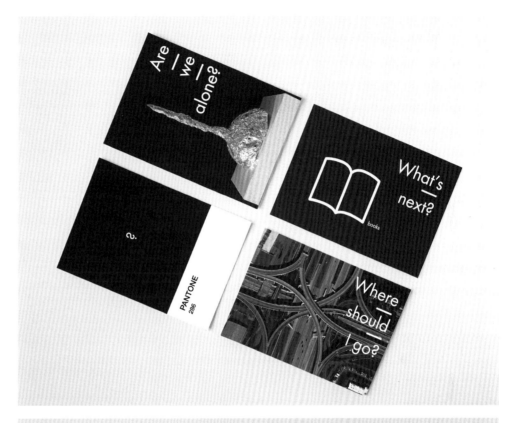

Silarba

Design: Another Collective

Silarba is a company that operates in the construction area.

Before a peculiar branding request, the designers seek to capitalize from the start precisely this aspect and use it in our favor. Thus they developed a photographic record of textures on the construction theme, such as concrete walls, stone walls and Portuguese pavement, elements applied in the development of the brand visual identity.

The application of a minimalist style on the website comes from the need to make the most of the information passed by the client, assigning a texture to each project, and enriching it with typesetting. Therefore, the designers look for an image that approaches the imagery of urban architecture in order to design the company in its new phase: the rehabilitation.

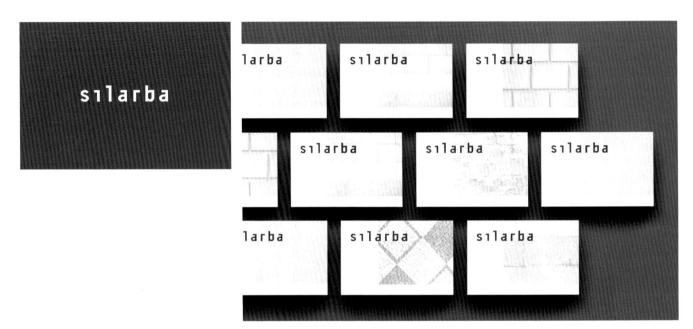

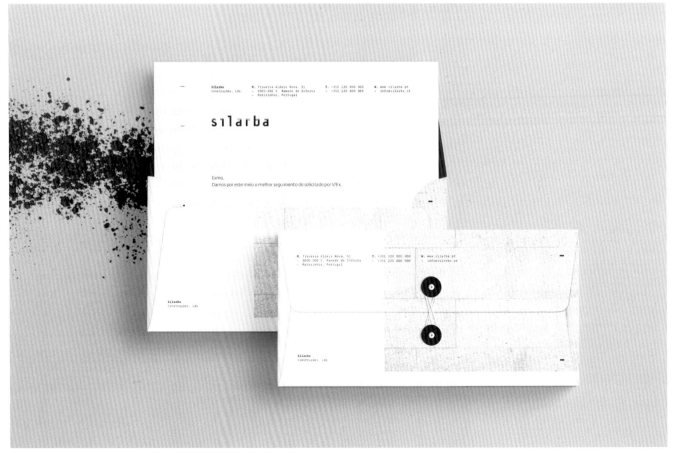

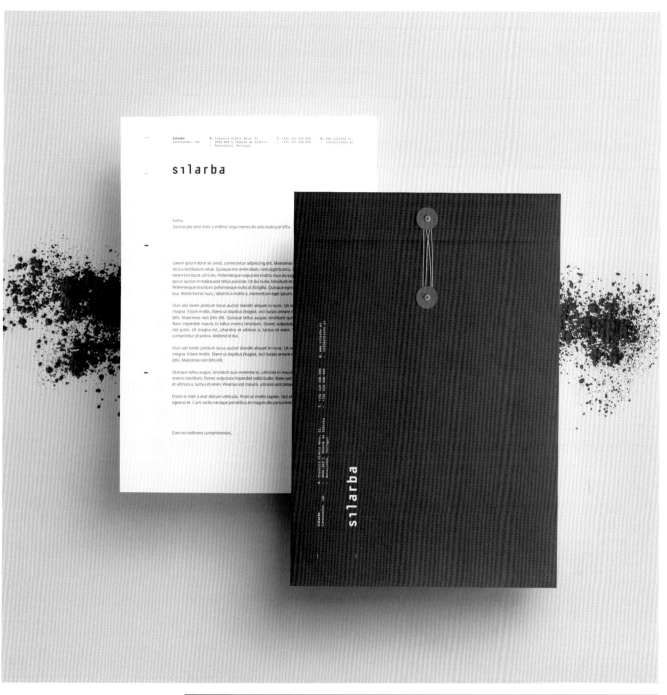

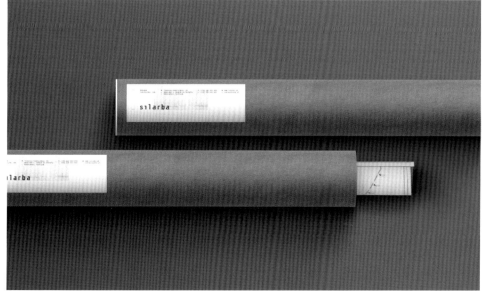

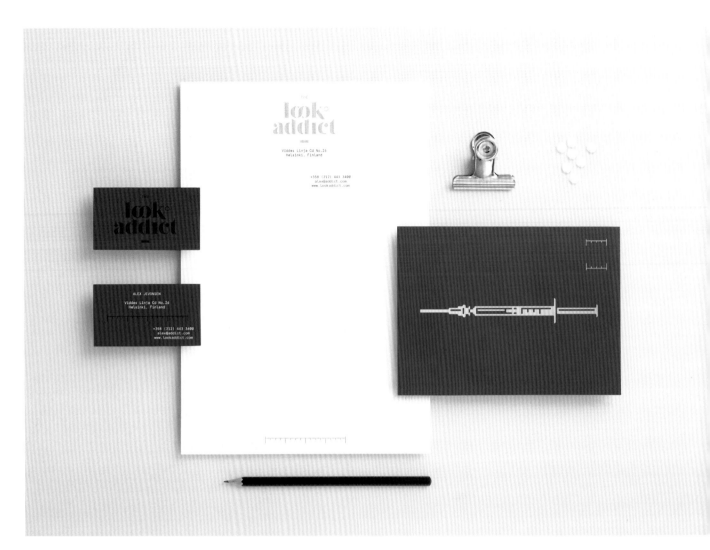

Look Addict

Design: Noeeko Studio

Look Addict is a fashion blog and online
store updated daily with new trends,
inspiration, and photo shoots. Look Addict
allows you to rate and buy outfits from
all over the world. With a dedicated team
focused on the fashion, art, and visual
inspirations, Look Addict is great place to
discover new products from fashionable
brands.

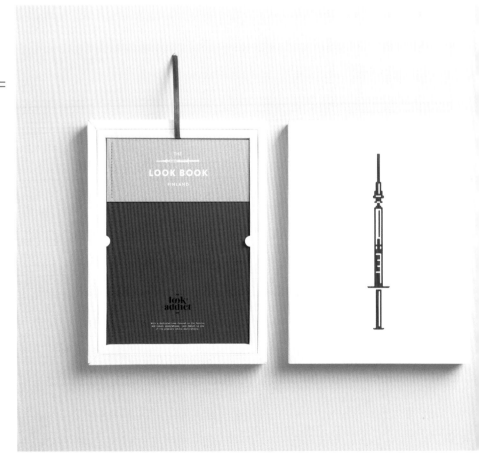

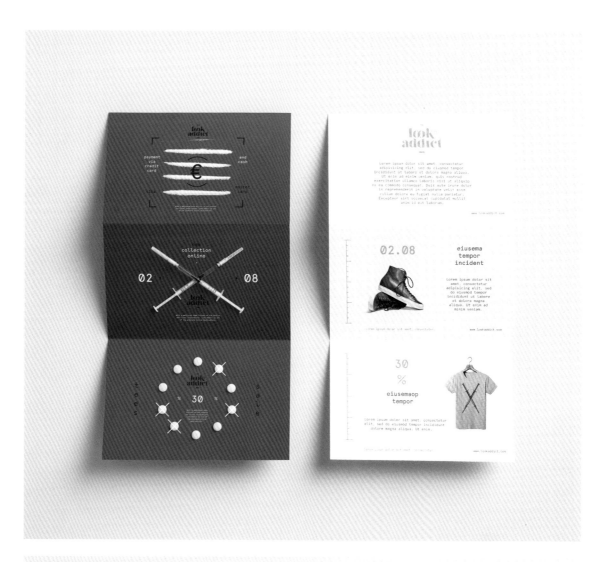

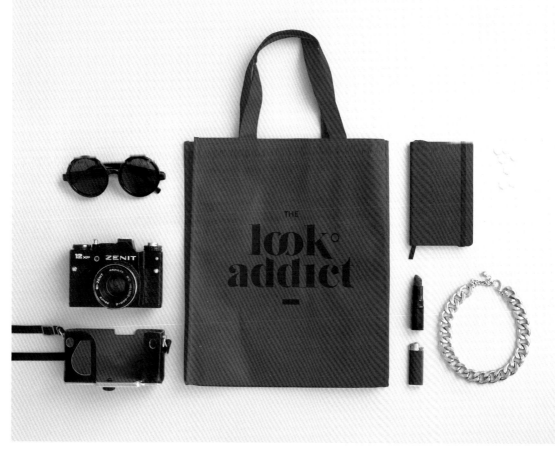

Proyecto Villa Ocampo

Design: Francisco Matte

Identity and graphic system for the cultural center Villa Ocampo development. The designer created the logo, website, brochure, banners, posters, merchandising, signage and archigraphy. The project attempts to recover some forward operating twentieth century in Argentina landowner. It is at this point that their culture was subjected to a process of plowing. The art itself is a culture.

 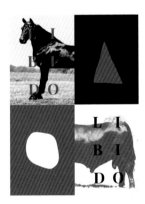

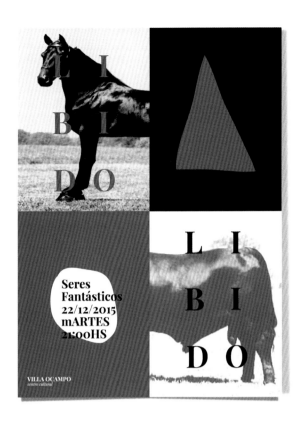

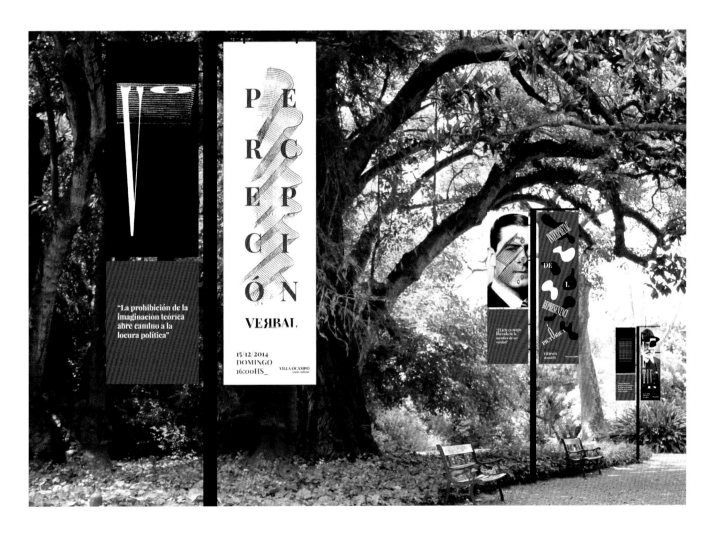

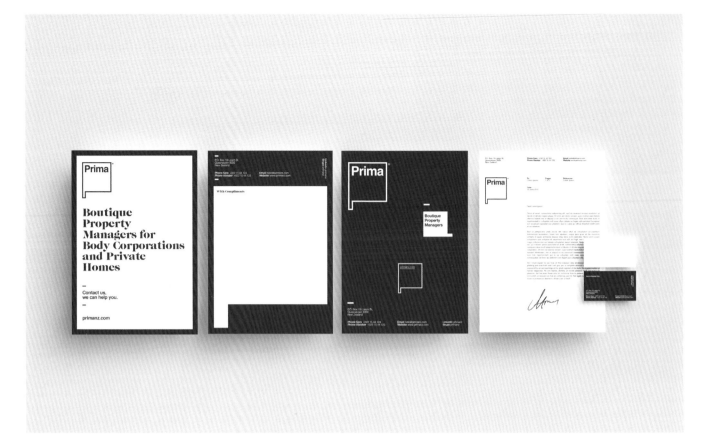

Prima

Design: makebardo®

The designers believe that the idea of "boutique" is not about scale, but about proximity to clients. One key factor is fluid communication with their clients and taking care of the space that they manage as though it is their home. The use of the bright blue color is associated with loyalty and honesty.

It is a spiritual, fresh, and transparent color. The petrol blue is a color that conveys maturity and wisdom. This color suggests responsibility, loyalty, and inspires confidence. The combination of both colors brings a perfect equilibrium, identifying the soul of the brand.

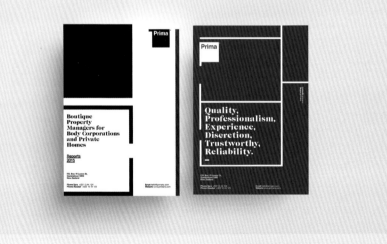

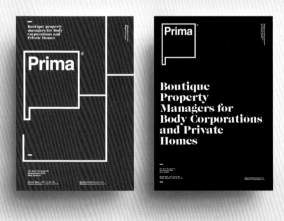

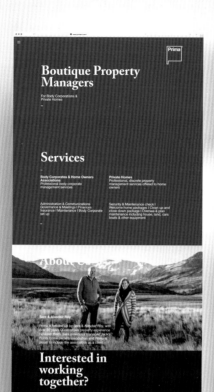

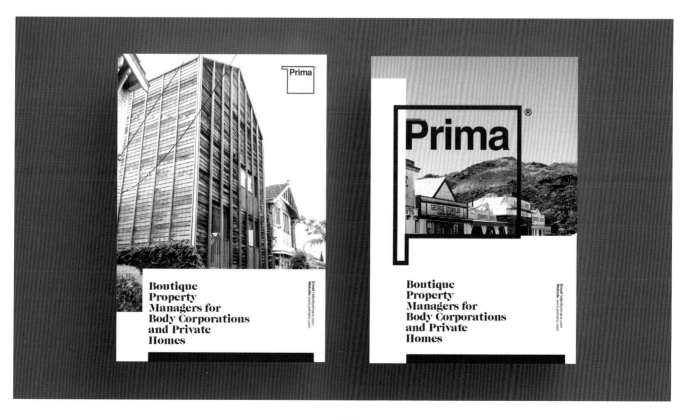

Happy End®

Design: Chris Trivizas

The inspiration for this wedding invitation came from the wedding location, the island of Cythera. The trip to Cythera became the communication means of the event, in the form of a package containing lozenges for the trip, titled "Happy End®."

It is an idea which combines complementary messages: the word "happy" refers both to the happy occasion and the lozenges in the box (since the word "happy" sounds the same as the word "pill" in Greek). By urging the guests to use the lozenges for a pleasant trip to Cythera, the invitation enhances the wedding mood.

At the same time, the paper containing instructions of use according to the marital status of guests, which is included in the box, adds humor and completes the pharmaceutical packaging style of the invitation.

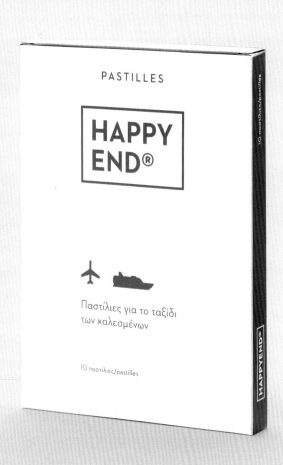

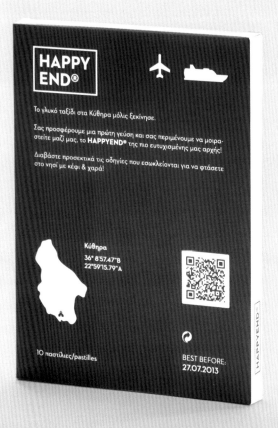

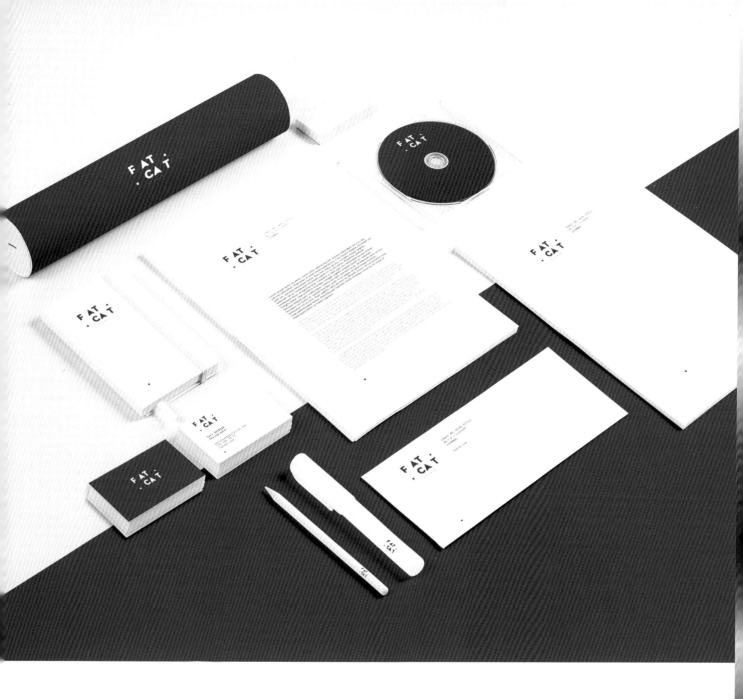

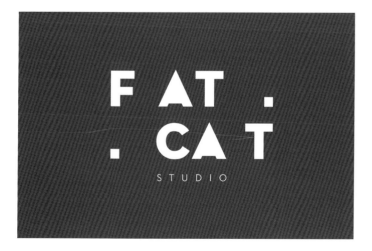

Studio Fatcat

Design: Volkan Seker

Studio Fatcat is a design and photography studio based Istanbul. This is a collective frameworks project. The designer created the photography, social media management, production and graphic design works.

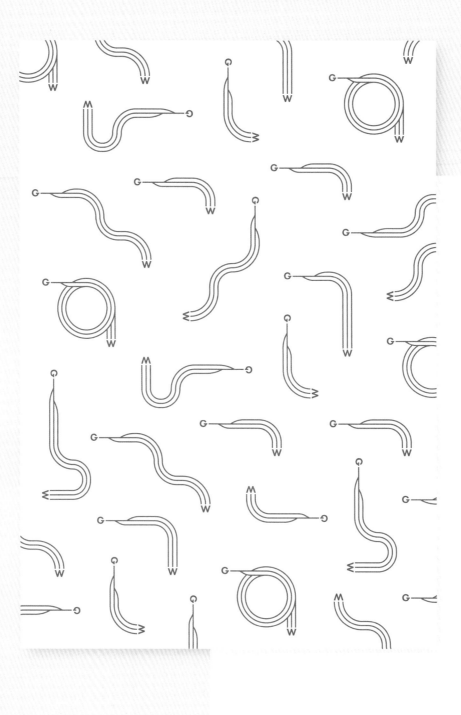

**Gary
Green**

CEO & Founder

gary@givingways
+4477 3411 4117

110-112 Kings Road
London, SW3 4TY
+4420 3728 2848

**Bence
Bilek**

Head of Design

bence@givingways
+4479 57479226

110-112 Kings Road
London, SW3 4TY
+4420 3728 2848

GivingWays

Design: Bence Bilekov
Agency: Designed by Awake

GivingWays Ltd Registered in England and Wales. Registration No. 12345678 VAT No. GB12345678

GivingWays is about combining opportunities to engage and support charities. It was a vital part of the project to reflect this in the brand's name and visual identity. The 3 lines used in the logo mark represent exactly that – ways of giving coming together for a common purpose.

Through the unusual design aesthetic and the prominent blue color, the brand was meant to stand out from the crowd. The brand's transformative, playful and honest values are captured in a form free of embellishments to ensure the designs will not date easily.

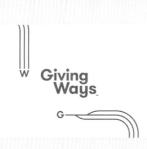

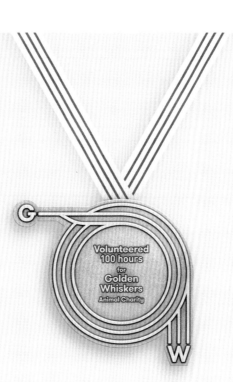

With compliments

110-112 King Road
London, SW3 4TY, UK

+4420 3728 2848

givingways.com

· ·

· ·

· ·

Giving Ways

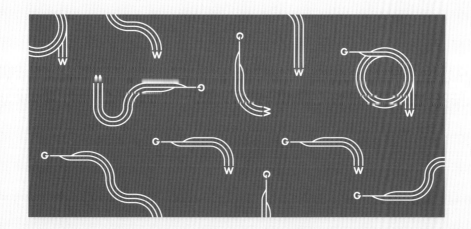

Iconnect

Design: Parámetro Studio

IConnect is a young company dedicated to intelligent digital security. The client wanted to create a fresh brand accompanied by a web design. For the creative solution, the relationship between "user and security device" was an important element for the creation of the logotype. For the word mark, the designers used a sans-serif typeface with a gesture of union in between letters. The brand's colors are display friendly to create a professional, technical, and savvy look.

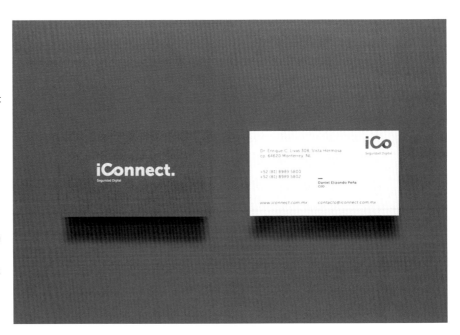

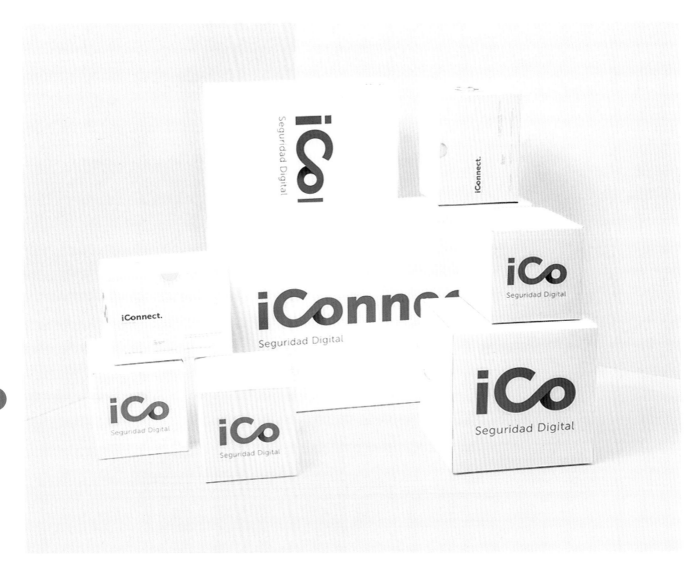

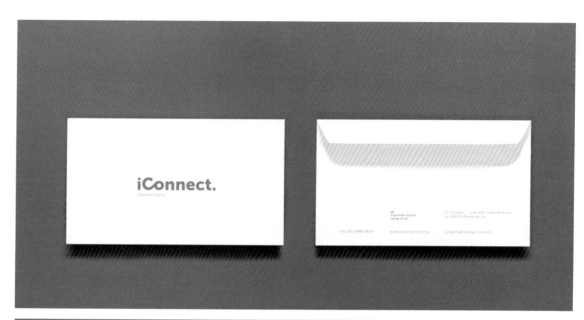

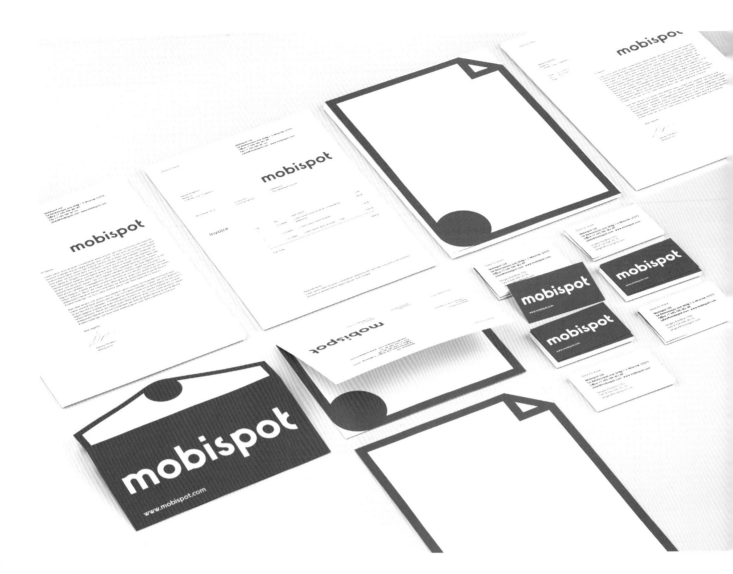

Mobispot

Agency: Flëve
Creative Direction: Vit Abrams
Design: Holga Balina

Flëve were asked to help launch a new ambitious product and service. For more than a year and a half we have been working shoulder to shoulder with Mobispot to bring this great product and service to life. The project has involved everything from creating an identity system and web interface to designing all the spots (wristband, key fob, and card) and crafting a successful design strategy.

Cine-Teatro Garrett

Design: Another Collective

The following visual identity was proposed for the Cine-Teatro Garrett, it focuses mainly on one aspect, what is called the "Poveiro" Graphics. The Garrett Theatre was once the home of the culture of Póvoa de Varzim and an important milestone in the north of Portugal. The "poveiras" acronym, known for the "poveira" writing, is a system of visual communication originated from Old Norse Bomärken.

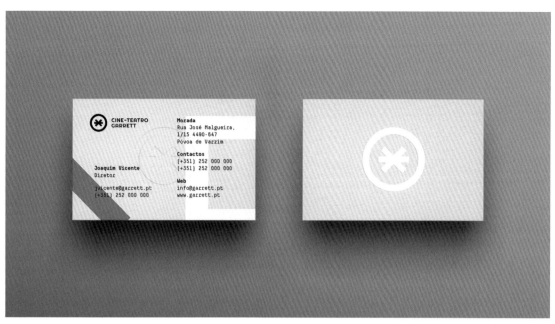

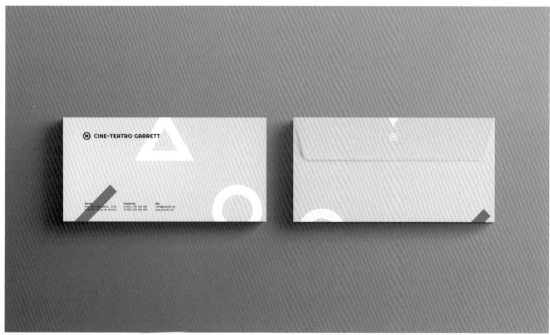

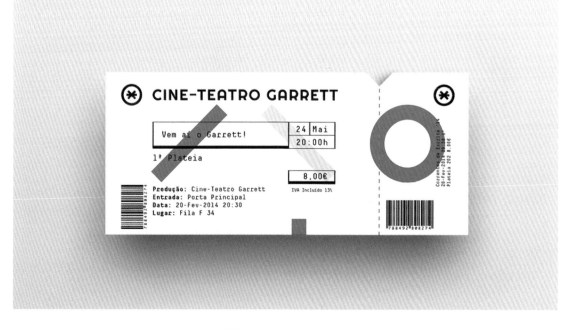

Cloud. Coffee Shop Brand Design

Design: Xianwen Wei

Cloud. is a personal project for coffee shop brand. The designer wanted to create a minimal logo with elements from sky to express quality within the whole brand and each of its touch points. The idea was to take disparate elements and unify them into whole systems that represent a fresh and playful attitude towards viewers. The combination of light color and creative pattern makes the perfect balance for a clean and sober design. The outcome is a minimal and modern execution for a fresh and fun brand!

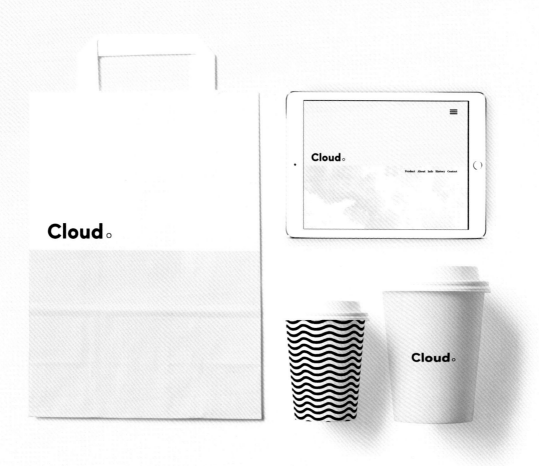

Eclectic

Design: Kristin Edøy

Eclectic is a fashion boutique for young women located in Subiaco. It is an up and coming area in Perth in West Australia and Eclectic is one of the latest fashion stores there.

The target audience is young women in the age of 18-30, who like to stand out from the crowd and are not afraid to spend money to do so. They are the type of girls who would like to wear a different dress for every occasion. They like to mix and match styles, for example modern and vintage and likes clothes that are a little different than every other girl would wear.

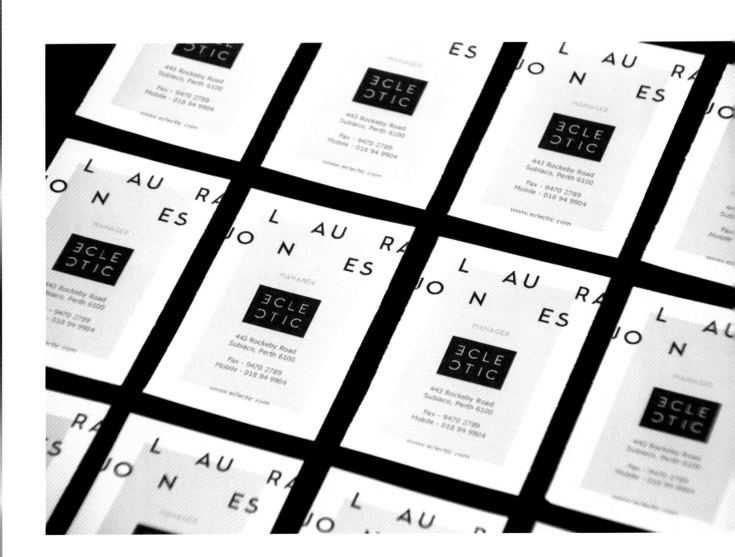

Soneas

Design: Peltan-Brosz Roland

Soneas is a high-end professional chemical-pharmaceutical company. It improves practical approach, which in turn create new opportunities for the customers and increase the value of their development projects.

The branding proposal focused on a visual language that conveys the image of molecules in symbiosis creating a presence that not obviously refers to chemicals.

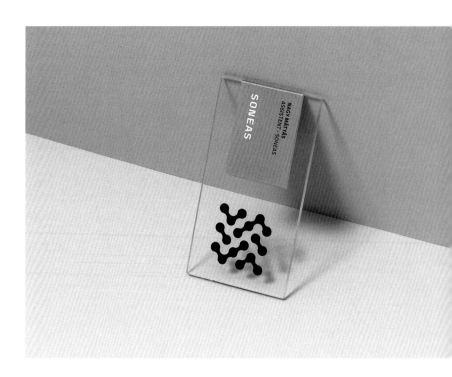

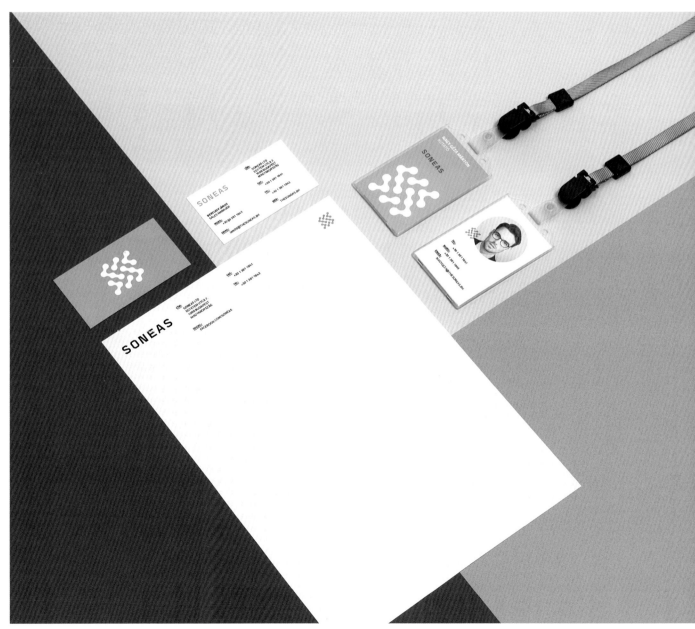

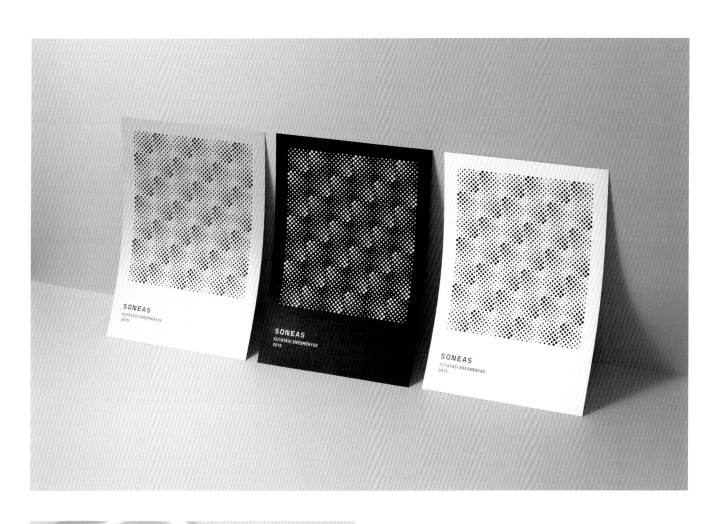

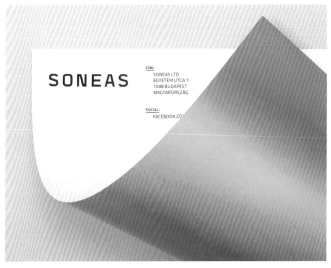

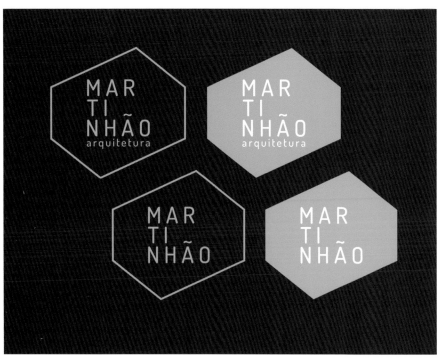

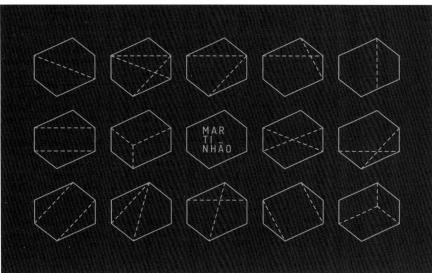

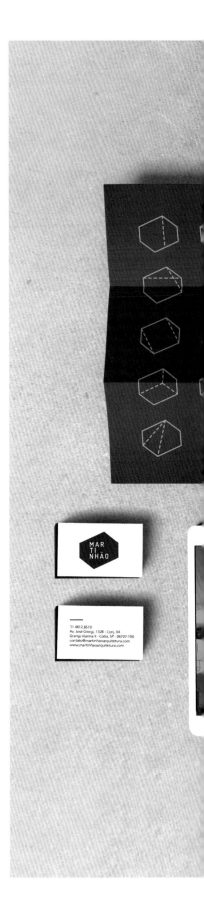

Martinhão Arquitetura

Agency: Alpina Digital Branding

For the chromatic pattern tones that bring great personality and differentiation for the company were used. The dark gray was used to represent the experience, strength and quality services. Symbolizing creativity, innovation, modernity and youthfulness, the designers used a vibrant shade of green. This color also shows the renewal and growth. This color palette is the new phase of the company, standing out from the competition and causing curiosity in the target audience.

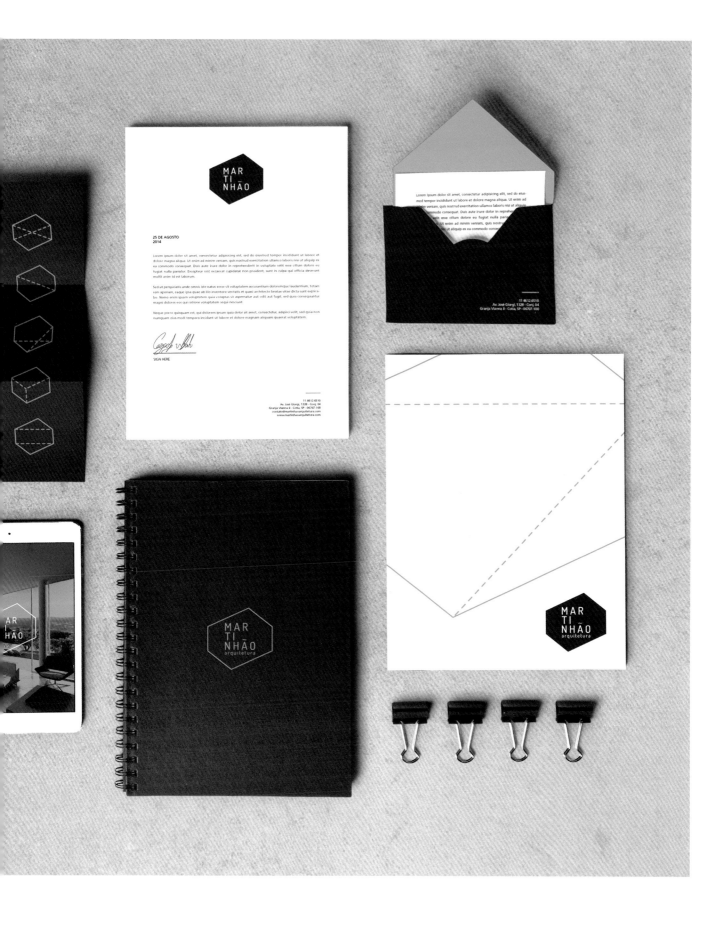

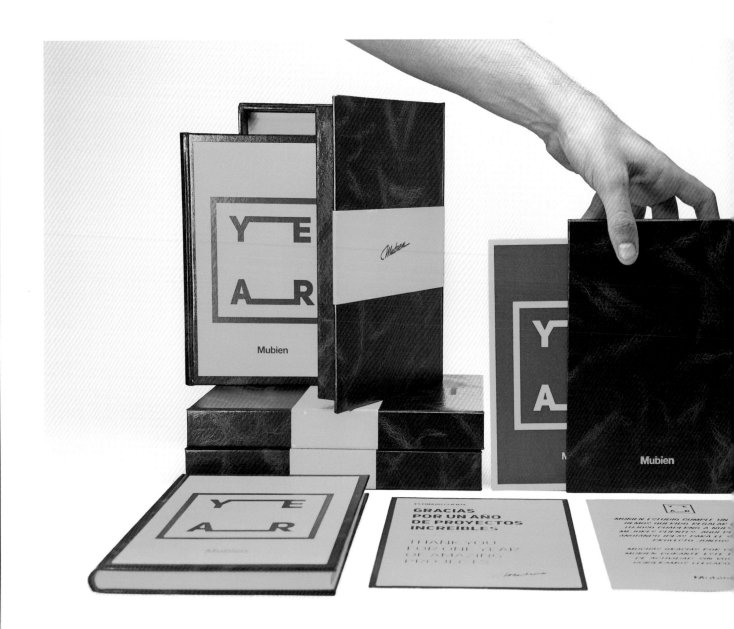

Mubien One Year

Agency: Mubien Studio
Creative Direction: David Mubien
Photography: Adrián Castanedo

To mark the first anniversary as independent design studio, the designers have given this luxury sketchbook to their best clients to write down ideas about future projects. All work was handmade in their studio. The designers use a combination of neon green and "Valencia Green" in order to reflect the hope we have in the project, it results in a luxury box that protects the notebook with series of printed sheets on neon green paper with gratitude messages.

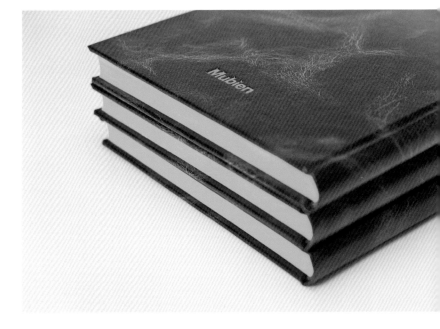

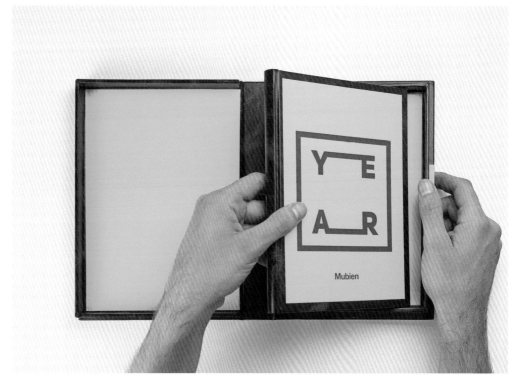

Mas Media Branding

Design: Manuel Berlanga

Masmedia is a project based on the generation of multimedia content and visual effects. The essence of branding is giving color and fluency to all your applications and use bright and spectacular sight tones.

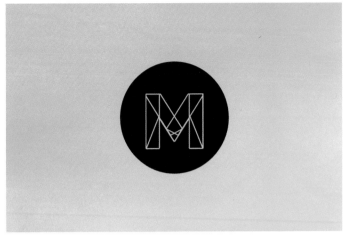

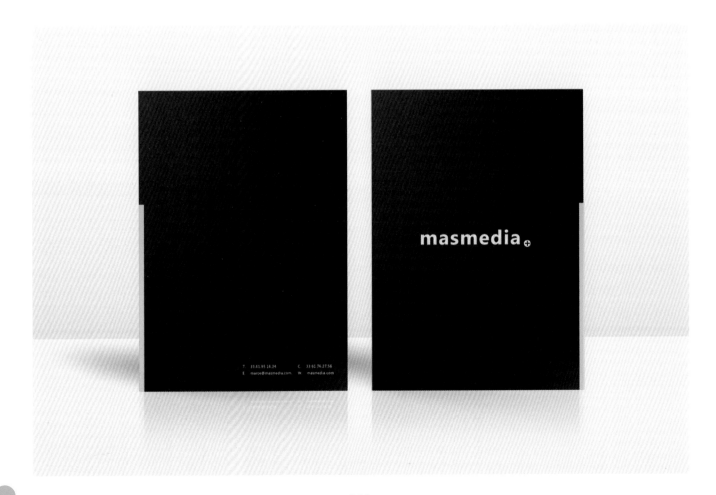

David & Estibaliz Wedding

Agency: Mubien Studio
Creative Direction: David Mubien
Photography: Adrián Castanedo

Neon yellow, graffiti and design were the ingredients. The designers wanted to surprise guests with a handmade invitation engraved in gold and customized with irregular spray lines on which they wrote the name of each guest. The wedding detail is a notebook made with high quality materials and a guest book with leather cover engraved in dry and gold.

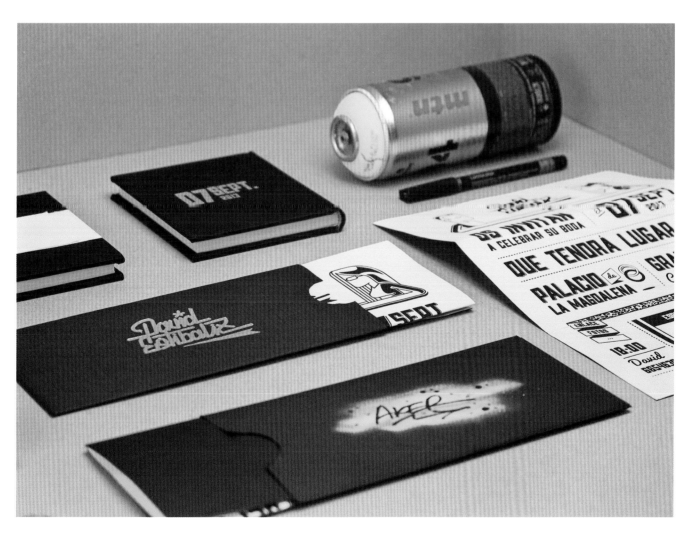

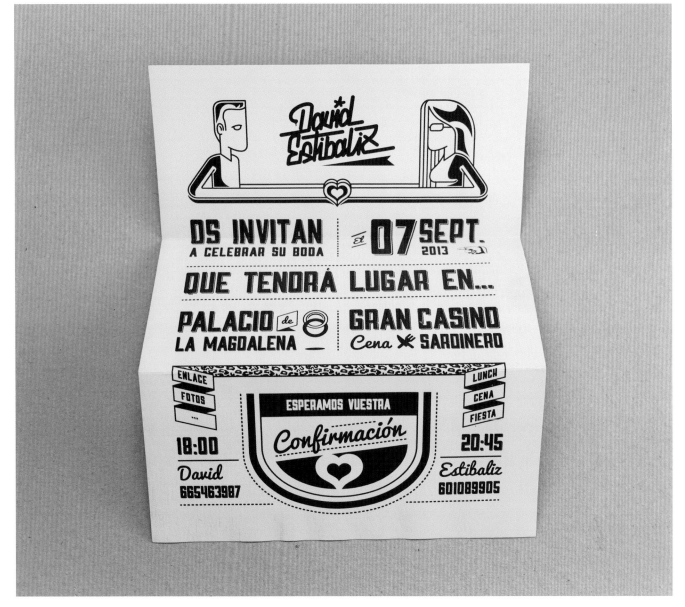

Index

Aaron Canning

www.behance.net/aaroncanning

Aaron Canning is a graphic designer based in Vienna, Austria.

— p190

Accidens

www.accidens.se

Accidens is a Swedish advertising agency based in Sundsvall, creating strategic design solutions for a variety of clients in disciplines such as branding, art direction, print and digital design.

— p154

ADDA Studio

adda-studio.de

ADDA is a Stuttgart-based design agency specialized in conceptual design, creation, and communication. Since 2009, Christian Vögtlin represents his holistic principle of creation, centering their customers' wishes, ideas, and views. The studio's goal is to create an emotional an informative benefit within clients and corporate values.

— p030, 072, 106, 160, 162

Agentur Lux

www.dieagenturlux.at

The design studio Agentur Lux is located in the south of Austria and develops and realises design solutions for companies, people or products. Benjamin Hösel's work can be distinguished by his state of the art design with a clear statement and a sense for style.

— p164

Agustono

www.behance.net/au8ustdesign

Graduated from Raffles Design Institute in Singapore in 2009, Agustono is a 27 years old graphic designer from Indonesia. He is currently working in Alessa as a Creative Director, managing the marketing side as well as the design.

— p020

Aleš Brce

www.alesbrce.com

Aleš Brce is a self-taught graphic designer based in Trieste, Italy. Focused on typography and geometric kind of visual style, he tries to put always an experimental approach and some custom graphic elements in each of his works.

— p028

Alphabet

madebyalphabet.com

Alphabet is a bold and brave design studio for bold and brave clients. Based in Leeds, UK. The studio was founded by Sam Lane, Abbas Mushtaq, and Sebastian Needler. Alphabet specializes in branding, design and creative direction. They work with clients big and small, in mediums far and wide, with the one constant throughout their projects being bold execution of concept.

— p068, 080, 184

Alpina Digital Branding

www.alpinaweb.com.br

Alpina Digital Branding is a branding firm with digital DNA. The team consists of young people, restless, and dreamers who are constantly looking for personal and professional achievements.

— p226

Anagrama

anagrama.com

Anagrama is an international branding, architecture and software development firm with offices in Monterrey and Mexico City. Their clients include companies from various industries in countries all around the world. Besides their history and experience with brand development, they are also experts in the design and development of objects, spaces, software, and multimedia projects. Their services reach the entire branding spectrum, from strategic brand consulting, to logotype, naming, peripherals and captivating illustration design, through architecture & interior design projects, and business based solutions around custom developed software.

— p012, 038, 088, 100

Andreas Williger

www.andreaswilliger.de

Andreas Williger is a M.A. Graduate in D esign and Communication Strategy at the University of Applied Sciences, Augsburg, specializing in graphic design, illustration, communication design, branding and corporate design, etc.

— p056

Andrés Requena

www.andresrequena.es

Andrés Requena is a graphic designer based in Barcelona, Spain, specializing in graphic design, art direction, and illustration.

— p140, 195

Ania Swiatlowska

www.behance.net/aniaswiatlowska

Ania Swiatlowska is a visual artist and graphic designer based in Warsaw, Poland.

— p031

Anna Trympali

www.behance.net/annatrympali

Anna Trympali is a graphic designer based in Greece. She is a lover of color, a patternmaker, and is addicted to popcorn.

_ p134

Another Collective

www.anothercollective.pt

Another Collective is a design studio formed in late 2012 and based in Matosinhos. Considering branding, web design, and editorial design as the main areas of intervention, the studio believes in an engaging work methodology. With a focus on experimentation and exploration of concepts, they relate customer and company in a relational symbiosis, having as a principle the clients' claims, always favoring direct contact with them.

_ p202, 218

ARENAS® lab

arenaslab.com

ARENAS® lab is a business consultant in brand management agency based in Moscow, Russia.

_ p102, 182

Arndtteunissen

www.arndtteunissen.de

Arndtteunissen is a german brand agency specializing in design and implement communication for brands, products, and services.

_ p024

Au Chon Hin

www.behance.net/untitledlab

Graduated from the Designing Department of Macao Polytechnic Institute in 2014, Au Chon Hin is a young designer specializing in branding, activity visual identity, and poster design. He established his studio Untitled Lab in 2015.

_ p086

Behance

www.behance.net

Behance, the leading online platform to showcase and discover creative work, is on a mission to empower the creative world. Behance is a proud member of the Adobe family.

_ p178

Ben Dickey

bendickey.com

Ben Dickey is an art director, photographer, and designer based in Ontario, Canada.

_ p188

Bence Bilekov

designedbyawake.com

Bence Bilekov is a branding specialist designer who founded Designed by Awake, a branding agency based in Shoreditch, the creative hub of London in 2011.

_ p212

Big Fan®

bigfan.agency

Big Fan® is a creative studio that leads with brand to produce impactful visual identity and design. The studio covers all bases to make sure your brand works just as well digitally as it does in the real world.

_ p176

Blok Design

ww.blokdesign.com

Blok is a design studio specializing in brand identities and experiences, packaging, exhibition design, installations, and editorial design.

_ p118, 128

Bond Creative Agency

www.bond-agency.com

Bond is a brand-driven creative agency in Helsinki, Finland and Abu Dhabi with a craftsman's attitude toward their work. The design agency creates and redesigns brands and helps new businesses and brands get started. The agency's services include identity, digital, retail and spatial, and packaging and product design.

_ p040

Buenas Design Studio

www.buenasdesign.com

Buenas is an international design studio with offices based in Guatemala City. The studio's goal is to bring brands to life always aiming for simplicity and functionality reducing each work to the fundamental, the essential, the necessary. The team takes pride in taking disparate elements and unifying the minto whole systems finding creative solutions for complex challenges in order to create powerful brand experiences.

_ p136

Butcher & Butcher

www.butcherandbutcher.co.nz

Butcher & Butcher is an award winning independent design company based in Auckland, New Zealand. The team believes that "brand" is the sum of all experiences between business, people, products and services. Their approach is interdisciplinary – whether it's brand strategy, packaging or digital design, they place design thinking at the centre of their business.

_ p094

Camille Jouarre

joamdesign.fr

Camille Jouarre is a French junior designer based in Dublin and specialized in branding, packaging, and illustration. Camille believes that creating a clean, simple, and well-crafted visual identity is the best way to showcase clarity and get across the essence of a brand.

_ p084

Charlie O'Halloran

www.charlieohalloran.uk

Charlie O'Halloran is an upcoming British graphic designer and visual artist.

— p146

Chris Trivizas

www.christrivizas.gr

Chris Trivizas operates within the field of visual communication since 2003. It is a creative studio committed in providing premium quality, integrated communication solutions tailored to each client's needs.

— p210

Christina Schinagl

www.christinaschinagl.com

Christina Schinagl is a multidisciplinary designer and artist based in Salzburg, Austria.

— p074

Edina Fazekas

www.behance.net/edina_fazekas

Edina Fazekas' main profile is designing issues, books and brandings. Her goal is creating strong concept for her works which outlines the procedures to be taken and give a framework for the visual appearance. She aims at extending the print based design projects by using other means, such as photo, video, animation, and web design, etc. to build up a bigger unity and to improve the complexity of the concept.

— p142

Eldur Ta

www.behance.net/elrendir

Eldur Ta is a graphic student at RMIT University of South Saigon, Vietnam. He's interested in brand identity and editorial designs. Inspired by minimalism style, his designs focus on the brand essence while still maintaining its effectiveness.

— p130

Eric Lynch

www.behance.net/eric-lynch
www.behance.net/axelmchugh

Eric Lynch and Axel McHugh are both graphic designers who are based in Dublin, Ireland. The pair were asked to collaborate on the IADT Gradshow project in 2015, at this time Axel had just finished his third year of the Visual Communication Design programme at IADT, Eric was the year below. Both began attending IADT to become multi-disciplinary designers.

— p141

Estefanía Leiva

www.behance.net/estefanialeiva

Estefanía Leiva is a design student in Buenos Aires, Argentina, specializing in typography, graphic design, and editorial design.

— p010

Estudio Yeye

estudioyeye.com

Specialized in graphic design, photography, publicity and illustration, Estudio Yeye's principal goal is simple: to give clients work that is relevant, innovative, and of utmost quality that will help their business to grow.

— p096

Farrukh Sharipov

www.behance.net/dymeet

Farrukh Sharipov is a graphic design based in Tashkent, Uzbekistan, specializing in graphic design, branding, and illustration.

— p018

Firmalt

www.firmalt.com

Firmalt is a branding and design agency based in Monterrey, Mexico that creates well-executed brands to help companies stand out and grow. Firmalt are designers, consultants, and creators of experiences.

— p070

Flëve

fleve.co

Flëve works on projects that range from startups that need help in packaging their products to creating identities for important cultural institutions, such as the largest Jewish Museum in Europe, offering strategy branding and digital presence.

— p216

Forma & Co

www.forma.co

Forma is an independent studio from Barcelona dedicated to graphic communication. Founded by Joel Lozano and Dani Navarro, it works on corporate identity, communication strategy, editorial design, illustration, animation, and web projects.

— p048

Four Plus Studio

www.fourplus.bg

At Four Plus Studio, they are after meaningful design solutions. Individual approach is the key to the specific needs of every project. They deeply value the close and honest communication with their partners, as they believe it is the essential basis for valuable collaboration.

— p036

Francisco Matte

f-r-a-n-m-a-t-t-e.tumblr.com

Francisco Matte is a student of Graphic Design in Buenos Aires. Francisco's design is intimately connected to the perception. The perception is an organizational task aimed at building meaning.

— p206

Frente

frente.cc

Frente is a design team based in Lajeado, Brazil, formed by graphic designers Germano Redecker, Luiza Oliveira, Rodrigo Brod, and Vagner Zarpellon.

— p044, 066

Futura

byfutura.com

Born in 2008 as an independent design studio, Futura is a boutique-like workshop that seeks to redefine Mexican design values, while maintaining functionality, wit and charisma. Futura specializes in resource optimization, paying attention to every detail. Futura's headquarters are based in Mexico but they have clients all over the world.

— p148

Glasfurd & Walker

www.glasfurdandwalker.com

Glasfurd & Walker is an internationally recognized design studio with a portfolio that includes branding and identity, packaging, web, print for publications and marketing collateral, exhibition, and signage design.

— p112

Gosia Zalot

www.gosiazalot.com

Gosia Zalot is an illustrator and graphic designers based in London, UK.

— p144

Grace Coakley

www.behance.net/gracecoakley

Grace Coakley is a Dublin based designer whose distinctive style of colorful minimalism is heavily influenced by her love of comic books and 90s hip hop. A conceptually driven visual communicator, she holds an honors BA from Limerick School of Art and Design and currently works with Ireland's top digital startup accelerator NDRC.

— p177

Haya Al Jamal

www.behance.net/hayaaljamal

Haya Al Jamal is a Jordanian graphic designer living in Jeddah, Saudi Arabia. She is a minimalist and a perfectionist passionates for branding, editorial design, photography, and film-making.

— p170

Hwanie Choi

www.behance.net/hwanie

Hwanie Choi lives in Seoul, Korea. He is majoring in space design. He has a lot of thinking about design including visual communication, logos, branding, and digital graphics. He also studies the various colors to emphasize the characteristics and meaning of design.

— p064

Il-Ho Jung

www.il-ho.com

Il-Ho Jung is a multidisciplinary designer and art director based in Berlin. With passion for design, he has developed a broad knowledge of many different disciplines and is always eager to learn more with each new project. He considers every work individually and creates strong concepts from the right design. He is convinced that design should be experimental without losing its focus and that the joy for design shouldn't be missed out.

— p158, 192

Jan Gallego

www.jangallego.com

Studied Architecture in the Madrid Superior School of Architecture, and Graphic Design in the European Institute of Design, Jan Gallego is a graphic designer specializing in branding design. Jan designs brands to help businesses and the people behind them to communicate the best of themselves, to connect better with the public, and to sell more.

— p187

Joana Gala

www.behance.net/joanagala

Joana Gala, born and raised on a suburban village in portugal, was waken up by the local traditional colors, smells, handwritten, non professional but fully reliable signs that her peculiar neighbors painted to sell their extra stock of potatoes and piglets, cabbage and rabbits.

— p166

Jongwon Won

www.behance.net/wonjongwon

Jongwon Won is a student in Wonkwang University major in visual communication design and also studying graphic design and UX/UI.

— p042

Julia Miceli

www.behance.net/juliamiceli

Student of Graphic Design at UBA, Universidad de Buenos Aires, Argentina.

— p060

Kim Hyunmi

cashslide.co.kr

Kim Hyunmi is a graphic designer based in Seoul, Korea. She is the leader and design director of design team Cashslide.

— p032

Kristin Edoy

www. kristinedoy.com

Kristin Edoy is a Norwegian graphic designer with a Bachelor Degree from Australia, who loves all forms of creativity and design. She works in her own design company called Kristin Edøy Design located in Norway.

— p222

La Metropolitana

www.lametropolitana.com

La Metropolitana is a company focused on providing solutions design, specializing in furniture, architecture, interior design, and graphic design.

— p150

makebardo®

www.makebardo.com

makebardo® is a graphic design studio based in Queenstown, New Zealand. The studio practices contemporary visual communication specializing in packaging design, brand strategy, and signage systems for national and international clients.

— p052, 208

Manuel Berlanga

www.bananaindesign.com

Manuel Berlanga is specializing in branding and corporate identity and he is always looking for an attractive and clean design that creates unique and unrepeatable experiences.

_P232

Marcin Markowski

www.marcinmarkowski.pl

Marcin Markowski is a Ph.D. in Graphic Arts, at the Faculty of Graphic Arts and Visual Communications in the Fine Arts University in Poznań. He is also a creator of posters, publications and visual identifications.

_p062, 082, 172

Marta Gawin

www.martagawin.com

Born in 1985, Poland, Marta Gawin is a multidisciplinary graphic designer specialized in visual identity, sign system, poster, information, exhibition and editorial design. Since her MA in Graphic Design (Academy of Fine Arts, Katowice) in 2011, she has been working as a freelancer for cultural institutions and commercial organizations. Her design approach is conceptual, logical and content-driven. She treats graphic design as a field of visual research and formal experiments.

_p122

Martha Luczak

www.marthaluczak.com

Martha Luczak is an interdisciplinary graphic designer and art director based in Leipzig, Germany. She is specializing in corporate design, design strategy, retail and brand design.

_p120, 198

Memo &Moi

www.facebook.com/memoymoi

Memo &Moi is short for Guillermo Castellanos and Moisés Guillén, the nicknames everyone knows them by. Memo &Moi are brand consultants based in Guadalajara mixing design, digital and marketing skills to offer premium branding solutions, functionality, and uniqueness. The two partners met in highschool around 2006, both unaware of where the future would take them. Seven years later, after Guillermo (Memo) had studied graphic design and Moisés (Moi) was influenced by the music scene, their paths crossed again.

_ p014

Menosunocerouno

www.brands.mx

Menosunocerouno is a brand-centric company focused on mobilizing commercial brands in Latin America. The team is an eclectic mix of brand leaders, creative directors, designers, copywriters, media executives, and brand managers, headed by French strategist Emmanuel Moreau and Mexican designer Gerardo Ortiz.

_ p026

Menta Picante

www.mentapicante.mx

Menta Picante is a studio focused on the creation and development of branding, based in Guadalajara, México.

_ p126, 196

molistudio

molistudio.com

Sebastian Dias, previously based in London, is now co-owner and art director at molistudio, a team of visual creatives from Buenos Aires, sharing the passion for art direction and design. They get involved into motion graphics, interactive experiences and imagery projects. The team is enthusiastic, full of energy and ideas, ready to get involved in high quality tailored projects.

_ p133

Moodley Brand Identity

www.moodley.at

Moodley Brand Identity is an owner-led, award-winning strategic design agency with offices in Vienna and Graz, Austria. Since 1999, Moodley has worked together with their customers to develop corporate and product brands which live, breathe and grow.

_ p114

Mooz Branding & Design

www.mooz.com.br

Mooz is a branding and design thinking studio based in Recife, Brazil.

_ p189

Mubien Studio

www.mubien.com

Mubien is a design and bookbinding studio based in Santander, Spain. The studio specializes in branding, corporate identity and bookbinding. They enjoy researching new formulas, combinations and techniques to apply them in the work for their clients.

_ p046, 228, 230

Noeeko Studio

www.noeeko.com

Noeeko is a small design studio based in Warsaw, Poland. The studio helps their clients express themselves and their products through memorable visual identities.

_ p054, 090, 204

Nouvelle étiquette

www.nouvelle-etiquette.fr

Nouvelle étiquette is a team of four graphic designers with complementary profiles, animated by the same desire for creativity, interdisciplinary, and quality. Conceived as an hybrid between graphic design studio and art workshop, Nouvelle étiquette develops institutional and corporate projects, while encouraging the artistical and individual experiences of its members.

_ p098, 108

Parámetro Studio

www.parametrostudio.com

Parámetro Studio is a multidisciplinary design studio based in Monterrey, Mexico.

_ p214

Peltan-Brosz Roland

peltan-brosz.com

Peltán-Brosz Roland is a graphic designer based in Budapest, Hungary.

_ p058, 224

PURO DISEÑO

www.purodiseno.rocks

Located in the city of Merida in Mexico, PURO DISEÑO is an agency of passionate graphic designers specialized in creative branding and communication of brands.

_ p138

Reynolds and Reyner

reynoldsandreyner.com

Reynolds and Reyner's philosophy is rooted in the true power of design. They believe it is less about making high quality brand experiences and more about the process at which they engage in, to create a real relationship between they brands and their consumers.

_ p174

Rita Fox

www.kitska.com

Rita Fox is a London based designer who runs her own visual communication brand: Kitska. She helps her clients establish a successful brand identity and produce effective visual communication, through a wide range of disciplines like Web & App design, identity and print. Making clients happy by finding the perfect fit design solution and produce work of creative value and high standards is her drive.

_ p124

Robert Gutmann

www.robert-gutmann.com
www.timkaun.com

Robert Gutmann and Tim Kaun are two design students from southern Germany who are just about to finish their studies with focus on media design, moving image, photography, and graphic design.

_ p152

Rokas Sutkaitis

rrrrr.lt

Rokas Sutkaitis is a graphic designer based in Lithuania, specializing in branding and identity design.

_ p022

Saad branding+design

www.saad-studio.com

Saad branding+design is an award-winning Brazilian studio that builds brands and identities that talk to people and create relationships. With worldwide experience, the studio focuses on creating tailored brands through our highly dedicated and exclusive services. The perfect synchrony of branding and design leads them to expressive, authentic and efficient solutions, building strong, relevant and truly valuable brands.

_ p092

Scada

www.scada.design

Scada is a professional agency with significant experience in branding, web design, and interface design field. Founded in 2002, Scada has successfully implemented over 350 projects. The clients of the company may be found all over the world: in Europe, USA, Canada, and Russia. Scada is not focusing on one field. Scada is interested in working with both creative Startups and financial corporations.

_ p104

Siegenthaler &Co

www.siegenthaler.co

Siegenthaler &Co is a design firm based in Bogota, Colombia specialized in brand development and packaging design. They develop brand systems, including visual identities, consumer packaging, digital experiences, and physical environments. Their designs bring ideas to life, transform brands and help businesses grow.

_ p194

Snask

www.snask.com

Snask is a branding, design, and film agency situated in the heart of Stockholm. Snask's work is frequently internationally referenced and results in brand platforms, graphic identities, short films, handmade photo installations, communication strategies, design manuals, stop motions, TV commercials, and carefully crafted corporate love stories.

_ p110

Studio Bruch

www.studiobruch.com

Studio Bruch are Kurt Glänzer and Josef Heigl, the duos main focus is on branding, editorial and package design.

_ p078

Studio Mozaika

www.studiomozaika.com

Graphic design for print and brand identity are the main subjects in the work of Studio Mozaika.

_ p050

Tadas Bujanauskas

www.tadasbujanauskas.com

Graduated from Towson University, Maryland, USA, Tadas Bujanauskas is a multidisciplinary designer who creates visual identities and works in the fields of illustration, print design and art direction. He aims to deliver aesthetically pleasing design with a strong sense of minimalism and cleanness.

_ p200